Dramatic Notes

Foregrounding Music in the Dramatic Experience

Neil Brand

UNIVERSITY
UP *of*
JL
LUTON PRESS

THE **ARTS COUNCIL** OF ENGLAND

British Library Cataloguing in Publication Data
A catalogue record for this page is available from
the British Library

ISBN: 1 86020 548 8

Published by
University of Luton Press
Faculty of Humanities
University of Luton
75 Castle Street
Luton, Bedfordshire LU1 3AJ
England

Book designed by Design & Art, London
Printed in Great Britain by Whitstable Litho Ltd,
Whitstable, Kent, UK

I would like to express my gratitude to
the following:

The eminent practitioners who allowed
me to interview them or generously
answered my questions by fax, often
during busy schedules.

My colleague, Philip Carli of Rochester
NY, who allowed me to pick his brains.

The education departments of the
Museum of the Moving Image and the
BFI, who have supported and encouraged
my work over the last decade.

Don Brand, who has provided the first
outsider's view of the book, and enhanced
it greatly by his scholarship.

Alison Glenny, who transcribed and
edited the interviews, typed the text and
curbed my wilder excesses.

My colleague, Mike Nicholson, whose
brain-child it was and continues to be.

My music teacher, Gordon Brooks, who
knew the score, and to whose memory this
book is dedicated.

Dramatic Notes

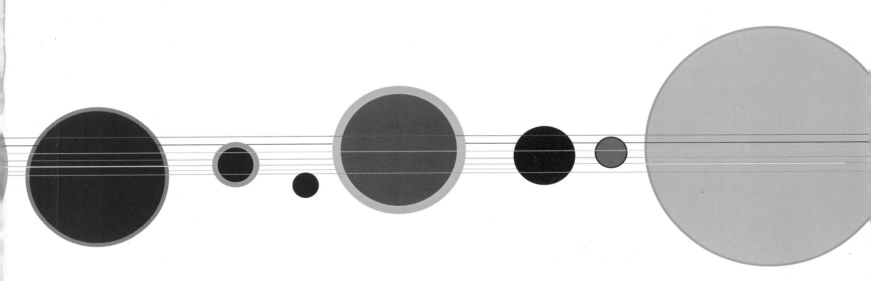

Dedicated to Gordon Brooks 1928-1996

Contents

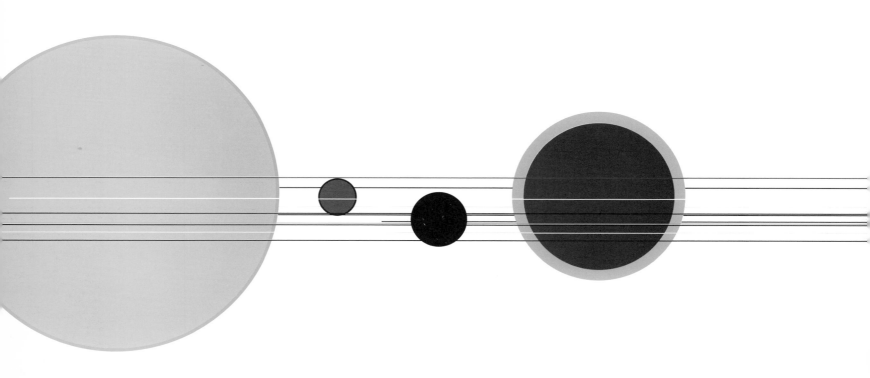

The great portmanteau thunder word marking the downfall of Joyce's eponymous hero on page one of *Finnegans Wake* was inspired by the author's fascination with a book first published in 1725. *The New Science of Giambattista Vico* is not only the first profound analysis of the origins and institutions of human society it is also a work of extraordinary poetic beauty. Vico asserts that it was thunder that drove people into caves thus creating the first societies out of which came language and art. It was sound that was the origin of all cultural activity, next came hieroglyphs – visual representations of the world. From sound comes language of which music is a universal manifestation. The fusion of sound and image is as old as history itself. There is little difference between the shadow play and story telling of cave dwellers and the sophisticated technology that we know as cinema. There has never been silent films. From ambient noise to programme music the moving image has always been 'accompanied' by sound. Neil Brand's book looks at that complex relationship and in an accessible way charts and explores the importance of music in making meaning.

This is the ninth volume in a series of books on the way the media has transformed our understanding of the arts. The first volume, *Picture This: Media representations of visual art and artists* (ed. Philip Hayward), deals with a range of topics, including the representation of visual art in popular cinema, and how broadcast television has revolutionised our relationship to culture and cultural practices. The second volume, *Culture, Technology and Creativity in the Late Twentieth Century* (ed. Philip Hayward), addresses various aspects of how technology and culture interrelate. Topics include digital technologies, computers and cyberspace. Volume three *Parallel Lines; Media representations of dance* (ed. Stephanie Jordan and Dave Allen) collects together accounts of how dance and dancing have been represented on public television in Britain. The book considers the role of dance in a variety of television practices including pop-videos, popular dance programmes, and experimental and contemporary dance. Volume four *Arts TV: A history of arts television in Britain* (ed. John A. Walker) is the first general, systematic history of the various types of genres of arts programmes – review programmes, strand series, drama documentaries, artists profiles, etc. – and gives a chronological account of their evolution from 1936 to the 1990s. Volume five, *A night in at the Opera : Media representations of opera* (ed. Jeremy Tambling), offers an arresting range of accounts of how the popular arts have represented this high art form written by specialists in music, media and popular culture. It raises issues which have bearings on the sociology of music and about its implications for television and video culture. Volumes six and seven *Diverse Practice: A critical reader on British video art* (ed Julia Knight) and *The British avant-garde film 1926-1995* (ed. Michael O'Pray) highlight the rich practice of artists working with film and video. Volume eight, *Boxed Sets: Television representations of theatre* (ed Jeremy Ridgman) discusses the aesthetics of television dramatic production and performance and reassesses some of the assumptions about the influence of theatre on the emergence of television drama as a specific form.

We would like to take this opportunity to thank Neil Brand for writing this book and the publishers – the University of Luton Press – who joined with us in its production. We are grateful to them for the untiring and thoughtful way in which they approached the task.

Finally, the views expressed herein are those of the author and should not be taken as a statement of Arts Council of England policy.

Will Bell
Series Editor
Arts Council of England

Introduction

Everybody, musicians and non-musicians alike, has access to the inner workings of music with drama. It works on an instinctive level, can be discussed in descriptive terms, has a bearing on many aspects of our everyday lives, and yet is still considered the domain of the musically literate alone. This book attempts to provide some pointers for the layman, the semi-skilled and the unskilled who, like me, have found that music exists beyond our capacity to read, write or understand its notation. It is not a set of rules, an academic treatise or a profound text. It is, if you like, an invitation to the curious to enter a previously private residence, look around and marvel at how familiar it actually is.

My first recognition of the power of music with images occurred at the age of seven, as I was leaving the local cinema with my family. We had been to see a Disney movie about a girl athlete who makes a startling discovery. She could run even faster when she heard a rhythm in her head. The title is lost in the mists of time, but I can still remember dashing the fifty yards or so to the bus stop with the same pounding rhythm in my head. Perhaps it would work. Maybe I *was* that demon athlete. Sadly the Disney magic evaporated at the next games lesson, but from that day on I was forever hooked on film sound-tracks.

Like many another sensitive child, I found that films that frightened me were made easier to bear if I had my fingers in my ears. What was worrying me was the sound of fear, not what I saw. Most of the time what I saw was not half as bad as what I had imagined. But loud noises, eerie music, screams, explosions, those you could not imagine in their intensity. Nor for that matter was the glorious music behind a last fade-out shot, the comic music behind a chase, the tear-jerking music behind a scene of tragedy. My senses were heightened by the cinema. Like generations before me, I emerged into the rain still wreathed in the experience I had just witnessed. The real world was already proving a big disappointment by the time I hit nine.

From an early age I could play the piano well by ear. I heard things and reproduced them. I made up little pieces. This stood me in good stead through school and a drama course at university, but it put paid to a formal musical education. I was too precocious to play other people's music correctly – I would tamper with it. Instead of scales I would attempt tone poems. I could hardly sight-read at all. Yet I knew what music

was doing, and how to turn it to advantage as a song or a theme. I desperately wanted to score films, but even my naïvety didn't extend to writing to David Lean to ask for a job.

Three years after leaving university as an actor/musician, I was asked to accompany a silent film on the piano. Thus began a system of schooling in film and image that money could not have bought. I found each film came with a metaphorical blank sheet of paper. That paper had to be filled in as the film progressed. The requirements were very exact, the characters, situations, suggestions, signals all clear and concise, their incompleteness an invitation to experiment. I learned early on that it was easy to play what you saw, less easy but much more satisfying to find and play the subtext of the scene.

My colleague Mike Nicholson, at the time education officer of Kent Opera, suggested my involvement in a tour of schools, preparing the way for a later tour of Monteverdi's *The Coronation of Poppea*. He was convinced that by getting children to see how music worked with film and looking at the story and events in *Poppea* as drama, they would begin to understand music's place in opera. It was the beginning of an investigation which now continues in the form of a company, Clicktrack, and this book.

Dramatic Notes will have done its job if it does a little to heighten the readers' awareness of music's place in the dramatic experience, if it sends them back to a particular show or film to reassess its musical impact, or if it simply brings the scoring to the foreground during an evening's television. I hope it will also serve to celebrate the many creative people within the arts and entertainment industries whose individuality and uncompromising standards are a cause for hope in an otherwise uncertain future.

Neil Brand
1997

1 | The State of the Art

All music communicates more than the sum of its notes. Instinctively, musicians and non-musicians alike grasp a depth of insight, sometimes meaning, that flows with the structure of chord and melody yet somehow transcends and defines it. When music is allied to drama, as text, verses, images or any other non-musical stimulus, the experience of the audience is complex and profound, yet still intuitive. One doesn't need to understand music to hear what it is saying. This book deals with music as drama, whether opera, ballet, theatre underscore, film or TV music, advertising, signature tune, background or ambient music. We shall look at music's development over the centuries, its wide use in modern society and its undoubted ability to influence emotional response in any audience. I hope to challenge some of the mystique of music composition, and show that many of the decisions regarding the choice of music to support drama are made by non-musicians or composers whose understanding of drama is at least equal to their musical ability.

If you were to take a cross-section of a typical Saturday night audience in a city cinema watching a new film, you would be presented with a mix of wildly different personalities and attitudes. Hollywood may have reduced its intended majority target audience to an early-teen popcorn bracket, but the audience for any film will contain huge variations of age and intellect, interest and reaction. That audience may have been lured to this particular film by its star or its subject, its director or its period, but almost certainly not by its music or its composer.

Yet that music will set out to ensure that every individual in that audience enjoys the same experience. It will attempt to make everybody feel the lurch of fear or the warmth of love. It will try to communicate more complex emotions like jealousy or irony, suspicion or apathy. It will give form and depth to fictional narrative so as to communicate the sensations of reality itself and so enhance the joy of communal response which is so much a part of cinema- and theatre-going. Most astounding of all, every member of that audience will have within them a well of musical response, shaped, seemingly, since birth and reactive to deep stimuli, which allows them to by-pass the intellect and give themselves over to the unreality of the situation (who ever heard an orchestra playing urgently during a plane crash?), thus making the experience seem more real than ever.

What is this well of musical sensibility? How is it fashioned in individuals, yet able to override that individuality and allow people to respond in a collective sense? It does not seem to be affected by the musicality of individuals. Someone who is a musician or composer will not necessarily react more strongly to musical emotion than someone who is not. Does it derive from people's musical influences? Certainly that must be the case. People will respond better to music they have grown up with than to the music of a different or alien culture, although their response to modern as against classical music, will tend to reflect their age and taste.

A recent survey to investigate claims that music could influence the clarity with which the human brain functions involved playing Mozart to one group of school children and Oasis to another, then giving both groups the same intelligence test. The idea was that the complex yet controlled patterns of Mozart's music could in some way stimulate the thought patterns of the brain to work more efficiently. The ones who had listened to Oasis actually did better in the intelligence test, though that had little to do with equating the mathematical ability and musical responsiveness of the brain, even if that connection undoubtedly exists. It proved rather that the children's emotions, senses and reactions, were heightened by hearing music that held a potency for them. They took the intelligence test in a more assured and aroused frame of mind. The ability of music to make you more intelligent has still to be convincingly proved. The ability of contemporary music to make young people more sympathetic to a piece of drama needs no proving.

Yet even today, in contemporary cinema, the vast majority of original music produced to underscore blockbuster movies is of the romantic classical style. Orchestras are still the mainstay of original Hollywood scores, if only for the elitist reason that Hollywood producers demand that everything about a new blockbuster is huge and luxurious – hence, orchestral scoring is a minimum requirement. However, an audience for a Hollywood blockbuster is hardly equated with the audience for a classical music concert, so what is the common denominator?

Moving away for a moment from music as an underscore to drama, it is worth looking at the

stimulus of music itself. From the dawn of civilisation, music has been seen as a necessary yet mysterious product of human ingenuity. Music hath charms to soothe the savage beast, yet was no product of the natural world. Birdsong appeared to be music, but not music that man could turn to his own ends. Orpheus charmed the animals with his playing and David soothed Saul's mad rages with the lilt of a harp. Ancient civilisation recognised that the sound of a flute or plucked string had the ability to communicate more deeply than words, and for that reason what they communicated could not be easily described. The sound of music, particularly harmony, that is, two or more notes played at once to form a chord, seemed to early man such a powerful magic that he attributed it to the very workings of the universe itself – the music of the spheres. The many spheres of earth, heaven, existence and time itself hummed in perfect harmony with each other, and the puny attempts of man to make music were the by-product of natural musical power. In this, as we shall see, lies the complex answer to the complex questions any investigation of music as narrative must throw up.

Through the centuries of man's development, his relationship with his music became more complex and sophisticated. Succeeding generations of composers drew upon the improved instruments and wider musical understanding of their time to build upon the work of their predecessors, yet without negating those predecessors. A Purcell composition of the 17th century is just as prized today as a work of the 20th. The audiences for music evolved in musical response both intellectually and instinctively, so that a modern audience is shaped by hundreds of years of musical thinking and feeling, just as it represents the product of millions of years of evolution.

During that time, music itself has evolved and overthrown an internal architecture which gave form and movement to concert music written outside the demands of drama – *sonata form*. This form, based originally on dances as movements, became the basis for the classical symphony and concerto. It relied on the repetition, relation and change of musical motifs and related keys to establish a satisfying musical experience similar to taking a long walk through an unknown environment and returning safely home again. Music carried abstract emotional feelings when written as symphony or chamber music, but did not rely on dramatic or narrative

explanation to make it understandable. The greatest composers wrote music which transcended the human condition, their own weaknesses or personalities, and which celebrated the timeless and eternal in all our experience.

Yet when we reach our own troubled century we find the evolution of western music becoming more fragmented, the hard lines of experience and style, innovation and populism becoming blurred. At the start of the twentieth century all music still seemed to grow from one creative root. Melody and harmony were recognisable and traceable to the classic mould. Yet within thirty years an avant garde route, a popular route, a modern 'serious' music route and the rise of blues and jazz had meant that individual tastes had a far wider diversity of music to enjoy. Before the 20th century, music could only be heard if it was physically played on instruments within earshot of the listener. From the 1890s onwards the phonograph, gramophone and eventually radio brought music of every kind into any home at the touch of a button or crank of a handle. People could now choose their favourite music, replay it as often as they wished and, indeed, influence the rise of that music – buying sheet music and records brought about an industry dedicated to giving the public what it wanted on a grand scale, and the 1920s onwards saw dance music swamp the musical world as the audience for 'serious' music declined.

So the audience of today are products of that diverse musical background. In specific terms they will probably respond immediately and emotionally to music that influenced their formative years. Looking back to myself as a teenager of the 1970s, I always considered I was cheated in comparison with the generations immediately before and after mine. The 1960s generation grew up with music that freed them from constraint and carried a powerful creative force – the generation of the Beatles and protest. The 1980s kids had the energy of punk and new wave and the rise of world music. The 1970s, with some honourable exceptions, seemed to be the era of easy listening and the concept album – the last gasp of melody and the pomposity of intellectual ideas linked to the emerging new music technology. Twenty years on, I am grateful to both these strands, as melody is still a very saleable commodity for a jobbing composer, and concept albums taught my generation how to understand and write film music. However, my contemporaries are becoming the film-makers,

TV producers and advertising executives of today, and are looking to their musical roots to woo a new generation. 1970s revival anyone? It's only a matter of time.

The composers for today's drama have all this musical experience to draw on. Unlike composers for the concert hall, whose music pushes forward the frontiers of classical creativity and who thrive on innovation and experiment, the media composers of today must be keenly aware and interested in the development and culture of their society. No music should, theoretically, be outside their interest or ability, yet the process of composition should still produce originality and inventiveness as well as accessibility. The need to communicate with a vast popular audience does not require simple or banal music but music uniquely suited to its purpose – music, in other words, as complex, emotive and direct as the context which it is written to serve.

This is why music as narrative requires composers who can understand drama as well as music. The requirement of drama is the understanding of a context in all its complexity and with all its nuances. Music without context is subject to interpretation and subjective response. Marry the requirements of drama with the vast communicative force of music and the composer's job becomes one of control – making music contain messages that are specific enough to relate to drama, broad enough to allow music to cast its spell, yet not so broad that the music is inconsequential. This is the creative equivalent of picking up mercury with your bare hands.

Just as the musical styles, moods and instruments that the composer can draw upon are legion, so are today's uses for narrative music. Historically, live drama underscored with music has given rise to melodrama, theatre music, opera, oratorio, ballet and the musical. The communications technology of the 20th century has given rise to cinema, TV and radio drama, advertising, background muzak for public places, raves and performance art and such spin-offs as sampling and the pop video. Music is being put to work as never before. The composer has never had such opportunities to ply his trade. Yet the requirements of each medium are specific and controlled, and the composer is seldom the final arbiter. Thus a film director can tell a composer what music he wants and compel changes if necessary. The advertising executive can decide what style of music best suits his product. All too often the final thumbs up is left to the public, or a representative sample drawn from the director's or client's acquaintances. This is the point where music is in the public domain – everybody can speak knowledgeably of music's effect, because everybody has felt that effect. The media composer is a hired hand who must tap that response or be replaced.

To understand this huge industry we must look at specific cases. Later in this book we will be talking to composers, directors and writers about their experience working in today's society, and looking at the historical development of music as a narrative force. For now it is sufficient to throw light on the current areas in which society and specially composed music collide, in order to work towards a thesis that covers the broad spectrum of popular response to music.

Let us take as an example the writing of a signature tune for a news bulletin on TV, such as *News at Ten* or *The One O'Clock News*. This is probably considered hack-work of the lowest order, a use of music which is at best tolerable, and at worst devalues the art itself. Yet it may come as a surprise to know that it is entrusted only to the leading composers in the field of scoring music for drama. The music needs to be short (probably about five to fifteen seconds), possibly scored to a visual sequence which already exists, and contain two powerful elements – an immediate, urgent impact and a recognisability factor.

The first is intended to call attention to the programme. This is the *raison d'être* of all TV music, as people may be in the room but not watching the programme, and if their attention has wandered they may turn over or switch off. Either act is disastrous for that channel's ratings. The second is to lend an air of security and memorability to the programme. The news could be considered a flagship programme for a TV channel. It is authoritative, distinctive and necessary, and regular news of the outside world, good or bad, makes us feel part of a wider society. The music we hear tells us all these things, and the short but memorable theme must sink firmly into the national subconscious. We may have to think consciously to recall it, but the broadcast over the TV becomes a call for attention that we answer almost subliminally. (Interestingly, the signature for TV news on national television in Zimbabwe is the pulsing of drums, a literally tribal evocation of calling to attention or to arms.) This is the context that the composer

must work to when writing a signature for TV news: the attention-grabber, or hook, and the sense of security and recognisability. We will be returning to these terms many times in the course of the book.

The most commonly heard, and indeed owned, music nowadays is the song crafted for the charts. The music industry spends and reaps fortunes in bringing a particular number to public attention, having already seen to it that that song has every opportunity to succeed. Its writing and production have been carefully supervised. The artist or band have a well-crafted image that they put across to the buying audience. The song itself is considered sufficiently cutting-edge, in musical and social terms, to be sought-after. But with what is that new song providing its audience? Often wish-fulfilment – a suggestion of a love or attitude which is ideal or unattainable, yet close enough to real life for the audience to relate it to themselves. Almost always the ability to move to it, a rhythm or beat that commands a physical response. And finally, a hook, a memorable phrase or melody line that sticks insistently in the mind and makes the number attractive – more-ish, if you like. Combine those elements with originality, and you have a hit, and a licence to print money.

But what does this have to do with writing music as narrative? A hit song dramatises life. Most modern hits are a story, carried in lyrics, to which the music gives impact and depth. Make it into a pop video and you have an idealised, fantasy world of super-human charismatic creatures who are singing and talking about all of us. Or so it seems. Music in this instance, is being used to dramatise and formalise love, hate, human behaviour, the least ordered of human emotions. In the shared enjoyment of a successful number we are all seeking the security of a communal experience, for good or bad.

When Bill Haley's 'Rock Around the Clock' crashed in under the title of *The Blackboard Jungle* (1955), Hollywood began its hard sell of 'teen related movies to a 'teen audience. From the first second of the picture, a young 1950s audience knew that this was a film intended for them, and were accordingly more ready to listen. Martin Scorcese is credited as being the first film-maker to construct an entire sound-track of period hits, for *Mean Streets* (1973), an evocation of his own youth in New York, supported by music that he considered 'the

sound-track of my life.' A generation of modern American tyro directors grew up with 1960s hits, memorable tunes over heavy, juke box-friendly bass lines, which pleased a communal coffee bar audience. These were consequently dusted off to grace the sound-tracks of 1970s and 1980s hit movies and please a new cinema audience responsive to nostalgia and the hip.

So what happens when that hit song is placed in a new dramatic context, such as a film score? There may be some people for whom, for personal reasons, a particular song represents the most romantic night of their lives. For others the same number is too tragic to listen to. The use of hits past and present in modern film and TV comes up for a good deal of discussion in the interviews section, but their use is understandable. They already carry a wealth of cultural references – style, romance, nostalgia. They are saleable as part of the album which will advertise the film and recoup some of its costs, especially if the company that makes the film owns the company that publishes the hits. They are also useful to directors for cutting a film and lending off-the-peg emotional thrust to a scene. Above all, they are already road-tested with the public and found to be popular. A sound-track full of hits will find its audience and hold them in security for the duration of the picture.

This is standard practice for the advertising world, who are happy to ransack hits from earlier times in order to sell a product. A raunchy 1970s hit, 'All Right Now', sells chewing gum, a 1930s Irving Berlin foot-tapper, 'Let's Face the Music and Dance', sells health insurance. British Airways achieved extraordinary success with a commercial in the mid 1980s which took a piece of grand opera, the duet from Delibes' *Lakme* (1883), and simultaneously won acclaim for BA and a new audience for operatic arias. This led directly to the 'hit of hits', 'Nessun Dorma', chosen to trail BBC's coverage of the 1991 World Cup. The host country was Italy, the Three Tenors were performing in Rome, and the prestige of Puccini was forever linked with football's greatest trophy. Yet the reason that sales of singles of Pavarotti's performance rocked the charts was not the hype but the tune. 'Nessun Dorma' is a brilliantly memorable tune, carrying a wealth of deep feeling, even when sung by a crowd of people who don't know the words. The 'hits' of grand opera were the arias, and they have proved timeless with a broad popular audience who long for melody.

Yet 'Nessun Dorma's lyrics are bound up with the plot of *Turandot* and the feelings of the single character who sings them. They refer only to the context of that opera. The music happens to release a wider set of responses in a modern audience, particularly one that cannot speak Italian. These responses have to do with effort and achievement (listen carefully to the very end of the piece) and, subliminally, the similarity of effort and achievement in an event like the World Cup. The use of opera in the British Airways advert suggested luxury and prestige, but also smoothness, relaxation (it is a very seductive, slow duet) and a sense of wish-fulfilment, which is at the heart of all music used for advertising. Perfect for selling a long-distance plane trip. The interview with John Altman goes further into this subject.

It is relatively easy to understand the effect that this use of music has when linked to a dramatic context. It makes us think of other cultural references that go to support the drama. If you were watching a play about a small village football team which was underscored throughout with 'Nessun Dorma', you would immediately get the rather obvious joke. If you see a shot of a 49cc moped being ridden along a country lane, and the accompanying music is Meatloaf's 'Bat Out of Hell', again the music would be making an ironic comment, contrasting the moped with a fire-breathing demon motorbike, because we know the real context of 'Bat Out of Hell'. In terms of wish-fulfilment this kind of juxtaposition is used again and again in films and TV.

It is more difficult to understand the effect that specially composed music is having on our emotional responses. An original music score means that we have not heard a note of it before, so cannot relate it to previous experience. We can only react to such music instinctively, and that is where we have to examine the notion of music in the mind.

Music exists in time. Unlike a painting, which we see in all its glory in a second, and which does not essentially change as we continue to look at it, music needs time to make its impact. The music begins, and straight away we are listening to it, aware of the path it is taking and the times when it varies onto a new path. How fast is the music going? Is it proceeding at the same rate, or getting faster or slower? Does it sound happy or sad? Is it exhilarating, violent, disturbing or peaceful, sad, depressing?

These are value judgements our minds make simultaneously with hearing a piece of music. The first of those judgements is probably, do I like this music? A ballet piece to a techno-lover or Japanese nose-flute to an African tribe will probably be an immediate turn-off and so will not be able to press the necessary emotional buttons in the listener.

The next value judgement, I suspect, is one of speed; certainly that is one of the first elements considered in scoring a piece of drama. How fast or slow does this piece need to be? This decision is not necessarily reached by looking at the speed of the action it is to underscore, although that may be the case with a piece of dance. Slavish musical scoring to the movement of a piece of action is called, in film scoring terms, 'Mickey-mousing'. This refers to animated cartoons in the cinema, where the music provided the sound for all the characters' movements. Thus, when Tom is chasing Jerry down a flight of stairs, we will hear the sounds of their feet running down the stairs as a continuous *glissando* down a percussion instrument like the xylophone. When one is hit with a frying pan we hear a metallic crash from a cymbal. When Tom's body runs into itself as he hits a brick wall and assumes the shape of a concertina we will hear that concertina. The orchestra is now providing the sounds of real life for comic effect, and the speed of the characters, their stops, starts, falls and jumps will all be mirrored in the music as they happen. The virtuosity required of both composer and performers is extraordinary, given that the music must follow the demands of the break-neck speed of the animation, and the orchestral colour must be controlled deftly and with precision.

Take a fast piece of live action, like a car chase – does it specifically need fast music? That depends on the rest of the context. Even in the worst films, a car chase does not simply happen for its own reasons – a character is chasing another character. The music may therefore be fast, exciting, pulsing at well above our own heart-rate, to make us feel what it is like to be in that car. This is empathy – the ability of an audience to get involved with a situation they have never themselves experienced by using the music to feel those emotions. What happens if one car speeds over a junction, but the other car stops? Does the music maintain its continuous speed? Not necessarily. You may hear the music come to a stop, hold a chord over the next shot, stop altogether, or continue. If the character in

the stopped car is frustrated, the music may tell us that. If that character has decided to let the other car go, the music may tell us that. If the stop is temporary and the pursuing car can continue, the music may pick up again, depending on how the rest of the chase is structured.

But to change the context, let us suppose that the driver in the front car is a woman, and the driver in the rear car is a man who has realised that he is deeply in love with her. She is literally driving out of his life, unless he can reach her before she gets onto the motorway. Let us also assume that this is the climactic scene of the whole film, that the story has concerned these two characters throughout, and the audience cares deeply that they should have a happy ending. The music could still be a pulsing, fast car chase, but now the *experience* of the chase is less important. The chase is visually exciting, but the sound-track could be playing a slow romantic piece of music, or a hit song that is 'their' song, or a variation on either. It will be telling us about something we cannot see – the driver's frame of mind. The man is chasing because he is obsessed with catching the girl. The romantic music is shaping our response to the chase, giving us signals, telling us that this romance is all-consuming to the driver.

But how is that music suggesting romance? What is love, in musical terms? Again, to some, it is Chris de Burgh's 'Lady in Red' or any other personal favourite. Ours, however, is an original score, that is pushing the 'romance' button in its audience. I suspect that the music is therefore a slowish, lyrical melody – a tune. This tends to derive from the wealth of romantic popular tunes written in the first half of the century by Tin Pan Alley songwriters – the great melodies of Gershwin, Porter, Berlin, who linked a memorable lyric to a simple and memorable hook of melody – and from there further back to the great romantic arias of opera. Love is usually a melody, in which the music *resolves*. This is a musical term relating to the path a tune is taking in relation to its start point. Resolution or lack of it is at the heart of all musical phrasing, and often the key to our response to it.

Take a well-known piece of music like 'Frère Jacques'. The shape of that tune could be drawn like this:

Fre-re Jacques, Fre-re Jacques

Dormez-vous, Dormez-vous, Sonnez les Matines

Sonnez les Matines, Din Dan Don, Din Dan Don

That is the movement the notes make, and the whole tune seems to come back to a note which we feel is the natural end point. This is to do with the key that the music is in, the changes the chords have gone through and the fact that the piece is back in the chord it started in. The key, throughout, is a major key, and the whole piece is happy and resolves. This is music that is too often described as 'pretty' or 'nice'. But finish the tune on the note above or below the actual finishing note, and the piece is unresolved. We feel that there is more to come, that the music has somehow to do more to bring itself back to 'home'.

That sense of the unresolved in music, of tunes or chords hanging in the air, or following paths that we find strange or instinctively do not expect, we equate in our minds with human experience. The 'home' key is precisely that – home. As a piece of music moves away from what we heard at its start, evolves or travels to other keys, resolves or is left unresolved, so does our sense of musical well-being. The feelings of *love, warmth, security,* are often expressed in music which resolves, in other words, forms tunes or motifs that we instinctively find

attractive, warm, understandable. The darker feelings, or feelings of *confusion, disorder, violence,* call for music which is in itself less ordered, unresolved. The course of music as narrative is often, at heart, the music travelling between resolution and non-resolution, the emphasis on one or the other tending to give the score, and therefore the drama, its character.

Thus the music's journey may not be the same as the drama it underscores, but is a narrative of its own – the music is travelling in time simultaneously with the action, giving us different signals which illuminate the action, signals derived from the music's relationship to itself and to the drama it supports. This is why the best music for drama can be listened to without having to watch the action it is linked to – it is in itself a satisfying journey for the listener, and becomes even more so when seen in its dramatic context.

Predominant resolution does not necessarily make a more satisfying score – indeed the satisfaction of the listener is more in following the highways and by-ways of the journey than always being able to see its end point. One composer has told me that he simply cannot write music that resolves, because, as he put it, 'the world no longer resolves – there is so much out there that is wrong and cruel that to write music that resolved would be a betrayal.' Drama is most often the struggle of a character or characters to achieve their ends against all odds – their life, their environment, other people. Music that reflects this will not resolve until the story does, if at all. Music always has and always will mirror life, even music that is not written to a context. As listeners, we will instinctively seek out a meaning for that music when compared to our own experience; this is why we probably all have some musical piece we need to hear when we are sad, something that is relaxing to listen to, something that cheers us up, provides the luxury of a miserable wallow or excites us. But, as playwright David Pownall (see interviews) has pointed out, music is non-political. Music always escapes. For although you can place an interpretation on a piece of music, that music will carry more layers of meaning than just the one, and different people will see different meanings in it.

Even the composer will not easily be able to 'explain' his work. In his play, Elgar's *Rondo* (1993), Pownall explores the curse of creativity when applied to Elgar. The composer intended

his 2nd Symphony to be a celebration of human joy, but written as it was in 1911 with the storm clouds gathering over Europe, the symphony became a terrible portent of disaster, written almost in spite of Elgar's wishes. His profoundest feelings had written in the music a despair which Elgar never intended should be there. Tchaikovsky enunciated his terror of life, his profoundest depression and his greatest elation in his music in a way which is almost painful. Mahler did not write a note that was not derived from his lifelong contemplation of existence and humanity.

Thus it is that often one wants to know more about a composer in order to understand that person's music. We desire to know the circumstances surrounding the composition, the emotional state of the composer, anything of the immediacy of creativity that could shed more light on a piece of music. This century has seen the greatest social upheavals of any, and so much great music has emerged from the most traumatic events that the old cliche that one has to suffer to write great literature or music seems to bear a ring of truth. That music transcends the circumstances of its creation is beyond doubt, but the greatest music is that which contains the truth of a shared humanity, simply and directly communicated.

Programme music, picture-painting with notes, provides a context which illuminates a musical work. Drama also provides a context against which we can judge what music is 'saying'. Songs have always had that ability, because we listen to the words to explain the music to which they are joined. There is not doubting the thrust of a joyous outpouring like Beethoven's *Hymn to Joy*, or a Beatles' hit like 'I wanna hold your hand', where the music gives a great depth to the specific context of the words which deepens and reflects our own experience. But take away the words, make the composer himself anonymous, the events attendant on the birth of the piece unknown, strip away all but the notes themselves and listen; miraculously, we will virtually all hear the same messages carried indefinably within the musical structure.

To try to understand how this can be is interesting to look at the parallels between the instinctive understanding we seem to have for music and Noam Chomsky's theories in the field of language and linguistics. Pre-Chomsky, the predominant school of thought in twentieth century linguistics was Behaviourist, seeing the

evolution of language and its development in different people and cultures as being dictated entirely by experience and environmental influences. People, it was argued, are a blank slate at birth, and can be manipulated by their environment to acquire almost any behaviour, language acquisition included. Chomsky, seeing this as a denial of innate human creativity and endeavour developed a theory of generative linguistics, investigating not the differences between languages but the similarities, uncovering a pattern of universal grammar and deep meaning which, as he saw it, was inherent in humans from birth. The brain and nervous system could not only create speech, but contained within a separate centre of the brain the blueprints for the organisation of language itself, a grammar system which underlay the structure of all languages. He also saw in religions, ethics, social structures, the arts and music, universal qualities which expressed themselves in remarkably similar ways throughout the diverse cultures of the world.

Is it therefore possible that beneath the nurture of personal experience which informs our appreciation of music, there is a universal inheritance of natural musical response, genetically coded within us all, a deep structure of understanding beyond language which music touches at a profound level? Despite differences in taste, knowledge, ability or interest, could we not all be the products of an evolution in which musical response is part of the equation? Music at its most abstract and anonymous touches us all, and musical ability is described as a naturally occurring phenomenon. Perhaps Chomsky's neural area that contains the blueprints for communication also contains our inner ear, our emotive well of response. Whether that area is developed through nature or nurture, it is the area which the composer of music for drama has the understanding to touch, the ability to stimulate – has in every sense, the key.

Composers' ability to 'speak' in these terms and our ability to hear them are part of a shared awareness of ideals, hopes and fears, and a sense of the inadequacy of language, which music overcomes with ease. Music, even discordant, dissonant music, represents the ordering of chaotic elements into a shape that is created and communicated. The hearers take part in that creative process and apply the music to their own experience. In an irrational, disordered, emotionally confused world, music is always a salve, simply because it imposes some order on

that chaos, yet also carries an emotional depth which in itself formalises disorder. Perhaps the truth is that the human animal needs both security and the excitement that the unknown can bring, and that both these necessities are catered for in music, as they are in drama. This is why music is such a natural narrative force, why it has been so often twinned with drama, and why its use is even more widespread today. Therefore to understand music as narrative one has to comprehend all the complexity of the dramatic context it refers to, and from that derive a sense of the job music is being asked to do. This is not the sole prerogative of composers, but the universal and democratic heart of great drama and great narrative music – it belongs to everybody.

2 | The History of Narrative Music

The birth of music can be traced to the earliest sounds of the human voice. What distinguishes music from human speech is the organisation of tones and pitches and the use of rhythm. It is, however, a short step from the instinctive pitch of the voice in singing to the instinctive need to communicate vocally, such as calling to attract attention for or help, and it is possible that singing predates speech as an early form of human communication. The response we all express to music may have developed from a memory of our species, our earliest ancestors' attempts to communicate on a basic level, now become man's attempt to communicate his deepest emotions and feelings. It is always difficult to assess the evolution of early man in cultural terms. Whilst it is easy to imagine universal and ancient emotions such as the fear of the darkness beyond the camp fire, the thrill and danger of the hunt, the sense of loss when a loved one dies, it is more difficult to imagine a vocal or musical response to those emotions. Yet it is not beyond the bounds of possibility that the extraordinary potency of the single voice humming or crooning notes, rather than mere sounds, was instinctively as much a part of prehistoric existence as it is of ours. If early man could paint representations of the animals he hunted in order to understand and in some mystical way control them, he could at least copy their calls and cries and, perhaps, make them his own.

In a tribal sense music as rhythm binds a community in its celebrations, worship, preparation for war or ceremonials. From the tribal dances of numerous ancient peoples, to the football chants of the 20th century, to the swaying of a child as it sings, to the marching band of soldiers, to the packed nightclub, a simple beat commands a uniform response in its listeners. They will sway, move, sing or dance to the same tempo, and a mass of individuals becomes one united animal. The rhythm has come to symbolise the act of belonging.

Babies are particularly alert to music, and singing as a form of security, as with lullabies or lulling a child to sleep, is an early awareness of music which still determines some of our responses as we grow older. Patterns of notes are more easily memorable than unrelated notes, and children grow up with nursery rhymes, songs and catches that are often hundreds of years old, yet precisely because of their simplicity of tune and structure, are both easily learnt and rewarding to sing. As children we learn stories that tell us basic

truths about the human condition and sing songs that form music and language into easily remembered structures. From this root, I believe, grow the twin branches that shape many of our later responses – story-telling and music as narrative.

Within the brain, musical memory seems to be stored in the right hemisphere, the left being the logical, analytical, language developing side. Emotional response, musical response – these have grown as strong yet distinct neurological events, capable of storing impulses that exist as very long-term memory which can survive even when an injury has affected the ability of the brain to form words or actions. Stroke victims who have sustained damage to the brain's left hemisphere, with no power to form words analytically can sing the line of a song that they remember, tune and lyric, because the instinctive recollection of that music is stored on the right side of the brain.

As children, none of us sat down and fiercely concentrated to learn Twinkle Twinkle Little Star, it sank into our memory because it was attractive, easy to remember and fun to sing, especially within a group. It paints a picture, it speaks of security and well-being, its rhymes are simple. It is no surprise that most nursery rhymes are hundreds of years old. Their longevity is proof of their ease of assimilation in generations of developing minds. The songs from Walt Disney films fulfil a similar function for today's children. So as we grow, certain music – music that we personally like or find attractive, lodges itself in our memories, bypassing the effort of learning, inhabiting a no-mans-land in the human mind, opening a crack in the wall between our daily lives and our emotional senses. In time, Twinkle Twinkle Little Star will be replaced by rock hits, film music, classical pieces and showtunes and our amazing natural powers of recall will be spontaneously demonstrated at parties. This is the soundtrack of our lives.

Two thousand years of musical history in the Western European tradition have shaped our approach to combining music with drama. Minstrelsy, the setting of epic poems to tunes, existed throughout the West from Roman times onward, at its height in this country from the 8th century. Minstrels were both the entertainers and news-gatherers of their day, and their songs were means of disseminating events and information the breadth of the country, as well

as pleasing the listeners. Troubadours were singers who accompanied themselves on pipes or stringed instruments and travelled to the villages, towns, courts and market places of medieval Europe. Their most popular songs or lays were taken up by the listeners, and passed on from generation to generation by oral tradition. Some were written down, and survive as Old and Middle English romances, but the music, lost because the tradition was a verbal rather than written one, was an integral part of the experience. The tune was the root of the hearer's pleasure, but it was also an *aide mémoire* for the words.

Ancient classical literature had considered music the embodiment of perfection. It was considered awesome, unworldly, and was an important factor in man's attempts to achieve a God-like status. The formal drama of theatre was accompanied with music from Greek times, in the use of the chorus. This was a group of singer/dancers who commented on the action as it took place, and whose lyrics were organised as verses rather than dialogue. As choral performances, the use of the chorus actually pre-dated theatrical drama until an Athenian named Thespis through his performance added the words of an actor to the entertainment. The chorus sang and danced to the music of flutes, although how that music was structured we do not know.

In those times theatre was presented as part of a religious festival to Dionysus, and the use of music and drama continued to be the centre-piece of popular religious festival or celebration. In most religions songs, hymns or psalms take some part in the act of worship, often as a way of bringing the holy texts to life. Plainsong developed during the first centuries of Christianity, possibly from Jewish synagogue worship and almost certainly Greek influences. The passages from scripture or the mass were sung unaccompanied, setting the verses to a repetitive melody and steady rhythm. Thus the music did not actually tell a story, but supported the spiritual nature of the words, exalting the singers and listeners into a contemplation of the Almighty, an awareness of a spirituality beyond the everyday world. In the Christian church of mediaeval times the desire to dramatise the scriptures further still, led to the performances of Miracle and Mystery plays, stories from the Bible or allegorical moral tales acted out by tradesmen's guilds at the festival of Corpus Christi. Music was integral to these

performances, as it was to the service of mass itself. Over the subsequent centuries the Latin mass would remain unchanged, but generations of composers would use its inspiration to produce great works – the masses of Bach, Mozart and Haydn, the great Romantic requiems of Verdi and Berlioz, Brahms and Fauré.

In the secular world, the madrigal, an unaccompanied vocal piece for three or more voices, became widely heard from the 14th century onward. The music did not differ greatly from the style of sacred music and anthems, but it was in the fusion of text and music that the madrigal was unique. The texts, poems of a lyrical or pastoral nature or love poems, were written to a metre and rhyme scheme, and the music was carefully shaped in order to express very closely the changes of mood in the words. Here we have a large amount of surviving written music, exploring a technique by which music can express feelings and emotions simultaneously with a narrative form. Every word the poet expresses, every shift of mood and emphasis, is given its full weight by the music in a manner largely unchanged over the subsequent six hundred years. Madrigals were sophisticated upper-class entertainments, mostly sung as after-dinner family or court occasions, written for the pleasure of the singers as much as the listeners. They required a degree of musical learning, as the music had to be sight read, and remained popular until the rise of organised public musical-dramatic occasions.

Opera and oratorio sprang from the same roots and the same place – Italy in 1600. The recitative, or musical representation of real speech, such as plainsong suggested, was developed by Emilio di Cavalieri (1550–1602) into the first oratorio, *The Representation of Soul and Body*. This work contains the characters, Time, Life, World, Pleasure and others – in other words it was an allegorical Mystery play set to music. At the same time, attempts were being made in Italy to take madrigals and use them for underscoring actors and dancers on the stage in a continuous narrative. This proved problematic, as the dense texture of madrigal singing (several voices singing lines that interwove lyrics with different melodies and timings) did not support the words simply and directly enough, and normal speech over this musical style became confused and inaudible. The solution was discovered in the literature and learning of ancient Greece, brought into Europe by the Renaissance. The Greek presentation of drama,

the portrayal of mythical subjects by a chorus and individual actors, was wedded by Italian composers such as Peri (1561–1633) and Monteverdi (1567–1643) to music that did not have such a dense texture as madrigal (counterpoint) but relied on solo lines being sung to dense musical accompaniment (harmony). The chorus still commented on the action, but the arguments, events and ideas were carried by the characters or solo voices, and what we now know as opera took its first faltering steps. At first the sung dialogue was music set to the patterns of speech (recitative, not unlike plainsong), but under Monteverdi's guidance, melody, the lyrical singing of songs and arias, became the backbone of opera. Thus began the art form which would result in the great works of Verdi and Puccini, Wagner and Bizet.

Over the next hundred years the music of Italian opera became more florid and ornamental, less wedded to the demands of the poetry than to the demands of its audiences for clever vocal displays by the singers. Gluck's opera *Orpheus and Eurydice* of 1762 restored the original intents of opera – the music was driven by the requirements of the action and lyrics, the overture prefigured the mood of the piece, and the arias and recitatives were mixed in an effective way to sustain the action but allow for the contemplative or celebrational moments that aria represented. In Austria this development was taken further by Mozart (1756–1791) with operas like *The Marriage of Figaro*, *Don Giovanni* and *Cosi fan Tutti* displaying his genius for dramatic composition deriving psychological depth from the events and actions of characters. In Richard Wagner (1813–1883), the concept of total music theatre reached its peak, for here we have a composer who not only wrote his own libretti, dictated settings, costumes and story-lines of his operas, but also developed an incredibly flexible method of music composition which allowed the smallest idea, the slightest change of emotion, thought or characterisation to have its full musical weight. This method utilises leading motifs (Ger: *Leitmotiv*), fragments of tune or musical phrasing that represent a particular character or theme. These *leitmotivs* are used throughout a work to represent its elements, and are subtly interwoven with others, or evolve in themselves, as the drama unfolds. This results in both a satisfying thematic development simultaneously in the drama and the music, and also new directions for

orchestral accompaniment to opera – the orchestra Wagner used was huge and its range of colour and voicing, its palette of sounds, was now large and subtle enough to represent flexibly the nuances of the drama taking place. His stories concerned the Gods and men of German legend, and their epic nature required the building of new opera houses to contain them. Yet the *leitmotiv* could sustain an audience's emotional memory over the duration of a work like *The Ring of the Nibelungen* (1876) which would take place over four nights. The music controlled the audience's response to the events it supported.

Oratorio is interesting in this context. Born in Italy at the same time as opera, oratorio was a devotional work of sung musical theatre intended for the church. Thus costumes, sets and actors were replaced by the dramatic nature of the music, with the religious faith of the composer plainly represented in the musical settings of the stories from the Old Testament or representations of the Passion of Christ from the New. In Handel's time the need for oratorio was a commercial one – they were intended play to profitably on holy days in Lent when opera and theatre were banned. Yet, for whatever reason, the settings of verses in Bach's *St Matthew's Passion* (1727–9), Handel's *Israel in Egypt* (1739) and *The Messiah* (1742), or Haydn's *Creation* (1798) are, for me, the earliest real evidence of totally developed musical picture painting. The orchestra and singers transport the listeners to the real, emotional, flesh and blood events they portray, engaging senses and emotions in a way which derives directly from the earliest uses of church music to open up the world beyond the everyday. Mass becomes theatre. As classical gods and heroes roamed the stages of early opera, so the faith of millions took shape and muscular form in the emotive musical evocations of oratorio.

English drama as it evolved through the 16th and 17th centuries owed a good deal to its medieval antecedents, Mystery plays. The subjects of Elizabethan and Jacobean drama may have been resolutely secular, but the tales told by Shakespeare and Jonson, Webster and Congreve contained strong moral messages, often made overt by songs and careful use of music. Shakespeare's *Tweflth Night* (1602), beginning famously with Orsino's 'If music be the food of love' speech, uses Feste's songs to maintain the bitter-sweet mood throughout the play. The characters' comments on music as melancholia

show that Shakespeare was not averse to allowing the music to carry emotional weight where words failed. In Act II, Scene IV, he even writes into the dialogue an instruction for underscoring, so that an entire scene is played out to musical accompaniment. In *Antony and Cleopatra* (1608, Act IV, Scene III, the scene in which the guards hear music (*hautboys* or oboes), 'i' the air. Under the earth,' Shakespeare is using music to represent Antony's war-like spirit, the god Hercules, leaving him. On the Shakespearean stage the musicians, unseen, possibly beneath the stage itself, conjured ghostly and mournful notes to support the supernatural, whether images of destruction in Macbeth (1606), mischievous sprites in *A Midsummer Night's Dream* (1594) or the benign representations of nature in *The Tempest* (1611). Love and passion, themselves recognised as powerful magical traits within man, were supported by music as a way of elevating them beyond the mundane. Like so much religion, celebration and mysticism in this country, music represented simultaneously the sacred and the profane, the Christian and the pagan within people, and as such served drama as strongly as poetry, prose and mime.

John Gay recognised this in his *Beggars' Opera* (1728), a phenomenally successful piece written both to parody Italian opera in the tradition of Handel and to make telling social and political points about the society of the day. The music was drawn from well-known folk songs, and the characters were the low life of London, yet the music (as it were, contemporary pop) allowed the 18th century audience to accept a low life anti-hero in MacHeath and give him cult status. From this one opera derived a tradition of levelling music drama which one can trace in Ballad Opera, the music hall, melodrama and the 20th century musical. Interestingly, Berthold Brecht and Kurt Weil grafted *The Beggars' Opera* seamlessly into Weimar Germany with *The Threepenny Opera* (1928) to achieve the same ends – the pointing up of social injustice through popular tunes ('Mac the Knife') and seductive characters. The use of popular contemporary music to attract an audience to difficult or unsympathetic stories comes full circle to the present day, where advertising, politics and propaganda all rely heavily on music to make an abstract idea attractive, whether it be for reasons of commerce or principle.

The Romantic movement which swept through Europe from the 1780s saw music being heavily influenced by the arts of painting and literature. Composers at this time often had interests beyond music and wanted to use music to investigate philosophical thought or literary fiction. The movement tended towards nationalistic expression, as in the operas of Wagner and the works of Chopin and Liszt, but more importantly the utilisation of music either with drama or as drama spread to all countries and art forms. The theatre developed music as an underscore in 19th century melodrama, not as sung performance but drama heightened by music behind the dialogue. This was the golden age of ballet composition with concert and opera composers refining the musical dynamism necessary to turn drama into dance. Literary sources provided material such as Prokoviev's *Romeo and Juliet* and Minkus's *Don Quixote*. Other ballet works derived from folk/fairy tales (the classic Tchaikovsky ballets and the work of Delibes and Stravinsky), or from classical sources (Ravel's *Daphnis and Chloe* and Stravinsky's *Apollo*). Programme music, that is music intended to evoke an event, picture or literary work, flourished with such masterpieces as Beethoven's *Battle* and *Pastoral* symphonies, Mendelssohn's *A Midsummer Night's Dream* and *Hebrides* overture, Berlioz's *Symphony Fantastique*, Saint-Saëns' *Danse Macabre* and *Carnival of the Animals*, and the tone poems of Richard Strauss. The orchestra had grown in size and tonal range, and artists such as Mahler and Bruckner, Vaughan Williams and Debussy experimented with combinations of sounds never before heard, to achieve an astonishing range of dramatic and thematic effects. *Aida* (1871), *Othello* (1877) and *Falstaff* (1883) are among the most sublime works of Giuseppe Verdi, uniting a profound dramatic insight and dignity with wonderful soaring melodies. The net effect of the cultural cross-fertilising which typifies the Romantic age was the refining of the aural vocabulary that we now respond to when we hear music allied with drama.

The 20th century saw the rise of mass popular art forms, with musical-dramatic achievements of previous centuries transformed from the entertainments of the elite to the staple diet of every class of society. The American musical theatre harnessed the popularity of melody and rhythm to tell everyday stories in heightened terms. The popular song reached its height with the work of composers like Irving Berlin and Cole Porter, Noel Coward, Richard Rodgers and George Gershwin. A generation growing up in

the 1930s turned to the romantic escapism of popular music and spectacular staging to escape from the misery of a world in Depression. In the musical theatre songs and stories promised a happy ending in spite of all troubles and the triumph of true love, the lyrics painting love in terms that reality could never match. A generation mistook idealist escapism for ambition and were returned to brutal reality by bitter experience and the carnage of a second World War. Dennis Potter's later TV plays, including *Pennies From Heaven* (1980) and *The Singing Detective* (1987) use the songs of the period to investigate precisely that musical influence.

The importance of radio is impossible to overestimate here. During the 1930s and 1940s, particularly in the US, a revolution was taking place that saw a wireless set in almost every house, playing every kind of music from a wide diversity of local and national broadcasting stations. During the 1930s and 1940s these stations beamed not just popular music but classical, world events, comedians, dance music and gripping drama into millions of homes. People who could never have experienced such music before now had access to the riches of every century. Radio created the melting pot which was to bring about the great years of pop. Programmes were transmitted on the medium wave, the stations on the radio set being very close together. As the dial was turned every type of music sounded for a fraction of a second to be replaced by another. So the legacy of Negro America, the haunting gospel spirituals, the insistent twelve bar work songs that were at the beginnings of the blues, the jazz of the deep south, were mixed in a fraction of a turn of the dial with the European folk traditions of the white south, the Celtic influences brought from Scotland and Ireland, the cajun styles, the earliest bluegrass and country. A generation in the forties brought up on this rich diet was to make the pop music of the fifties and sixties, deriving the music from these diverse traditions to speak of their own experience.

The early cinema drew its musical influence and much of its dramatic narrative structure from the theatre of the 19th century. Silent films used music rather as opera: continuous evolving narratives with *leitmotivs* drawn from within the drama or imposed from outside by the use of music already known to an audience. Thus the repertoire of 19th century romanticism nursed the silent film, grew with it as sound

took over in the 1930s, and came to epitomise 'film music'. Max Steiner, Eric Wolfgang Korngold, Franz Waxman and other film composers of the 1930s drew on their (mostly German) antecedents to portray historical subjects, glossy romances, horror, war, crime and plain entertainment to a cinema-mad generation. As the music had to be allied second for second more closely to film than any previous art form, Max Steiner developed in 1932, a Clicktrack, an aural guide laid across the film containing the exact speeds and changes required for the music which would be used in recording to exactly match music to action. Much of the film drama represented ideals, wish-fulfilment, the hunt for perfection, and music came to repeat its idealistic role of two centuries previously, but this time to an audience that had little knowledge of opera or what had gone before its own time. Thus film composers shaped the popular view of what ancient Rome sounded like in *Ben Hur* (Miklos Rozsa, 1959), of the terror of the unknown in *Psycho* (Bernard Herrmann, 1960), of the size and grandeur of the American West in *The Big Country* (Jerome Moross, 1958). Over the 20th century music came to be used more subtly, less continuously, utilising jazz and blues (as in Berstein's score for *On the Waterfront*, 1954) and eventually contemporary pop music.

Now film scoring is an eclectic art, composers drawing upon every style and application of music to satisfy the requirements of film drama. As narrative music has developed, so its voice has become simpler, more direct. No longer is an orchestra the minimum requirement for underscoring drama – indeed the simpler brushstrokes of solo instruments are more appealing to many. Composer Elmer Bernstein featured solo instruments in many of his scores (for instance the defiant piccolo march that drives *The Great Escape*, 1963), thus summing up the film in terms of one overriding instrumental colour as well as melodic theme. However the 1970s resurgence of fantasy cinema with Spielberg and Lucas has also meant the resurgence of the Romantic orchestral score, through the influence of John Williams, John Barry, Jerry Goldsmith and others, and the addition of a pulsing electronic texture to broad symphonic sounds with the scores of Danny Elfman and Hans Zimmer. Michael Nyman has developed an austere, formal 18th century style of scoring, while Ennio Morricone still revels in the 'big theme', a direct descendant of the

Italian opera's love of melody and aria. Many other film composers are more anonymous, happy to turn their hand to a variety of musical styles rather than display their signature on a film, but what binds them all is the willingness to subjugate their music to the dictatorial requirements of the drama.

Inevitably, clichés have grown up over the years. These are the musical motifs or effects that are so over-used that they have lost their capacity to motivate the emotions. Seldom is love represented (except ironically) by the passionate sweep of Tchaikovsky's theme for the tone poem *Romeo and Juliet,* beautiful as that theme may be. Seldom does solo piano underscore a modern film. What exposes these clichés is that they tend to trigger a cultural memory in an audience, not an instinctive response. Music specially composed for any drama is intended to concentrate the mind on the events it supports. It may need to call upon music with existing cultural references to throw light on a particular aspect of its subject, but on the whole, originality derives from allowing an audience insights into events without making them aware that their responses are being dictated to. This assumes that one understands the nature of the audience. Different countries have their own cultural preferences; what works as narrative music in one country may not work in another, but, in general, certain tonal colours still maintain a particular dramatic emphasis, and as discussed in the previous chapter, the resolution or non-resolution of music is often the key to whether a situation is depicted as unsettling or secure, cold or warm.

Drama is about tension and release, and that is most often the path of the music that accompanies it. It is certainly the element of music that an audience is most aware of, whether that music is tonal or atonal. Just as a story is structured to represent a controlling idea, so musical architecture represents the structuring of musical ideas as a controlling factor, themes and variations representing and matching the elements of a story. The music may be describing the geographical location of a story, its mood, the character's frame of mind, the impending shock of a gunshot or the temperature in the room, but the recognition of those signals takes place mostly without the audience being aware of the cultural antecedents of the music, only the satisfactory rendition of the drama.

What about the sound of narrative music? The moods certain combinations of instruments evoke have not changed in three hundred years. In *Don Giovanni* (1787), Mozart has the statue of the Commendatore rising up from the dead accompanied by three trombones playing low, sustained notes. Handel uses a similar combination to underscore 'There came a great darkness' in the oratorio *Israel in Egypt.* Deep brass of that nature represents the underworld, while trumpets, being higher sounding brass, represent heaven and the trumpets of the angels. This, one imagines, is traceable all the way back to the mediaeval representations of heaven and hell. Immediately we have the forefathers of musical representation of horror, the unknown, fate on the one hand; ecstasy, achievement, honour and glory on the other. To take another example, Weber's opera *Die Freischutz* (1821) contains a scene set in the Wolf's Glen at midnight where a pact with the devil is about to take place. The overture to this scene begins with high violins, played tremolo (literally trembling), while the contrabass strings and timpani play quiet single notes, and two low clarinets descend the scale. These are the elements of innumerable suspense scenes in 20th century film and TV, the tension of the unknown, the high violins used to create an eerie, disturbing effect in the mind, the low instruments descending with an inevitability that bodes ill for the characters and ourselves.

The use of the famous theme from the film *Love Story,* Lara's theme from *Dr Zhivago,* even Wet Wet Wet's 'Love is All Around' in *Four Weddings and a Funeral,* derive from the song repertoire (Ger: *Lieder*) of the 18th and 19th centuries, and musical attempts to equate non-verbal sound with verbal meaning. The nature of a Big Theme, like the overture in opera, is to sum up in one sweeping statement the controlling idea of the work. It can be huge, such as the themes from *Gone with the Wind* or *Superman,* or it can be tiny, such as the guitar-accompanied song 'Do Not Forsake Me Oh My Darling' in the western *High Noon* (1952) or Harry Nilsson's 'Everybody's Talkin' At Me' in *Midnight Cowboy* (1969) – see the John Schlesinger interview regarding the troubled genesis of that classic.

Interestingly, the popular idea of music for the western genre has been hugely influenced by two men, Dimitri Tiomkin, a Ukrainian, and Ennio Morricone, an Italian. European composers, drawing on their own heritage, shaped the world's vision of itself through the

cinema. Much that is current in under-scoring can be traced back through these types of family tree.

The music the moors brought with them when they invaded Spain in the eight century was Arabic, rhythmically complex and micro-toned (in western music a tone is split into two semitones – in micro-tone split into three). Although this music is easily placed in its geographical context, it may fall uneasily on western ears and be less able to carry a more universal narrative thrust. Yet by the fifteenth century a folk tradition had grown in Spain called flamenco, using almost the same instruments as the moors had brought, with its roots undoubtedly grounded in the moorish music, but speaking eloquently of passions that were universal.

As peoples travelled for whatever reason throughout the world so they mixed the music that meant so much to themselves with the music of their adopted, captive or enslaving culture. Middle eastern music was brought into Europe by invaders and became the folk music of eastern Europe and the southern Russian states. However when Spain overran south America it planted its culture so firmly over that of the original inhabitants as to bury it forever. Much American popular music is derived from Negro music, the rhythms and chants of Africa filtered through the misery of slavery and the muscular faith of spirituality. Yet since the 1980s contemporary African bands have come to the notice of the west, their music carrying a pulsing celebratory feel that easily communicates across continents. Whether this interest was sparked through the burgeoning world music trade, interest in the civil rights movement in South Africa and the end of apartheid, or the phenomenal success of Paul Simon's *Graceland* album (1986) that music is now, like its counterpart jazz, which grew up on the other side of the world, the domain of everyone. The happy outcome clouds the issue of cultural colonialism, for one could see *Graceland* as an exercise in colonial piracy by a cynical musician escaping his own bankrupt culture, or a sensitive musical response to deep artistic similarities that crossed borders and oceans. The connection is made, the repertoire is increased, humanity ultimately wins out, if you can ignore the paths not taken, the cultures swamped in the process.

Now the musical boundaries are down. Since Buddy Holly used plucked violin strings to suggest the rain in 'Raining in My Heart', George Martin (who was very influenced by Bernard Herrmann), arranged a nineteenth century string quartet accompaniment for the Beatles' 'Eleanor Rigby' and Brian Wilson of the Beach Boys used a theremin (an early electronic classical instrument) for 'Good Vibrations' because it reminded him of 1950s science fiction films he saw as a kid, crossover music is all around us. Modern performers in one genre of music happily work in others, the previous musical cold war combatants are talking and funding is available for more and more experimentation.

Music that touches us as emotion, and also has a narrative strand, can be traced back to its antecedents but does not need to acknowledge them. World Music, so recently described and acclaimed, has always been with us only now there is the technology to bring it to the high street record shop and a public interested in buying it. That interest is there because people like another culture's music as music, it touches them at a level beyond geographical or cultural differences. Its original context may be forgotten but its effect is the same, to make us understand joy or sorrow, to recognise something in human experience which we share with a vastly different tradition or civilisation, to unlock an insight into our humanity described by someone different from ourselves who sees what we see, but describes it in their own terms. This catharsis, since Greek times, has been the highest intention of drama and the ability of music to match its power provides another link in the fundamental bond between music and drama.

3 | The Analytical Process
Music As Magic

Programme Music

'I always have a picture in my mind when composing,' declared Beethoven, immediately making clear the problem of differentiating 'programme music' (music which is a direct representation of a character, event or mood and has a pictorial or literary scheme) and 'absolute music' (which exists as more of an abstraction than a picture). Playwright David Pownall has written about composers and their work because 'music is impossible to politicise – music always escapes.' The tone poems of Saint-Saëns' *Carnival of the Animals* may indeed represent the movements of certain animals, the mood they conjure up and the environment they inhabit, but the piece is not written as a zoological tract. The music represents more than anatomy, for it relates, as does all music, to the human condition, to the world as seen through our eyes. The art lies in the musical conceits, their beauty, texture, comic quality and mood.

Holst's *The Planets Suite* (1919) is, strictly speaking, not programme music, but an investigation into its deft control of mood is enormously rewarding. Holst was influenced by astrology in his view of the planets that make up our solar system (Pluto not being discovered until 1930), so his initial response is to their astrological character, as the bringer of War, Peace, Joy, etc. Yet the planet as an image is always there in the music, a huge monolith within the void in the case of Mars, a twinkling light source in the case of Mercury. Also present is the planet's representation of environment, particularly in the case of Neptune, the mystic, but also the god of the sea. Bringing huge orchestral resources to bear on the task allowed Holst tonal colouring of every possible shade, huge scope for his uncanny ability to write music which created pictures that every listener could recognise and empathise with. His representations have influenced mood music ever since.

Mars, the bringer of war, is glimpsed approaching from afar – a planet revolving into view or an army of vast proportions. When the clash of arms comes, the relentless rhythm seems the antithesis of humanity, a mechanical, chilling, grinding beat. Momentarily we hear bugle calls, and experience a sense of speed, possibly galloping horses, charging cavalry. Horrifyingly, this music carries a feel of exhilaration and joy, a recognition of war as seductive and magnificent – but it is soon brought stumbling to a halt.

Holst is seeing all war, from every century up to the inhuman machine-made carnage of the Great War, which had only just ended. His conclusion is that war is only ever destruction, within which all nobility, all humanity, all courage is swept to oblivion. The last terrifying hammer blows are unquestionable and shattering, and the final chord suggests the atomic bomb, which was still twenty-five years in the future.

Venus is the bringer of peace but also of love. Where Mars was the rapid succession of images, clashing and desperate, Venus is the slow perception of security, the gradual recognition of a dawning and common experience – love between two people, love for all people. It is mystic and warming and, like all of the *Planet Suite*, suggests a vast interminable space. Space is the cosmic environment within which we are so insignificant an element, yet the abstract of peace is a universe in itself, the love of beauty, the love of people, the universal well-being of man.

Mercury runs and skips across the ether, a messenger delivering good news across difficult terrain. Jupiter, the giant planet, casts a spell in which the trumpets of Mars are the harbingers of great good fortune. Joy is communal, a dance of delight and celebration that literally whirls faster and faster (even famously affecting the cleaners in the hall at the work's first rehearsal) until brought to a breathless halt. Joy becomes a hymn of thanksgiving, at once personal and universal, building to a huge climax which pauses before its last chord momentarily to allow the dance of delight to begin again. The final slow repeat of the tune of thanksgiving seems to whip us up above the joyful crowd to see, again, size and breadth of image. Holst, in his music, seems to have seen paradise.

Yet with the appearance of Saturn, again approaching from the vastness of empty space, the creeping advance of age is inexorable yet welcome, threatening yet ultimately part of a grand design. This is not the hammer blow of war but the shuffling tread of time, noble, dignified and, ultimately, accepted. The stillness of death is conjured, not as an abyss but a sense of timeless peace.

Uranus, the magician is introduced with chords which would ultimately herald every movie monster one could think of. The leaping dance that follows is heavy with the spirit of dark magic. The elements he controls become almost

visible as the magician weaves his spells. Here is the devil's dance, cavorting witches from the *Symphonie Fantastique* and the *Sorceror's Apprentice*. What is ultimately conjured seems shocking and huge, more H P Lovecraft than Faust. Yet if this is the realm of fire, Neptune stands ready to plunge us into the cool depths of the sea.

Neptune is, for me, the piece which seems to contain most resonances for later composers of mood music. The sea, another vast universe of mystery, contains the harp-driven bubbles of air that rise to the surface, the high mysterious sound of women's voices balanced by the low dreaming strings which seem to carry the impression of floating and the image of the sea-bed stretching further and further down into darkness. This is not the storm-tossed surface but the vast unchanging depths of the sea, and as such, music similar to Neptune has accompanied action into the depths of the sea in decades of movies, from *Thunderball* to *Jaws,* from Bernard Herrmann's twelve harps in *Beyond the Twelve Mile Reef* to innumerable underwater dramas in which the music slows and drifts as the characters dive beneath the waves. We all recognise and accept it, just as we all acknowledge the emotional experiences described so succinctly in *The Planets*.

Beethoven's Pastoral and Battle symphonies, Mussorgsky's Pictures at an Exhibition, Mendelssohn's *Midsummer Night's Dream* and *Hebrides* overture, Berlioz' *Symphonie Fantastique,* the tone peoms of Richard Strauss, programme music is at the heart of the classical repertoire. It is popular because it allows the audience to create pictures in its mind. Yet, to return to the Beethoven quote, music always takes you to a picture. This picture may not be a photographically real one, a finely detailed landscape or a colourful portrait – it could be impressionist, or the first sketches for an image that we create for ourselves – it could be an indistinct feeling of unease or the warm tingle of recognition.

E M Forster's *Howard's End* contains a justly famous scene in which Helen Schlegel attends a concert of Beethoven's fifth symphony. Initially using the music's influence on his characters to bring out their individualities, ('Helen, who can see heroes and shipwrecks in the music's flood … Margaret, who can only see the music'). Forster settles down to a pictorial critique of the work. The final movement he describes as 'the goblins and a trio of elephants dancing'. The music starts with 'a goblin walking quietly over the universe from end to end', who 'observed in passing that there was no such thing as splendour or heroism in the world' until 'Beethoven took hold of the goblins and made them do what he wanted'. In five paragraphs Forster describes in cinematic terms the images conjured by this climactic movement, concluding that '...the Goblins were there. They could return, He had said so bravely, and that is why one can trust Beethoven when he says other things'.

This is wonderful evocation of music's ability, even when abstract, to pictorialise. The images are not dictated, as in programme music, by a contextual title or literary reference, but emerge as something inferred, something profoundly understood in all its breadth and diversity of meaning. The path to that enjoyment of music may require a little training. Very young children are encouraged to use music as the basis for movement, to create the movement of animals or basic emotional behaviour patterns derived from musical rhythms or colours. At an early age we recognise music as textures, the natural, harmonic, easy flowing of major keys equating with the natural world that we perceive; the exceptions to that ease, violent rhythm or key change, unnatural time signatures, frightening sounds, suspended, unresolved musical narrative finding its pictorial equivalent in violent storms, dark, strange paths, headlong rides into the unknown. As we develop, our musical response becomes more sophisticated, more abstract, just as a child learns from a picturebook until it is experienced enough to visualise something for itself.

Even when allied to drama, music is still taking us to a picture, possibly a different picture to what we are watching, but one formed in our minds, which can exist at the same time as the dramatic stimulus that the music supports. We may watch one opera singer performing, yet the music is ushering into our consciousness images more wide-ranging, more complex, more abstract than that which our eyes take in. An inner picture.

Even in the cinema, where images are already complex and absorbing, music could be creating a further picture to stand alongside what we watch. Stanley Kubrick's extraordinary use of *The Blue Danube* to underscore the awesome technology of *2001* gave us two pictures, those

we were seeing and an equally sharp-focus representation of old-world beauty and lushness, the Viennese waltz whirling joyous dancers through a ballroom the size of the universe itself. Alternatively a camera panning across lush countryside being accompanied by music descending with awful inevitability into a bottomless hole will make the listener prepared for horror in that environment, perhaps the physical terror of Mussorgsky's *Night on the Bare Mountain*, or the spiritual death of the last movement of Tchaikovsky's *Pathetique* symphony (1893) or the numbing oblivion of The Doors' *The End*. People love pictures, but they love particularly the pictures that they create themselves, that could not possibly exist outside of the imagination. It is towards these waiting canvases that programme music works its magic.

Musical Theatre

E Y Harburg, lyricist of 'Buddy Can You Spare A Dime?' and 'Somewhere Over the Rainbow', said, '… words make you think a thought, music makes you feel a feeling. A song makes you feel a thought.' He is one song writer who links his work with popular songs to the social climate of his day and claims a crusading task for popular music – to speak to and of common shared humanity. This is the terrain of the musical, a show which by its use of accessible popular music and theatrical opulence communicates stories to a huge theatre audience, these days larger than the audience for straight plays. In recent years the definition of 'the musical' has become blurred – the musicals of Boublil and Schoenberg and Lloyd Webber are operas in all but contemporary accessibility, in that they are through-scored and sung, and Schoenberg accepts a debt to Puccini in his methods and style. The Broadway musical is usually taken to mean the more traditional style, as in the works of Cole Porter, Frank Loesser or Rodgers and Hammerstein in the middle part of the century – stories with the minimum of dialogue in which up to twenty individual songs carry the thrust of character, events and emotions. Thus a musical like *Carousel* (1945) can contain at least six well-known songs, sung out of context as 'standards', classic popular songs outside the show for which they were written. These shows are song-fests in which the music reflects the needs of the moment rather than a thematic overview of the whole show. Frank Loesser's *Guys and Dolls* has a stylistic unity because of the street-wise city jazz that forms the score, yet no single theme runs through the whole show, and each song is utterly different from the others, ranging from comic bump-and-grind to cheery march, to bluesy ballad, to triumphant gospel pastiche according to the scene's context.

The dramatic requirements of the Broadway musical are dictated by that very musical diversity – an audience may expect a warm love-ballad but not a whole showful. Thus the story is invariably a love story, but the musical strength often lies in the background detail, the secondary characters, the big chorus numbers. The traditional musical comfortably inhabits a cosy fantasy world in which wish-fulfilment, allied with the emotional punch that a fine composer and lyricist can bring to the popular song, create heightened reality – love greater than it is possible to experience, sadness profoundly deeper than our own, joy bordering on ecstasy, wit of the highest order. In the musical, as in opera, the work of the music as a narrative force is the soul of the art form, but the musical appeals to a wider popular audience because its language is contemporary, populist and uncomplicated.

From fantasy worlds of the thirties when dancing girls and huge sets dominated a puffball of plot, or love triumphed in Ruritanian kingdoms, the musical theatre world changed when the curtain rose on Rodgers and Hammerstein's *Oklahoma* in 1943. Instead of a huge chorus filling the stage the audience was presented with an old woman churning butter and, from offstage a cowboy singing 'Oh What a Beautiful Morning'. Like *Porgy and Bess* before it, *Oklahoma* proudly proclaimed itself a folk opera, born of American history and culture. The plot and characterisation were all important, the songs grew naturally from the form, rather than being imposed on it, and the audiences could become involved with the drama.

The great musicals touched a wider popular audience than opera, moving with the times and musical developments. Bernstein's *West Side Story* (1957) placed *Romeo and Juliet* in the harsh, hip world of west side New York and pulsed with rhythms of jazz and Puerto Rico. Tim Rice and Andrew Lloyd Webber's *Jesus Christ Superstar* brought the rock band firmly onto the West End stage and the technology became available to make a stage sound as clear and compelling as the studio. The strength of the book was equally important to audiences as the strength of the score. They wanted drama

placed first and music to serve the needs of that drama. More musicals have failed because 'the book didn't work' than for any other reason.

In the last few years, at least in the West End, the trend has come full circle with shows made up of songs by a particular composer or writing team joined together by the thinnest of narrative links. The proliferation of these and through-sung musical shows in which there is no unsung dialogue seems to imply that the 'book' dialogue musical is past its time. However one composer of Broadway musicals still maintains that it is the dramatic requirements of the text that launch the music into a song, that 'songs happen when words are no longer enough'.

Stephen Sondheim began work as a scriptwriter. His mentor was Oscar Hammerstein, and he grew up in the traditions of Broadway musical theatre, writing lyrics for Leonard Bernstein's *West Side Story* (1957) and Jule Stein's *Gypsy* (1959), before embarking on a career as a composer/lyricist. He has done more than any other composer to experiment with the limits of the musical, to use it as a medium for exploring harsh, truthful reality as well as sophisticated and witty entertainment, and to re-think its form. His shows are artistic unities; he writes in a style that is unique to him but follows a thematic and musical architecture which is closer to film scoring or classical opera than his Broadway predecessors. Each show has its individual approach, every element of the show is subjected to rigorous intellectual analysis so that every note, word and thought is justifiable to the demands of the whole.

He tends to pay the price for being a pioneer. His shows are often box-office disappointments, seldom critical failures, always ground-breaking and original. He will often start with a single stylistic musical decision. In *A Little Night Music* it was to make the whole score variants on three-four (waltz) time. In *Follies* it was to pastiche the styles of an earlier era. In *Sweeney Todd* it was to conjure up the hell of Victorian London with variations on the Dies Irae of the Requiem mass. From there he will build a unique edifice.

Sunday in the Park with George (1984) is looked on as one of his more difficult works – it had a so-so run on Broadway, was revived successfully at the Royal National Theatre yet is generally considered a flawed work. It does, however, bear fascinating analysis in that it occupies a musical ground between drama and film score and

represents Sondheim's attempt to explore the nature of creativity itself.

The show deals with Parisian painter Georges Seurat at work on his pointillist masterpiece, 'Sunday Afternoon at the Grande Jatte'. Seurat's method was to make up shading and colour texture through the merging of tiny dots of primary colour. Thus Sondheim's unifying musical decision was to make the music redolent of dots of colour – the whole score is percussive, textured, with 'dots' of tonal colour making up the accompaniment to the songs and the overall style of the music. The story is fiction, yet the unifying idea is to explore how it feels to be an artist, and the lives of the people who surround him – his subjects, his family, his critics. The creation of the painting is the metaphor for all human creativity and the frustration attendant on the need to create perfection.

In the first act we see the process of making the painting and the gradual collapse of Seurat's relationship with his lover and artistic model, Dot. The painting *is* the stage, the challenge of completing it is outlined right at the start of the show with short unresolved piano lines until the word 'harmony' ushers in the whole orchestra with a resolved major chord and a French horn tune. This is the blueprint for the musical and thematic handling of the show. Sondheim treats the successful work of art as a display of harmony, and the eventual goal of his characters is their harmonious existence with each other and their environment. This is the 'happy ever after' of fairy stories, a perfect world which can never exist (as Sondheim was to demonstrate triumphantly with his next show, *Into the Woods*), but which provides a destination worth the struggle.

Musically, he matches this ambition in his characters. Unresolved, nervous, unconnected music underscores unhappy, unfulfilled people, whilst the act of creativity is marked by steady, warm, resolved music, surging with excitement. The 'harmony' extends to the placing of people within the picture, the similarity of the dog to the shape of the parasol, the matching of perfect colours.

Yet the music is also, variously, communicating the heat of the day (shimmering strings and brushed cymbal strokes), the depth of love (Dot's first song becomes, momentarily, a floating dreamworld where she describes George and his painting), the paintbrush on the canvas and the humming of a person concentrating on the job

in hand, the light (from sunlight, the music draws shafts of light onto the painting – 'Colour and Light'), wine being poured from a glass, the relaxation of a day off in the park and a thousand everyday impressions that an audience can relate to as easily as they can understand a conversation. The music deftly rings its changes of mood and description almost from line to line, threads of tune and tonal colour building up to an overall picture of immense complexity, yet a unity of intent that is the result of careful planning and execution, just like a fine painting.

The immediacy of the experience is in the clear link of music to lyric, necessary with a theatre piece where the audience has to apprehend immediately or the moment is lost. At the end of Act I, as the painting is completed the diverse characters on stage move into the positions of the Seurat masterpiece in a scene which is simple yet breathtaking; the music eases into a warm, totally resolved hymn tune for which we have been prepared since the first notes of the show. The love story and its attendant music remain unresolved until the end of the show – the end of the second act and a hundred years into the future for the story.

This, for me, is a musical which proves the strength of the medium. Drama linked to descriptive and eclectic music provides an insight into our world which is both simple and immensely complex. The architecture of poetry, music and story becomes one process, simultaneously intellectual and instinctive, stimulating and emotive. A character can be saying one thing, but the music is informing us of something else, another facet of the situation which the audience apprehends with the pleasure of having made the connection themselves. This is the process at the heart of all rewarding drama – the connections made and the insights achieved are not forced or led, but occur naturally through careful structuring and decision-making on the part of the writer – the audience is left with some of the work still to do. The use of music in the process allows the audience's response to be on an even more instinctive, emotive and natural level, for while drama may be an intellectual communicator, music is not.

Sunday in the Park with George starts from an intellectual conceit, but its language is direct and emotive, thus satisfying our need for stimulus, insight and pleasure, both mental and emotional. Musical theatre is instantaneous yet timeless, and when all its elements, music, lyrics and design, are carefully chosen to serve the same ultimate aim, it provides, for me, the most stimulating and pleasurable art form ever devised.

Television

The amount of music employed on television is vast. Aside from programmes about music, nearly every programme will contain at least two pieces for opening and closing credits (more for commercial channels), the inserts for news, weather, even the station identification will be musical. In some programmes music is wall-to-wall (particularly documentaries), in others it may consist of only a solo instrument playing a tune. Adverts are almost never without music. Yet through all this, music is still working as drama, except that the story it is dramatising is our everyday lives.

Television is our window on the world. Through it we see sights we could not experience any other way, and we belong to a nation with a common bond of interest (albeit five terrestrial and innumerable satellite channels). Television makes up for the deficiencies in our own lives and experiences by providing stimulus that does not require us to leave our living space. It provides security and familiarity yet is constantly changing, adapting, evolving.

However, George Orwell was not merely being paranoid in seeing the telescreens of *1984* as two-way channels for state control of the viewing public. Television does indeed have an agenda beyond providing a service. It exists to keep you watching. To do that it has constantly to remind you of its presence. It has to grab your attention. It has to make what it shows attractive. It has to by-pass your immediate critical faculties and snare your instinctive curiosity, connect subliminally with your desires or create those desires as a receptive area to contact. Trance-like, the hypnotic quality of television is carefully controlled and balanced, programmes coming and going within the bombardment of stimulus from the screen, but the whole aimed to one purpose – attracting and holding your attention. Try doing all that without using any music.

Advertising has to try even harder to engage our interest, because it knows that we will attempt to resist it. When people declare that 'the adverts are better than the programmes,' that is

seldom less than the truth – they have to be, and probably have a budget for thirty seconds that equals the previous programme's thirty minutes. Here is a chance for music, linked now to image, to influence our lives. Where music has always represented aspiration, music for advertising focuses that aspiration on the product in hand.

Much of the use of music on television has come no further than the effect of a rattle on babies. We hear the stimulus and look towards the object. When music is well-used on television, however, it becomes an art form in itself. Over the years the necessity for television to make an impact has resulted in brilliant TV themes, terse distillations of the programme to come that have become part of the national consciousness. Longevity helps, of course, but memorable themes from long forgotten programmes are still remembered fondly and are a useful signpost for guessing someone's age.

The best television never loses sight of the audience to which it appeals, and the empathy it creates is the result of connecting our experience to the experience we are watching. Music is usually carefully chosen to have the broadest popular appeal on a demographic basis, programme to programme. The big band razzamatazz that greets *Play Your Cards Right* and the muted baroque trumpets that made *Tinker Tailor Soldier Spy* so memorable are doing the same job – appealing to a section of the audience that would respond to that kind of programme. Both elitism and populism are unashamed on television, and the music that supports the programming is chosen with that in mind.

The programmes that regularly get the highest ratings are the soaps. Here the music is an old friend, recognisable and welcoming. It is interesting that Australian soap operas employ incidental library music whereas English soaps do not. At the end of every scene of *Neighbours* there is a musical button, upbeat or downbeat but not scored specifically for that scene, which carries the prevailing mood at the scene's end. Yet it is impossible to imagine *Coronation Street* or *Brookside* with that kind of musical dressing. This is, I suspect, because British soaps pride themselves on being true to life – real people with whom an audience can get involved. Australian soaps, to a British audience, are much more sunny fantasy worlds where mood music is less out of place. One can only guess if that's how they are seen in Australia.

The way in which music was used with TV drama grew from the use of music with radio drama. Early TV serials were often radio serials lifted direct from one medium to another. *The Lone Ranger* had been a long-running forties radio serial, complete with classical music links including the Beethoven pastoral symphony and, most famously, Rossini's 'William Tell' overture. When it went to TV in the 1950s the music was very top-heavy, much in the manner of cinema serials of the 1930s. Now the pictures could speak for themselves, and slowly the music was pared down to necessities, yet would still be necessary to fill out what a TV budget could not show on screen.

With TV drama we have a slightly different set of requirements to cinema, although as the years go by TV drama is coming to resemble feature films more and more. In the 1970s TV produced a wealth of brilliantly written drama shot very cheaply on video in the confines of the studio drama derived from the theatre rather than the cinema. There was no attempt to copy the 'big images' of cinema, but instead the shooting concentrated on talking heads – large frame close-ups of the actors with a small but significant amount of detail in the background. The onus fell to the script to involve the audience, and the music to provide the environment that was missing. This was the antithesis of the 'pretty pictures' approach to TV that is prevalent today. The music then was the land, the scenery, the world of the programme, from *Colditz* to *Doctor Who*, from *I Claudius* to *Edward the Seventh*.

One writer who achieved his greatest work at that time was Dennis Potter, whose use of music was personal yet universally appealing, as much a part of his playwrighting as the words he used so lethally. In his TV drama, *The Singing Detective* (BBC, 1986), Potter employed similar techniques to his ground-breaking *Pennies from Heaven* (BBC, 1980). Popular songs from the 1940s and 1950s (mimed in their original recordings by characters in the drama) were used to comment on the action and to provide a context for a complex narrative structure that involved two different time scales and a fictional thriller genre. His ambition was, as always, to sum up the human condition by reference to his own past and experience. His response to the great popular songs of his youth is unequivocal – they promised much that life could never deliver. He often places the most bitter images alongside the most saccharine songs. Yet he sees

society as shaped by its music, the potency of music being equal to the potency of the written word. As his character Philip Marlowe, inflicted like Potter with the skin disease psoriasis, goes into delirium in a hospital bed, the medical specialists and nursing staff erupt into a toe-tapping rendition of 'Dem Bones, dem Bones, dem Dry Bones'. The sadistic village school mistress from Marlowe's youth is transformed into a nightmare scarecrow shambling into his hospital ward in the middle of the night to blurt out a line from Al Jolson's 'After You're Gone'. Childhood fears and bitter loves are described, linked and counterpointed by songs like 'You Always Hurt the One You Love', 'We'll Meet Again' and 'It's a Lovely Day Tomorrow'.

In using songs in this visceral way Potter is evoking the music that formed his generation's character. After the war there was a new hope for the future but a dawning awareness of how much had been destroyed in the conflict. These songs are somehow reminiscent of an earlier time, an era of innocence. Yet Potter's world, even for a child, is anything but innocent, and the detective's search is nothing less than a search for what gives life meaning. To these romantic songs, love gives life meaning, yet that is the theme wherein Potter finds most of his bitterness, disillusionment and horror. This is a completely different use of music to any we have so far encountered, because the songs are being used within their original context to comment ironically on an unromantic world. They provide mood, character definition, recognition of scene and genre yet exist in a world utterly outside the story itself.

How far we use music to dramatise documentary reportage on TV is a vexed question which has a bearing on the manipulative abilities of TV as a whole. Where a report is intended to be impartial, the judicious use of music can influence the viewer's opinion without the necessity of words. I was once in a situation where music I had provided for a documentary dealing with the policing of Budapest had to be changed. The Hungarian police have little funding or resources and are expected to track down 1990s criminals with 1960s technology and back-up. I had produced a fast, up-tempo 'police chase' piece to cover a police raid that had gone wrong. 'We can't use that,' I was told, 'it will make the film look like a hatchet-job'. It was my first introduction to the complications of TV documentary scoring.

The ethical questions raised by the use of dramatic music in factual reporting embrace programmes such as crime reconstructions involving a perceived miscarriage of justice. In some cases the programme itself is submitted as evidence at a court of appeal. The music could be said to be influencing perception of the facts, an unspoken bias inadmissable in court – if that influence is recognised. If the music is subtle enough, it could result in getting somebody freed from, or thrown into, prison.

Some news items now have music running continuously through bulletins, with a 'sting' to herald each new story. This gives the impression firstly that the stories are so wildly urgent that our attention must be riveted, and secondly that they are not going to last very long. The music is bland enough not to blur the speaker's voice but fast enough to lend momentum to the moment. The treatment is derived from the same thinking that is put into advertising – the news is boring and must be sold to the viewer. The influence of MTV, the music video satellite station, must also be taken into account. One often reads of the 'MTV generation', viewers growing up with a short attention span and the need for continuous spectacular stimulus, visual and aural, in order to find TV interesting. This does not bode well for the documentary, the studio drama or current affairs discussion programmes.

As TV production becomes more fragmented, as smaller broadcasters find themselves competing for less money in a wider market, so the temptation to vulgarise music will grow. Specially composed TV music is still of a very high standard in this country, but it remains expensive. Ultimately there will come a time when we will hear very little. The subtlety of well-written, well-used music, like expensive drama or fine documentary, may eventually fall victim to the demands of the free market. It is all a matter of cost.

Film

One of the most famous of all feature films opens with a title but no music. The low brooding chords do not start until the first image, a 'No Trespassing' sign on a metal fence that seems to stretch up into the sky. As the camera climbs the fence we hear a low, five-note theme on the horn, and the image dissolves to a huge letter 'K' above the gates. This theme, low, short, unharmonised, is the theme for the whole film, which will return in triumph as the mystery is

solved in the film's last shot. But for now all is doubt and confusion. The high, shimmering, bell-like vibraphone ushers in images of monkeys in a cage, Venetian gondolas, ruined Indian temples. Are we travelling the world? The sinister music continues, binding these diversities and placing them all behind that metal fence we encountered. The low sounds fade away, the five-note theme returns, on the vibraphone this time, and suddenly all is clear. In a metaphorical finger-to-mouth 'sshh', the music has told us that this is a graveyard. All these buildings, animals, possessions are dead, redundant, forgotten.

Where there is a graveyard, there must be a body, and the light in the window of a castle high above has been growing brighter, offering, perhaps, an explanation of the strange land below. The music builds in warning as we approach the window, then with a crash the light is extinguished. A ghostly glow inside shows the silhouette of the body we expected, snow cascades bizarrely across the image, and for the immortal word 'Rosebud', the music stops. The most important word in the whole film is spoken to silence, underlining its power and significance. The crash of the snowscape glass and collapse of the music tell us the speaker has died. The restless, solemn score, reminiscent of a Wagnerian tragedy, which has accompanied the whole sequence, repeats the five-note theme and resolves for the first and only time into a major chord as we leave the shrouded corpse musically 'at rest'. Seconds later it blares back into the 'News on the March' theme. *Citizen Kane* (1941) has begun.

So much of the decision-making that underlines fine film scoring is present in the construction of that scene. There is no music under the title because that would give away too much too soon. The introduction to Kane must be a mystery, a groping passage through thick fog. Bernard Herrmann maintains the simple, low, dolorous feeling in the music whilst allowing for tiny hints, guide-lines, messages that relate directly to the images they support. Orson Welles, fresh from triumphs with theatre and radio, was very clear in his requirements for sound, and plays with the audience in this sequence, teasing them with what will and will not be revealed. By the end, the mystery is as deep as ever, but one thing is unmistakeable – we have met Kane, we know his story is profoundly tragic and his world is unique. That is enough of a hook to satisfy any audience.

Herrmann's greatest collaboration was with Alfred Hitchcock, another director who understood the part music could play in keeping an audience in suspense. Music can give messages, forewarn the audience of an event to come, and innumerable films that have the camera prowling round corridors to 'he's gonna get ya' music bear witness to that. In one scene in *Vertigo* (1958), Hitchcock and Herrmann provide a musical double-bluff. The character played by James Stewart has been given the job of protecting the wife of a businessman. He has been told she is in a confused mental state and believes she is being possessed by the spirit of her grandmother who went insane and took her own life.

He follows her car from the art gallery that contains her grandmother's picture to the dockside by Golden Gate Bridge. By Hitchcock standards this is a long travelling scene, and as the shot shifts from the woman in the gallery to Stewart in his car, the focus of the score also shifts, almost imperceptibly. The music in the gallery is eerie and disturbing (using many of the same musical elements as the *Citizen Kane* opening) but in the car the music becomes warmer, more concerned. A tune begins to emerge, and it is clear that the score is now commenting on James Stewart's character. His concern for the woman is becoming a fascination which could (and will) turn to love.

The two cars arrive at the dockside and the woman gets out, but the music maintains a neutral, quizzical mood. Suddenly she jumps into the water, a shock for which we are totally unprepared, because the music has not warned us. In fact the music sounds as if it was caught out by the jump, for it immediately erupts into hysterical, braying horn scales ('Oh God, she's jumped!') until calming down at the sight of Stewart rescuing her from the dock.

Music has its obvious uses and its less obvious ones. A score becomes fascinating when it makes its points in the way one doesn't expect. Unfortunately, when that happens the successful technique is usually over-used in later movies and becomes a cliché. The first time I heard a light, pleasant song given horrific overtones was in a Roger Corman movie, *The Premature Burial* (1961), in which Ray Milland was slowly driven mad by hearing 'Molly Malone' whistled by somebody just out of sight. Horror films involving children are almost always scored with

musical box renditions of nursery rhymes, creepy and effective, but now, sadly, clichéd.

Happiness communicated through a sad tune and tragedy conveyed with a happy one are the hallmarks of bitter-sweet romances of recent years. One thematic change in cinema since the 1930s is that issues are seldom black and white any more. The moral absolutes of the Western genre, the hero in the white hat and the villain in the black, are replaced with post-war explorations of the grey area, and the music scores of such movies consequently are less markedly two-dimensional. The bitter-sweet textures of classic film noir, such as *The Lost Weekend* (1945) and *Double Indemnity* (1944) bear witness to the talents of Miklos Rozsa, who could turn from the most sinister under scoring to a heart-breakingly wistful romantic tune in a single moment. Compared with the unequivocal heartiness of a Korngold historical score or a Steiner romance, Rozsa revelled in films which occupied the middle ground, where love was always in doubt and cynicism was survival.

However, when we come to mainstream Hollywood action blockbusters of today, the lines are well-drawn between good and evil, and scores tend to be bombastic, fast-moving and nearly continuous. The heros and villains are two dimensional comic book creations, the music is mostly there to keep the pot boiling. In these days a score that plays against expectations has to be very sure of its ground. The nuclear submarine in Tony Scott's superior underwater thriller, *Crimson Tide* (1995), submerges to the sound of a male voice choir singing 'For Those in Peril on the Sea', which, for at least one audience member, was unexpected to say the least.

Suddenly I was miles away from the submerging submarine and in a Welsh valley, or possibly the Fleet review at Portsmouth. Aware that this was only my individual perception, I struggled to regain some objectivity, only to realise, that for the most part the audiences for *Crimson Tide* would probably be unaware of the hymn or its significance in Naval ceremonies. So all that was left was the words, and we know that the crew was in peril, or was going to be, because if they were not we had all wasted our ticket money on a dull routine mission. The music was simultaneously not enough and too much, a charge that can be levelled at all too much film scoring nowadays.

Often Hollywood film soundtracks are continuous, unrelenting, and outweighed in the final mix by digitally perfect sound effects. There is no light and shade because there is almost no silence, the music only comes to the fore when a chart song is featured, beyond that it remains a dull nagging rumble in the background, all but imperceptible. One sympathises for the composer who has laboured over two carefully crafted hours of music that the audience cannot hear.

Some of the finest film music exists for films that are less successful as films. Ennio Morricone's score for a 1970s space spaghetti Western called *The Humanoid* contained a stunning double fugue for orchestra and pipe organ which lifted the action onto a different level entirely. But as John Altman observes, 'music can't save a bad film'.

Often the decision to be made in film scoring is when to have no music at all. The number of films containing no score is small, but the decision has been taken for good reasons. In the case of Sidney Lumet's *Fail Safe* (1964) and Powell and Pressburger's *One of our Aircraft is Missing* (1941), it was to insure that the films had a documentary realism to them that belied their source as fiction. Climactic scenes of action movies will often take place with no music, because the score has worked so hard to prefigure that scene that it has nowhere else to go. When the protagonists of such action operas as *The Good, the Bad and the Ugly*, *The Terminator* or *The Last of the Mohicans* fight it out in the last scene, it is the real sounds you will tend to hear, not the score. Cary Grant running to escape the crop-dusting plane in Hitchcock's *North by Northwest* is unaccompanied from the moment he gets off the bus until the plane crashes into the petrol tanker. It is a scene which one would assume is scored, but the result of leaving the music out is to make a melodramatic situation more naturalistic.

Music may even be used to distance the viewer from what they are watching. It is a proven conundrum of narrative music that its use can draw the listener into drama, yet its very artificiality can place a barrier between drama and the audience. Peter Greenaway's films such as *The Draughtman's Contract* (1982) and a *Zed and Two Noughts* (1985) have been scored by Michael Nyman in an austere serial style derived from baroque music. The texture is highly decorative, elevated, classical, yet without a

narrative impetus of its own. Rather than communicating emotion it seems to portray a cool elegance very much in keeping with Greenaway's characters. We are being continually distanced from the drama, viewing it as outside observers rather than involved participants. The music is not telling us what to think, rather it is adding to the complexity of the puzzle, making the characters actions more opaque rather than clearer. We look in vain for insights from the music, but they are being intentionally blocked. The effect is to repel those audiences who want their cinema easy, accessible, all-embracing. Rather it is intended to create a musical equivalent of Greenaway's unique pictorial style. This distancing technique, similar to Brecht's theatrical use of music can be found in the work of film-makers such as Robert Altman, Alan Rudolph, Wim Wenders and many European directors.

The irony inherent in comedy films has brought out some wonderful scoring coups over the years. Mel Brooks (with composer John Morris) was one of the greatest exponents of musical outrageousness in film. Brooks spoofed the genres, the clichés and the traditions, as the Zucker brothers do today.

In *The Producers* (1968), an entire piano concerto joins the erupting fountains as Zero Mostel persuades Gene Wilder to help him rip off his investors. *Young Frankenstein's* (1974) monster performs 'Puttin' on the Ritz' and Cleavon Little rides the range of *Blazing Saddles* (1974) only to meet the Count Basie orchestra in the Arizona desert, playing his accompaniment. In the Coen brothers' *Raising Arizona* (1987), Nicholas Cage's decision to go straight and win the love of Holly Hunter is accompanied by Beethoven's 'Ode to Joy' on guitar and harmonica. The 'heavenly choir' that accompanies the lovers' reunion at the end of *Airplane!* (1980) screeches higher than human voices should, and in a thousand comedies noble underscoring is told to 'stop that!', and winds down as though unplugged at the mains.

Music often provides the moment for contemplation in a scene of tragedy. The Albinoni and Barber adagios have been effectively used in war films like *Platoon* (1986) and *Gallipoli* (1981), where a scene of carnage has had the sound faded down, the music filling the gap with objective pity. In Kenneth Branagh's *Henry the Fifth* (1989), the Non Nobis Domine sung after Agincourt (written by Patrick

Doyle) was, in many guises, the theme for the whole film, underlining the loss and carnage of the campaign, not, as in the Olivier war-time version, its glory. Moments where the music is allowed space to take over entirely from other sound tend to be the moments of apotheosis, the culminations of stories, the establishment of environments, the points at which the plot or character is undergoing a major change. As many of our interviewees make clear, these moments are very few and far between, and are to be grabbed with both hands.

There are also times when the score is making us aware of the significance of the smallest or least photogenic image. As Richard Rodney Bennett mentions, the shots that he scored so brilliantly in *Murder on the Orient Express* (1974) are just a train travelling at speed, yet the waltz music evokes its opulence, its exhilaration, the aristocratic 1920s neverland of Agatha Christie novels, and ultimately the murder that is about to take place. The crashing score behind the empty chair in *High Noon* (1952) is the march of destiny – the man who sat in that chair is returning for vengeance.

There is the notion that the best film score is the one that you do not hear. I was amazed to find that there was an hour of music (for which John Williams won an Oscar) in Spielberg's *Schindler's List* (1993), a film harrowing in its documentary realism and impressively unmanipulative in its treatment. Yet that music had done its work, and hearing it again I could immediately see the scenes it underscored. I suspect the best film score is the one you hear when you have to. It should be intrusive when necessary, discreet when necessary and absent when necessary. This explains why film scoring is a collaborative art. These are decisions the director and composer must make together.

Music is so influential within the context of a film that an instrument can become a character in itself. The harmonica theme in *Jean de Florette* (1986), the zither in *The Third Man* (1949), the low, bowed violins in *Jaws* (1975) all contrive to represent and embody something, be it a character, theme or personality within their films, which take on a life of their own. Through repetition and careful placing of the music we do not need to see the actual characters to feel their influence. The music is subliminally unfolding the story as the visuals do, and the momentum of both must be exact and simultaneous. Thus a composer can sometimes feel that a scene cut

has come in the wrong place because the music has registered the disparity between its own progression and that of the film. This is discussed further in the George Fenton interview.

Ultimately music as an influence on audience response is a double-edged sword. Obvious emotional signals will not work, particularly with today's audience. An audience knows when it is being manipulated and requires coaxing to form an opinion. The very use of music can make the unpalatable acceptable. In many action movies the intoxicating music is making an audience enjoy images that they would recoil from if faced with them in real life.

It is sometimes difficult to know if music is making a genuine point or merely blurring the moral argument of showing a violent scene. In Alan Parker's *Mississippi Burning* (1988), a thriller set during the civil rights campaign in the 1960s, we witness a brutal attack by the Ku Klux Klan on a Negro chapel. As the beatings begin, the sound, disturbing in itself, drains out of the scene to be replaced by Mahalia Jackson singing a beautiful Negro spiritual, 'When We All Get to Heaven'. In this instance I think the emotional thrust is genuine – the fight that is happening is the age-old fight for freedom, justice and independence that black America has fought since slavery, and which it would ultimately win, at least in the terms of the plot of *Mississippi Burning*. Yet a film-maker with fewer scruples than Alan Parker could have been using the score to add spurious and patronising significance to run-of-the-mill movie mayhem.

Ultimately the success of a score does not depend on its size, its elements or its hummability. It is the care and ingenuity with which it is planned and executed, and the exactitude with which it complements the film that count. There is nothing that music cannot evoke, and no complexity of plot, character or situation that it cannot embrace. The imaginations of director and composer are the only limit to its potential.

4 | Knowing the Score: Interviews

Scoring Points

Over a period from January 1995 to April 1996 I was able to conduct interviews with composers and directors concerning their work in theatre, film, television and radio today. In my previous experience, composers of music for the media were happy to talk when given the opportunity, since the process of composition, between initial meeting and first recording session, is a fairly solitary one. Once the music had reached the public, composers had no 'right of reply', and the pressures under which they worked were little known or considered. The questions I asked were intended as general inquiries into the process of scoring music to drama, the relationships that exist within a creative team, the demands of today's media and the influences from which musical ideas are drawn and decisions made. The resulting conversations were edited for clarity.

Judith Weir

My colleague, Mike Nicholson, and I spoke to Judith Weir in January 1995. Considered one of the finest composers of modern opera, her credits include Blonde Eckbert, A Night at the Chinese Opera *and* The Vanishing Bridegroom, *operas on TV,* Missa Del Cid *and* Scipio's Dream, The Consolations of Scholarship, King Harald's Saga *and work with Second Stride dance company. She was made a CBE in 1997.*

Telling Stories through Opera

NB: Most of your work has had a narrative base to it. Why particularly do you enjoy working with a story rather than a piece that has no context?

JW: Firstly, I think that that's something that's been neglected a lot. When I started to write music, it was very much the age of high modernism, which I don't necessarily disapprove of, but abstraction was the thing that you were always talking about. That's what you were taught. So perversely I began to do the opposite, which to me seemed to be stories and music attached to concrete events. Once I started to work in opera, in whatever size (because I've written opera on all sorts of different scales), I felt that at that particular moment in the history of opera it, too, had got very abstract – not led by plots or events. Music theatre tended to be the kind of work that Berio was doing. I felt a great desire to go in the other direction. Often I think the quality that people don't like about my main operas is the speed of the narrative. For instance in my last opera, *Blond Eckbert*, there was a 20-minute bit where somebody told her life story, and that was all that happened. That's quite unlike the way Verdi would have told a story. There's a point in that aria when a character says, 'I came to a village. My parents were dead, and no one remembered me. I settled down and bought a house.' In a Verdi opera, I suppose she'd come into a village; there'd be a big chorus of villagers, and they'd all say, 'We don't remember you.' And she'd say, 'Now I'm going to buy a house and settle down.' All that takes such a long time. What I'm saying is that in the modern age we're used to seeing very, very fast narrative in films and on TV.

We're used to a lot being understood, and jumping from scene to scene. The pace of 19th century opera is simply too slow for me, writing now. I love Verdi operas, but that kind of leisurely unfolding plot, to my mind, is too slow for the end of the 20th century.

NB: How far do you have your audience at the front of your mind when you're writing, or are you writing mostly for yourself?

JW: This whole thing about having the audience in mind … I mean, what audience? We don't know now who will come. I think that's a big problem for people working in classical opera. There is still a very old-fashioned opera audience that comes along and has certain expectations, but on the other hand, we're all looking out for those people that go to all the other art forms. There's much more of a feeling now amongst arts organisations that they'd like to attract people who go to all sorts of other arts events. I suppose if I had an ideal audience, it would be people like me, who go to the theatre and to films just as much as they go to other stuff. So, yes, I am writing for that kind of ideal audience, and also taking for granted that film, and perhaps now TV, are the major art forms for most people, and have been for the generation that's now grown up. That's their idea about how stories are presented, so I don't think I'm that unusual in taking film as my model for telling stories.

NB: No, you're not, but it is quite a step to take that sensibility into an operatic context.

JW: Yes, and I think that's where so many of the problems happen now with new operas. Opera is really *the* most historic medium, and its core repertoire shrinks every year. Every opera house in the world is doing the same four or five composers – Mozart and Puccini (who is quite filmic in a way) and a couple of others. With that very historical repertoire, and with performing companies that are designed to deal with that, anything at all contemporary causes immense problems – a lot more than, say, in the theatre.

NB: In the piece that you wrote for *The Opera Book*, you said that you found the pace even of your own work, once it's transferred from the stage onto TV, seemed slower, because it was in a TV rather than a stage context, and that therefore when you were writing for TV you had to be even speedier with the narrative. Is that just to do with getting across the pit?

JW: Yes, and the audibility of words. It's such a big issue in opera, given that you don't have surtitles. None of my work has been surtitled, though probably I'm one of the last composers in history for whom that's the case! I'm sure surtitles are going to be absolutely all over the place. But if they're not there, you have to have a certain amount of repetition. It's no accident that in all those Rossini operas people just say the same words over and over again. That's how people can catch them. It's a very important device. So, indeed, I think you have to pace things a little slower than you might think is natural in in live opera.

The Process

MN: I really liked the piece you did with Caryl Churchill, *The Skriker*. How did that come about? Did she approach you?

JW: She did, but I have to say my part in that came about very late on in the process. It's been said often that she has a new working aesthetic for every piece, and she has sometimes done work which she not exactly improvises, but builds up through a rehearsal process. In this case in fact, the text was absolutely complete when she brought it to the National and invited me to collaborate, and Ian Spink to do the choreography. I wrote the music during production. To a certain extent it was quite a collaborative way of working. When I write music for the theatre (not that I do that often) I never write ahead of the rehearsals – because you never know what's possible and what will happen. So (apart from the fact that, like everybody, I always put things off until the last moment), in the theatre particularly that is a deliberate decision.

MN: So how long did you have to write?

JW: Maybe a couple of months. It was collaborative to the extent that there were a couple of numbers which I took in that didn't seem to be quite right, or Caryl (or the director) changed their ideas about the mood of the scene, so then I just did another number. I think that's a very normal experience in doing theatre music. I think if we were to do it again there could be more music, but when the production was taking shape it was difficult to know exactly where the music should go. For the first hour there was no music. It was Caryl's idea that there would be a big scene in the underworld, and in fact that was more or less the first piece of music. People at the National were very worried about this. The management would come along and say, 'Couldn't you just have some background.' My role was largely to argue against that and preserve silence. I think one of the ways you can make an impression now is not to do that filmic thing. I think it's expected now in film that there'll be a sort of musical wash over every scene change and some background music.

MN: Do you think that shows a lack of confidence in what they've got on stage?

JW: I think it can do. To put it in a more positive way, when so much theatre now is done on a shoe-string, and in small places where you can't expect a lot of scenery and scene changes, it's nice to think that the music can be such a profound source of impressions. But I must say, I'm worried by a lot of theatre I go to with this kind of rather washy sound, and I've a feeling that a lot of people who are directing theatre think that's ok. I don't know if they stop to think too much about it really.

NB: The way music can affect people's responses seems to have been fairly hijacked for TV. It has come to the point where the effect it's having is diluted because people are so used to it. It has to be all the more spectacular, all the more up-front before it has an effect.
It's almost like a treatment for a disease.

JW: Yes, exactly, the drug has to be stepped up every time! And now it's so easy just to vamp a soundtrack on. Now when I go to films the one thing I notice is when there's a big orchestral score. *Home Alone 2* (which, of course I enjoyed so much! – I saw it on a plane) had the most fantastic Straussian tone poems in John Williams' score, and all you could do was sit there and think, 'God, that must have cost millions!' Perhaps that's just a composer's view of the medium! I think the technology has a lot to do with it. It's just so easy now for people to put this kind of soup on top.

MN: In the theatre do you think music should be performed live, if you're going to use it at all?

JW: From a Musicians' Union point of view I think it's very good if it is, and it does present possibilities of using the musicians in a very interesting visual way. The Guildhall School of Drama did a production a couple of months ago of a screenplay for *War and Peace* by Bulgakov (I think). They did it live as a theatre piece. Being the Guildhall, with students, they had a live 70-piece orchestra – and some marvellous music. A Russian student there, called Alex Lubin, did it. The great thing was that they had these 70 people who were available, and at times they would put their instruments down, and they would be Russian peasants or something. At the RSC, the musicians are five floors from the audience, and I think very often the audience doesn't know if the music's live or not. Although this doesn't happen in opera, I wish opera orchestras got on the stage more often, or were put somewhere more interesting than the pit.

MN: I saw *Cabaret* and *The Threepenny Opera* at the Donmar recently. In both productions the band were incorporated into the play and also played roles. You were aware of the band all the time, and what each person was contributing to the whole piece.

JW: Yes, and the musicians would enjoy it a bit more too, although I think you have that big difference in culture between

musicians, who have the three-hour rehearsal then off they go, and actors. I must say, that *The Skriker* production comes to mind. On the acting side people were there all the time. We had a great set of musicians whom we did use visually, but I remember doing a lot of negotiating the next half hour's over-time – constantly going up to the director, saying, 'You do realise the musicians have gone into over-time by five minutes.' That sort of difference in culture is, I think, quite significant in its results.

NB: The process of developing *The Skriker* is interesting from the collaborative point of view. At what stage did you decide what ensemble pieces and what musicians you were going to use?

JW: Well, the first thing I knew, they were saying you can have however many musicians. It always starts off with an economic decision, against which you argue and ask for twice as many. In the end the decision was that we could have four live musicians. The other thing I knew was that we would probably want to use them visually, so we needed people who could move with their instruments – which leaves out cellos and basses. What we used in the end were three clarinets and a keyboard. Clarinets are a choice I often make, just because clarinet players tend to be able to play saxes as well, and there are all these clarinets which have such a big register. So I made that decision in my own head on completely practical grounds.

NB: You say that Caryl Churchill arrived with the text pretty much sorted. Then I assume it was a case of you sitting down with her and discussing where you thought music was necessary?

JW: That almost was written in the script. It was quite specific. During the rehearsal process we discussed it a bit more, and of course there was a director, Les Walters, and Ian Spink who was a joint director as well as choreographer. So there were quite a few people to discuss it with. But that particular piece was more laid down than it might seem. There was plenty of discussion, but I think that Caryl had quite

an idea. She did change some of the order of the scenes at some point, and we talked a lot about the pacing of the whole show.

Collaboration

NB: Can you talk about the difference between collaborating with somebody and having total control yourself. Obviously, you're happy to collaborate under certain conditions, but when does it become not an enjoyable experience?

JW: It might sound a very grand thing to say, but I think I've tried to avoid experiences where it wouldn't be enjoyable. I've spent a lot of time avoiding (in my view) bad librettos. I know many people may view the ones I've come up with as equally bad! But I've seen it so much with colleagues who get given a commission by this or that person. Somehow they end up working with the librettist, and they perhaps haven't seen the libretto before the project starts. To me that would be unacceptable. It has happened to me once. It was a very interesting show, but the director wrote a lot of the script, and I ended up setting a lot of words which I didn't really think were the best, but I didn't have the power within the team to change them. To me it's a question of avoiding those situations. I don't do so much theatre, so I don't very often find myself writing for plays that I hate, but I know of many colleagues who do. Although I find that once you're in a team people lay their reservations to one side for the duration. If I was working more than I do in theatre music, I think I might have more of a problem. I think what everybody is looking for is clear direction, and I'm very willing to follow a director's advice. Everybody just wants their work to be successful in the end.

NB: Do you ever find yourself in the awkward position of having to explain what you are doing with the music at any particular point?

JW: Oh, yes. With directors that I've worked with on the main stage operas that's happened a lot. The problem (and I think it's one that's not very often acknowledged)

is that when an opera's performed for the first time, nobody's heard it. It's a point worth making, because most historical opera is on CD, but the most that people have when a new opera is performed for the first time is a piano score of the piece. People don't know what the orchestration sounds like, and frankly none of us are good enough score readers to know that. So the only person who can say is the composer, and even I don't know exactly. So, indeed, I find myself doing a lot of explanation and saying, 'At this point you'll hear this beautiful, rich strings bit,' or something like that. That's when you have to use a lot of verbal descriptions.

NB: Do you think there's a common experience which everybody has, whereby they can recognise an effect in music even if they can't recognise what the music itself is doing technically?

JW: Well, I wonder. It is something that's said. There are a lot of people working in opera and the straight theatre whose experience of music is very different from a classical composer's. Fair enough, particularly in a post-modern age, there's no prescribed listening canon. It's quite possible that you might be working with a director who says, 'Wow, this sounds rather like *Boris Godunov* at its biggest.' It's perfectly acceptable that they might not know what that is technically.

NB: Does it ever become a problem for composers? With musicians you can at least use some form of shorthand, which you can't use with people who aren't as aware of the repertoire?

JW: Yes, I think that is a problem. At least if it's historical you can play people bits. Richard Jones, who directed *A Night At the Chinese Opera*, is extremely musical. He is a brilliant jazz pianist. I think, in fact, at an early stage in his life he used to earn money playing in restaurants. I remember him once actually score-reading a page of *Night at the Chinese Opera* in a rehearsal. He's extraordinarily gifted. I can't say I've worked with any other director who has those musical skills – though Jeremy Sams has done a bit of directing now.

MN: I wonder what it's like when a director is presented with a project like *Night at the Chinese Opera*. He doesn't know the music because it hasn't been finished yet. So I wonder what he's going on. It must be the basic story, the set and the design.

JW: Yes, certainly he would be going on the story. The great problem about putting new operas on is the time-scale. Ideally someone should be able to design something, and then you see it, and they say, 'Is that all right?' The stage at which people suddenly appear on stage in costumes, and the scenery and stuff begins to appear, is always such a shock. Although people are very good about showing you models ahead of time, you can never really know what it's going to be like till it happens. It's just such a gamble.

NB: Because you're handing over your idea and your voice to someone else to interpret.

JW: That's it, and there are so many people working from their own view-point in an opera team. In the end they're all just throwing their own cards into the ring, and just occasionally it comes out ok. Mostly it comes out so so, kind of all right, and sometimes it's a disaster. There's really a small chance that it's all going to fit together.

MN: Do you think you have more control in dance – such as the work you've done with Second Stride?

JW: I would say my work with that company has been the most collaborative. You do have a sense that you can make things up as you go along, thanks to the fact that rehearsal for dancers is a sort of improvisatory process. No choreographer can come along with fixed ideas. Perhaps in Tchaikovsky's day they did, but now I think no choreographer would organise all the steps before the rehearsal. That makes an interesting contrast with what we were saying earlier about the musicians' view of what a rehearsal is like. A musician above all expects to see the notes in front of him or her, whereas dancers are the opposite – they're the furthest away from that. They don't expect anything to have been

decided in rehearsal. That's rather marvellous for the collaborative process, because when you're working with dancers they're not standing around saying, 'Well, when are you going to make your mind up?' To them that's normal. I must say I feel that Second Stride particularly have made a thing of this kind of process.

NB: Does that mean that you didn't arrive with anything fixed either?

JW: Yes, I think that's true. I mean you have ideas. I'm thinking in particular of a piece we did called *Heaven Ablaze*, which actually is on video. We'd discuss a bit at a time, and I'd have an idea and maybe try something out. But again, because that's a score for two pianos and some singers, it's so easy to change it if it needs to be different.

NB: And was that a six-seven week development, or was it longer?

JW: With the artists about seven or eight weeks, but we certainly spent at least a year on it beforehand. We met every month or two. At that point the designer of the piece, Anthony Donald, was a person of equal stature in the production, which is often not the case. That was interesting, because he would give a visual interpretation. We started off with a Hoffmann story as a base – the *Coppélia* story.

NB: Have you developed dance work where there hasn't been any context, where you've developed a thematic idea, or have you always worked to a story structure?

JW: I haven't done an awful lot of work with major dance companies – not particularly out of preference, that's just how it's happened. I did a score for London Contemporary Dance Theatre in the late '70s – which was an absolute classic of how you *don't* collaborate. This was a piece which Robert Cohan had done with several different scores, but he still wasn't happy with the score, and he wanted to put a new score on. All that happened (because this was before video was widely available) was that he kind of told me

about it! Then I wrote the score. We got it on tape, and then the poor old dancers just had to fit their steps from the old piece to it! Eventually we kind of got them together. When I think about doing that. ... It was just bizarre. But I've a feeling a lot of work gets done in that way. We can go on about, 'Isn't it marvellous all these artists working together?' – I think, 'Was it really?' Weird things happen.

NB: With the operas, particularly *The Chinese Opera*, you're telling a very complex and quite formalised tale, and you pull in every possible narrative method of telling that story. Is that a conscious feeling that that is what your audience is used to these days, or do you yourself prefer this variety of story-telling methods?

JW: I do like that very much. At the time of writing that piece, I don't think I was aware that that was how it was turning out. But now when I see other people's work, that's what I enjoy a lot – some of these original Robert LePage pieces. It was very typical of him, in that it had three acts, and each one was done in a completely different narrative style. Indeed, within each act there were lots of different little tricks that he would use, and I must say that appeals to me a lot. It's unpredictable.

MN: It's not part of the British tradition, is it?

JW: I think you're right, but there's a folk tradition. Britain is very fortunate in that it's got so many different distinct regions, and for story-telling I think it's a very interesting place to be. For a westernised, industrialised country we do very well in that respect. And yet there's this kind of high theatre style which has got nothing to do with that at all. Maybe Shakespeare's got a lot to do with it. In the 16th century this very brilliant guy was around, and he wrote these very ornate things, and that's become the foundation of our theatre tradition. I think that tells stories too, but in a formalised way.

NB: The Italian style of grand opera is that you break down your story into basically what will work as beautiful arias, and what will work as huge ensemble.

JW: Big chorus numbers. That's right. I never would have been able to identify myself as doing this at the time, but I think I did feel it was an almost democratic step in opera to start having a different kind of story-telling style. There's something that can, at its worst, be rather fascistic about that opera tradition of huge choruses. All the grandness – to me it's just not late 20th century. I don't know if it's possible to be effective doing intimate, small-scale story-telling in somewhere as big as an opera house. That's the big technical problem. I think there are perhaps ways round that by using media like film.

The Contemporary Scene

MN: Why do you think there's been such a reaction to abstract composition in the last five-ten years not just in music, but in other forms as well?

JW: Some people would say it's a popularisation that has come about partly because of the decline in modernism. Perhaps twenty or thirty years ago there was an arts-going public that could deal with that sort of thing. Some would say pessimistically that that doesn't really exist now. Those looking at it from a different stance would say that now we expect the arts to be more widely followed. We expect art to be more – what is the Arts Council buzz word?

MN: 'Accessible.'

JW: 'Accessible'! You've got it in one! You could say that people are being more accessible. Personally, I don't like the idea of artists suddenly being accessible because they've been told to be, but I do think there is a big difference from the public and indeed the critical response of twenty years ago.

MN: Maybe you feel like that because your work is instinctively accessible. You once said of *A Night at the Chinese Opera* that you were very definite that you didn't want the story to be told in the programme, because if that was necessary, then in a way you would have failed.

JW: I think I changed my mind later! Yes, I certainly think people should be able ideally to know what the story is. I'd be very surprised if there were composers who didn't want the audience to know clearly what it was about. But indeed there are some such!

NB: You do go to great lengths to make sure that people know the story. I'm thinking of *El Cid*.

JW: I tell the story in the four headings. That's right.

NB: Do you think there's a point beyond which music isn't a great means of getting a story across?

JW: If you've written a piece of music out of interest in the subject matter as well as the emotional range, then indeed there will be some details of subject matter which can be clarified a lot more in ways other than music. There's this whole topic of how much of the words you can hear when they're set to music. I am one of the people who thinks it's a great priority to be able to hear the words, but I think people have to admit that there's a certain proportion of the words you're never going to hear. The effect of music on words is to make them less clear. I don't think there's any way round that. Thanks to the influence of CD technology, people are used, when they listen to their CDs, to hearing the words very clearly – that's because everything's beefed up. The modern audience – in this year 1995 – has a big expectation of getting a lot of the verbal information very clearly. In *El Cid* I knew, because the music itself was very melodramatic, that there was no way you were going to be able to hear all those words. Also some of it's in Spanish. Given that, I wrote that text partly out of an interest in the subject matter.

NB: Can we talk about *King Harold's Saga*. That really does distill the drama of music down to almost the simplest method of putting the subject matter across. You wrote it for a soprano soloist. Was that a challenge you set yourself, or was it of interest to find out what the soprano voice was capable of?

And why a soprano voice to tell particularly that story?

JW: It would seem very impressive if I thought this up from those first principles, but as usual a lot of those things were already there. It was a commission from the singer Jane Manning, who is well known for her pyrotechnic effects. I remember that the original commission included a piano, and then for some reason the pianist was too expensive. I think my feeling was, I've got to do this piece for a solo soprano. How can I make it more interesting than just setting a few poems. I remembered this Norse saga that I'd read at school, and picking the book up again it seemed quite comic. My first feeling was about its straightforwardness. It reminded me of *Noggin the Nog*. I think the very vocal effects partly just come from Jane Manning. Anyone who writes for her takes it for granted they will use those effects. There was a slight feeling in my mind of parody of a whole lot of modern vocal music that I'd heard about that period. Nobody would ever set anything in a straight melodic way. You'd always always have all this 'wo-oo-oo-oo-oo.' I decided to go a bit over the top with that. When I've written music in operas it has tended to be the opposite of that. It's quite linear and plain. Again, that's partly a gesture towards audibility. So it's quite unusual from that point of view. As for the narrative, it's clearly based on the saga. It has to be like that. And as with *Chinese Opera*, it uses a lot of different ways of telling narrative. I think any composer is constantly thinking, 'Well, what do I do now?' You want to keep honing the technique. I think of listeners as being the same as myself and wanting variation, wanting new things.

NB: Do you choose stories because they're particular stories that you want to tell, or do you choose stories because they provide a framework for the style of music that you're most interested in?

JW: A bit of both. I'm not sure if I could quantify it between the two. I've ended up mostly writing librettos myself for operas. Which, I keep telling people, is not really out of admiration of my own literary gifts,

but just that, in the end, it seemed the most convenient thing for me to do, in that I have quite strong ideas about musical drama. I can see how the words should go. It's better than having terrible arguments with some poor librettist who, after all, can't be expected to share my views. I don't see that I can go up to someone and say, 'Well, I'm going to write a piece about Chinese canals in the 14th Century, so. …' It seemed to me a more reasonable option to write the words myself. I do look out for things that I personally can, with the least inconvenience, make into a libretto or treatment. I'm looking out for things that are convenient for me and my own technique.

NB: What are you looking for particularly? Emotional depth?

JW: That is one thing. Actually, I'm just looking out for structures that might work well musically. With this last opera, *Blond Eckbert,* which was a story I'd known a long time, it suddenly struck me it had some features which would be good musically. The whole of the first half is set in just one room, and then the second half of the story goes all over the place. I thought, that'll obviously set it in two acts, and that'll be very interesting. It has this great big dénouement right on the last page, which struck me as good formally. Musically we want that too. So I'm looking out for musical structural features. I don't think it's something that a lot of – it sounds a bit arrogant to say 'non-musically trained people' – but I think musical form is something that composers are particularly concerned with in a very rarified way.

NB: Do you mean 'form' as a non-theatrical structure, as sort of musical evolution throughout?

JW: Yes, the way music is constructed on a long-term formal level. I have to say, that is a sort of introverted musical issue! But I think it matters even to the untutored listener. If a piece doesn't have that kind of overall structure that works in a satisfying way, then obviously it won't seem right in various ways, whatever they may be.

NB: At what stage do you decide whether the story is large enough to become grand opera, or whether it will only provide you with a 20-minute piece?

JW: I don't think there is a stage particularly. I've constantly been surprised by things that I thought weren't very big, and suddenly I thought, 'Oh, but no, this could be very big.' This most recent opera at ENO, *Blond Eckbert,* was a very good example of that, because it's just a 20-page short story, which I've known for about ten years. Talking about expanding things, I don't think I would ever add lots of material, but you suddenly see that the story has a hole. It's as if it has a big space in it where something quite big musically could happen, and perhaps it's just a question of noticing those little moments in the story.

NB: What is in that space? Is it something that appeals to your experience as being an emotional or narrative issue that you just know has got all this potential in it?

JW: I think that probably is it. I think also, to be a bit more prosaic, that suddenly you see a certain scene that could exist there. Something that in the story is just described as being an event, you suddenly see could be a confrontation between two characters or something like that. And I'm sure a lot of things that one thinks of as imagination are actually a sort of repertoire of a lot of work that we've seen before.

The Director

MN: Would you like to direct your own piece?

JW: On the whole my relationships with directors have been very good, particularly in the first productions, because there's so much shared in these experiences. I do feel that the director is somebody essential who can bring something new to the piece. Particularly with things that I've written librettos for myself, I think it would be pretty disastrous if it was just my view that prevailed, because it would be just too introverted. It's not something I've thought a lot about doing, just because I admire the

director's skills very much. I know there are a lot of composers who get very annoyed about direction, and there have been directors that I haven't enjoyed working with, but on the whole I see the director as a very positive and, let's face it, today a very major creative force. We're talking about people like Robert LePage. They're not just directors. Again, we're approaching the tradition of film. Really I can see an argument now that in new operas people like composers, and particularly librettists, are approaching the status of the screen-writer in film, ie, not very important. Think about somebody like Peter Sellers with *Nixon in China,* whom I think most people know worked with John Adams and Alice Goodman. I think you wouldn't be surprised to see that described as Peter Sellers' *Nixon in China.* A lot of young directors have seen that, and they think of themselves in that way too – which could be exciting, except then they've got to remember the job of being the composer in an opera is not something one would undertake lightly.

MN: I wonder why that's come about, this low status of the composer. Because obviously the composer in an opera is the most important person.

JW: Well, I'm touched to hear you say that! But I think there are plenty of people who don't particularly see it that way. I think this is a very crucial thing now, that people see opera from all sorts of points of view. I went to see this recent Birtwhistle opera at Glyndebourne – the one with the Russell Hoban text (The Second Mrs. Kong, 1994). I met several people there whose main experience of that piece was of Russell Hoban's work. Fair enough, he's a very major writer. You couldn't hear most of the words – as with most operas you can't, so I don't know how they felt about that. We say now that when we put on opera we want audiences to come from all the different art forms. Then you've got to accept that there may well be people who come to an opera who are not primarily concerned with the music. You might get young stage design or visual arts people coming along, and visually is the main way that they appreciate it.

MN: Why do we see this broadening out?

JW: In a way it's part of a good trend. Everyone agrees that in the last ten or fifteen years staging and visual presentation of operas have become much more expert and much more a big part of opera. When I was at school and used to go to operas, it was a dingy experience. Certainly not so much money was spent on production relative to the whole thing, and there was a lot more reviving of productions. Now opera houses realise that they have to have new productions of the old pieces much more often, whereas in the old days people like Covent Garden would keep a production of, say, a Mozart opera in the repertoire for maybe twenty years. People didn't really mind about that. You often hear from old-style opera people that production has taken over. I personally don't think that. I think it's exciting if production is an important value, but there's no question that in the realm of new opera this now means that the status of the composer is perhaps less than it was.

NB: In a perfect world, what do you think the director is out to do?

JW: I think there are all sorts of different roles that they have. As I've said, I admire people like LePage. He's the most famous example of somebody of that kind. If they are great creators, then that's marvellous – if they're also able to realise the work in that way.

NB: Rather than hijacking what you've done?

JW: When I hear about that sort of thing happening, I think it's important always for the composer to get stuck in with the director and really work it out, because you don't always have the power to stipulate who's going to direct your work. For a first production of a new piece, given that I do so much work on that, I would be very disappointed if I wasn't working with someone whose work I like. I always hope that the director will bring something extra, something that I haven't thought about. But obviously there is a large part of their work that is just practicalities – making sure that it works on stage. I think

there is an alarming trend – I've certainly had this happen to me – for directors to pick and choose the bits of the opera they like. Maybe, 'Shall we change this bit a bit?' Ok, but there is the importance of overall formal thought in music. Once people start saying, 'Could we add another two minutes to this scene?' …

NB: … the architecture begins to crumble.

JW: Exactly, the architecture is the word. It might seem as if theatrically it's a good idea to do that, but in fact it can get a bit dangerous.

NB: That's where the composer *is* the most important person in opera, if for no other reason than that that person has built the foundations of this building. From that point of view, do you feel when you're dealing with the director that your flexibility must have limits?

JW: I would hope so. I always hope that with any changes or suggestions the composer will have the power of veto. Once the piece has been done for the first time, I think in the subsequent productions your power gets a bit less, and that's when funny things start happening. By that time I suppose a piece is strictly speaking repertoire, and people can start revisiting it.

NB: Do you assume that the narrative, is pretty much watertight to your own requirements before you begin collaborating?

JW: Yes, although even that is open to discussion, particularly things that are not so closely based on original sources. The way I've most enjoyed working is to have discussions with the director while I'm writing the piece over a long period, and on the whole that is what's happened. With *The Chinese Opera* we got the director about two-thirds of the way through, but even then I was still discussing things about the plot. I think that's rather peculiar to me, because in most cases I've written the libretto myself. Normally one would be discussing these things, presumably, with the librettist.

MN: The way that we listen to and appreciate music now seems to have changed a lot. Do you think that's anything to do with the way music is used in films and television? I wonder how much we can leave that behind when we go to an opera or the theatre.

JW: Unfortunately the relationship between film and music has made people notice music less, though one can't speak for every listener. Now I get the feeling in an opera house, looking round the audience, that people all have a different cocktail of interests in their head, and there may well be people who have come to follow the story or look at the design. They vaguely hear the music going on, but they're not really following every note – which is a perfectly ok way to follow an opera. But I think that can cause problems for new opera particularly, because it needs a lot of faith at first from the audience. That's why we have a difficult situation now. So little new opera has continued life. People are too ready just to put the music aside. They've had that experience, and now it's on to the next one. The idea that an opera score is a big thing that you take a long time to get to know, that you hope you will be able to hear ten times – that's not happening. Economically it's just not making new opera possible on a big scale. People are doing these big pieces that cost so much to rehearse that you just do one or two productions at the most. It's not worth anybody's time to do that for just a one-off experience. The lowering of the status of the musical element of opera is a big problem in that respect.

TV and Accessibility

MN: How much did that bother you when you did work for TV?

JW: In a way I put working for TV in a different category. I think the good thing about doing original pieces for TV, is that it's a great opportunity to get everything right and the way you want it. Opera is a chancy business, but TV film doesn't go out, theoretically, until it's ready. In other words

you can track the process, and there is the possibility of saying, 'Oh my God, we made that scene far too long.' The cutting process is a lot easier. I think it's a bit more flexible in the creative stage. The awful thing about an opera for the stage is, you write it, and then it's finished, and then people have got to do it whether it's any good or not. It might indeed have disastrous bits, but the chances of changing that for the first production are very little. You hope that you're good enough to get it as good as it should be. The great thing about TV is that the working process is very different from that, and the timing of getting it ready is a bit more flexible.

I'm well aware that compared with the decision somebody makes to go out to an opera house and sit there for the whole evening watching your piece, it's less of a commitment for them just to see it going by on TV. Of course the pay-off is that many more people see it, albeit casually, on TV than could ever see it live in the theatre. It doesn't bother me because I perfectly well understand the spirit in which people watch things on TV, and I think you create something quite different for that. The quality of the piece is a bit different when you create it for TV, and you take into account what people's attention span will be. It's something you accept if you agree to write an original piece for TV. If you're not stupid, you know exactly how much attention it'll receive – which is probably not a lot!

MN: Because you know you're writing for TV, do you adopt the conventions?

JW: They are there. That's certainly true. The kind of original work for TV that I've been involved in writing has always been for very experimental music-led TV series, so I probably had a lot more status than a composer would normally have on a run of the mill piece of TV. I haven't been asked to do *Columbo* or anything like that!

MN: *Cracker!*

JW: Well, it would be interesting.

NB: In terms of the way you want to tell a story, can you see a situation where you would rather do the piece for TV?

JW: I think so. TV has now got so many story-telling conventions of its own that you'd be bound to find things about which you'd think, 'Oh, yes, that would work like that.' I think you're right that soap opera is the place where it would be most interesting to intervene, because some of the soap operas we're most used to, have many more truly operatic moments than most operas do these days! It would be very interesting to see the effect of music there. It would be an interesting idea, just for a week of *Brookside* or something. Ask a different British composer every night!

MN: And watch the ratings plummet!

JW: Well, yes. Except funnily enough it's always said that people accept advanced styles of music readily on film – all those Schoenberg pupils who scored Hollywood movies. People love that, and they take it as being totally normal. Then you put it in a concert and it's, 'Uuhhh!'

NB: Have you ever thought about your position as a composer in a world in which music seems to be rising like a tide?

JW: It certainly has occurred to me once or twice that music is so easy to achieve now, particularly electronically. I compare ourselves even with people of my parents' generation, who once in a blue moon could attend a live concert. Even putting a 78 on a gramophone was more of a physical effort. If you had to wind the gramophone up, you really listened to the record. I'm sure that this is a big part of the problem for new music now. People blame composers a lot for the unpopularity of modern music, but it's very difficult for composers to achieve any real attention to their work.

NB: Particularly with new music, you have either to decide that your audience is 'there,' and they're going to come, or you have to work within a context which the bulk of people can understand – which will appeal to lots of people.

JW: I think it's a difficult line to draw too. Composers, certainly of my generation, who were brought up within the modernist heritage, I think would all say, 'You've got to be true to yourself.' But once you start working in opera, all these different viewpoints come into play. You do have to think, 'Are the audience going to understand this bit?' or 'I wonder how we can put this more clearly.'

MN: Has that sort of experience changed the type of music you do?

JW: It's hard to say really, because all this has happened over quite a long period, and I think my work would have changed anyway. All the work that I write expresses my current musical interests, whatever those might be. I still don't sit down and think, 'Are the audience going to like this?' I come back to this thing that I learnt in my Kent Opera days – that you can never tell who the audience are going to be on any particular evening. You'd go to one place and it would be intellectual opera lovers. The next night, for no particular reason, it would be completely different people. I still have that feeling that you simply cannot predict who your audience will be. There's no point in even trying to begin to guess what they might like. People's experience of art now is so completely personal to them. There's this great choice of things open to them. In a way, I think that makes you a bit freer as a composer just to say, 'Well, this is my idea, my music, and probably there are a few people out there who will be interested in it.'

NB: Given that Berio wasn't a musical influence, what are your musical influences?

JW: I love Berio's music – I was thinking of a piece like his *Circles*, which was the kind of thing I ended up not writing. I really find that question difficult to answer, in that I know a lot of music. I had a proper classical training, and love a lot of that music. Now, I suppose, the art form that I go to the most is the theatre, so a lot of the new work I see is more likely to be theatre work.

NB: In terms of your contemporaries, whose work are you interested in at the moment among those who are working in a similar field to you?

JW: Composers working in music theatre? The trouble is that so few people are really, on a satisfactory level. I go along to things and enjoy them very much, but people are not having a lot of opportunities these days. I think when you work in the field you get very sympathetic towards people, because you know what's gone into just getting a piece to that stage. I can appreciate it perhaps more than the average person. I wouldn't say there's a major composer of whom I think, 'Yes, my work's got to go that way.' It's more a collage of things that I've seen. Martin Butler did an opera last year, based on the story of *Superman*. I enjoyed his work there. Michael Fillis did an opera based on *Thérèse Raquin*. I think Dominic Muldowney has always got a very interesting viewpoint. In a way I wish he'd do more work of his own. He makes very interesting contributions to the theatre. I'm always interested in that.

Dominic Muldowney

Dominic Muldowney

I interviewed Dominic Muldowney in December 1995 for this book and for the Radio 2 Arts Programme. He had just completed work on a Japanese musical theatre production of Hamlet *with a female star and was about to leave for Los Angeles to write music for Edward Bond's theatre adaptation of Ken Loach's film* Land and Freedom. *Our talk ranged over his work with the Royal National Theatre, his approach to his composition and broadly populist work in TV series with* Sharpe.

Hamlet in Japan

NB: Can we start by talking about *Hamlet*? This actually is a rock opera in the way the show is approached. It's happening in Tokyo at the moment. Can we talk about how you came to be involved? I imagine that it's a project that takes a very large decision to get involved with?

DM: Well, absolutely. When they asked me would I be interested, I have to say that it was a case of, 'I'll get back to you'. I thought about it for a long time, and it was only really when I heard the singing voice of the woman – can you believe this? – the *woman* who was going to play Hamlet that I decided. You see what a strange project had been asked for. I realised that she'd spent most of her life playing men anyway, in this Japanese company where all the women play the men's roles as well as the women's roles. In the performance she really gives Laertes a seeing-to with the fencing in the end. She's a very physically strong woman, and she sings – not like a man; I don't mean that it's all about a different gender – it's that when you watch her perform in *Hamlet* it doesn't occur to you that you're watching a woman. You're just watching a character performing. This is because she's a very good actress; she's a very good singer, and she's physically very free and mobile. I was very pleased that eventually I did get involved in this idea, because it's a piece of work that I'm very proud of now.

NB: Is she the only woman playing a man in it?

DM: Yes. Ophelia's a woman and Polonius is a man. She floats in and out as this man/woman, but, as I say, you don't get

disturbed by that, because it's such an extraordinarily good acting performance. I think I wouldn't quite describe it as a rock opera, because only she sings in it – and Ophelia of course sings her songs. Interestingly, her songs – Ophelia's – are memories of the songs we hear Hamlet singing, so it's as if she's remembering the songs of the boyfriend – what he used to sing. Only Hamlet sings, and then Hamlet only sings at those moments when we normally expect the soliloquies. The one soliloquy we haven't set to music is 'To be or not to be?' That's spoken in Japanese. It's moments like when the court leave Hamlet alone on the stage, and she/he then comes and tells us his feelings about his father and the new father and the mother.

NB: So this is 'Oh that this too too solid flesh would melt'?

DM: Yes, that one. And those moments have been lyricised, if you see what I mean, by an English person. It's English lyrics I set. They're not those words, but they're sort of poems on those words. It's a very dangerous thing, isn't it, fiddling about with Shakespeare like this? But I think that because it was done in Japan, that was a great liberation for all of us, because we were able really just to try and get something right in another culture. And it really did work. I still to this day can't quite put my finger on why it is such a big success, but I think that none of us were worrying about English critics, quite honestly. We just did what we were good at, and were allowed to. That's quite interesting.

NB: The Japanese do love this kind of music as well. You say you were writing to English lyrics, but was she singing in English?

DM: Oh no, she sang in Japanese. You see, it went through many stages before it got onto the stage. Another stage, of course, was that we had to work with a lady who'd done the lyrics for all the Lloyd-Webbers and Sondheims. She was the best Japanese translator. She was a wonderful old lady – she must have been nearly 80, and she'd done everything there since the war that had required new translation. So she

worked with us. It was very interesting, because I'd set a word 'sea', and in Japanese that's two syllables, and just singing 'the sea' didn't work. So I had to change a lot of the music, which I don't mind doing. There was a wonderful collaboration between us to get it absolutely to the ear – so that the ears of the Japanese didn't have anything equivocal or difficult.

NB: So did she send you a sort of phonetic Japanese?

DM: We had a lot of conversations actually in Japan when I got there. They tried to do their best until finally, in their very Japanese way, they sort of looked at me and said, 'What are you going to do about it?' It's all very polite up to the last second, and then at the last second somebody's got to jump. I thought, well, it's my turn now, and I changed the music, but they really did do a wonderful preparation. I must say, by the way, that there's no question that the musicians I had there were the best musicians – the quickest, the most friendly, and the most willing to take notes – that I've ever worked with. I had a great time with the pit band.

NB: Were you conducting as well?

DM: No, it didn't need a conductor. It was led. Because we couldn't have a huge orchestra for this, we had a lot of electronic instruments, and a very well-known synthesizer company donated all their instruments free, so we had the absolute highest-tech kind of orchestra you can imagine. I was using instruments that haven't come out in the West. There's this thing called 'morphing' where you change a face into another face. Well, we had an instrument that did that with sounds, so you thought you were hearing a soprano and actually it was a flute, or vice versa. I was very pleased that we were able to get our hands on all that kind of gear. So we had not a very large orchestra, and it was able to be like a string quartet: they'd just nod and play together. But we had a wonderful big sound.

NB: Can we hear a little bit of the score?

DM: Yes, I can play you a bit. You know the famous scene where Hamlet asks the players to do the play for the court, and it's his way of trapping the King into revealing what he'd actually done – ie, kill Hamlet's father? I can play here the moment when the king realises that Hamlet's set this whole thing up, and he clears the court. This song that Hamlet's been singing with the players suddenly erupts into pandemonium. The other thing about the music that grips it in a kind of classical way is that the harmony is very baroque. It comes from just after Shakespeare's period. In music the baroque is the equivalent of Shakespeare; it's the highest moment in music – Bach and so on. So I've used that as a kind of structural under-pinning. The thing is held up by something quite classical, but you'll also hear a drum beat and all the the paraphernalia of rock music as well – at absolutely the same time. Mixed into that music is a fugue, and all the things that you don't normally get in rock music. But the thing I'm most interested in, of course, because I come from a classical background, is not to throw that all out for some sort of 'they won't like it if it's not simple.' It's about drama; it's about dramatic music. That's a very dramatic moment, and it deserves the most dramatic moment I can make.

Creativity

NB: It seems that you had so many different sides to the brief when you started this show: that you had the necessity of the kind of style that your leading actress used, your own background – with the RNT particularly it had to be a theatrical experience. You're also drawing on baroque and on rock opera. Did you start off with all those balls in the air, or was it something that began on a very simple basis and then took all these various parts on?

DM: Well, looking back, that's a hard question, because you know creativity is a bit like juggling. It is about a lot of balls in the air. Some fall down and you never see them again, because they're not required. I remember thinking two things. I had to be

very true to Shakespeare, in that people do go to the play to get the play. This music was always going to be an interruption, and if it was going to interrupt, it really had to have some solid flesh on it. The other thing was the girl who was going to sing this part. Her background was cabaret. She's very like a cross between an actress like Julie Covington and Elaine Page. She's a proper actress and a proper singer. I don't know of quite that person in England. It would be absolutely no good to her if I came along with something that had strayed into a musical world that she couldn't ever feel she could inhabit. As it was, this frightened the life out of her. It only frightened the life out of her in the sense that she knew it was a challenge. I think the reason that it was a big success there, was that her audience (who really follow her about – when she came to England, she came with a plane-load of fans) weren't just going to get from me what they were used to – because they weren't used to seeing her in Shakespeare anyway. So I had to keep up with *Shakespeare*, not them. That's why in the end it was a very fulfilling project for me, because although it produced some of the most popular music I've ever written, it was in the context of something very serious and challenging for me too.

NB: How did you work with the lyricist? Did he produce the lyrics first and then come to you, or did you work together?

DM: Well, it was a *fait accompli*. It was all done by the time I was asked on board. But once I'd started, I realised that for me the lyrics weren't rhythmical enough. In fact they were a little too poetical, a little too loose, and I kept going back saying, 'Look, could we cut all that, and just get that to rhyme a bit quicker.' Because I just know that the ear loves rhyme; the ear loves repetition. The thing about music is that it enjoys repeats and choruses and verses. It was almost ok, but I just encouraged the lyricist to make it a bit squarer than it was looking on the page, and in being squarer it gave me more freedom, funnily enough.

NB: When you say 'squarer', it was actually to make it look like a song?

DM: Well, yes, that's right. I mean when you look at Sondheim lyrics, they go, 'de-dugga-de-da, de-dugga-de-da, de-dugga-de-da.' The 'dugga-de-da' bits are wonderful rhymes of course, but in their rhythmical essence they're very simple. And those wonderful rhymes of Sondheim's wouldn't be extraordinary if they were in a looser rhythmical context, because it's the sense of, 'yes, he just got the rhyme in on the last beat!' It's so satisfying.

NB: Let's look at the soliloquy you mentioned, which in the original Shakespeare is, 'Oh that this too too solid flesh would melt.' Here the song is called 'Death the Delectable'. Can you start from first basics?

DM: This is the first song in the play, so it's the first moment the audience think, 'Hang on, what's going on here? Is this a Shakespeare play?' So I had to use this in a very subtle way, and this is where my baroque side comes to the fore. You know the Hamlet advert that has the falling bassline? It's very common in baroque music. Well, I just changed it to the minor key, so it now it falls just as Bach would use that progression. That was a way of saying to the audience, 'Don't worry, we're almost in the same period, and, yes, she is going to sing, but instead of the original she's going to sing a lyric,' and we start this 'Encompassing the sea, death the delectable'. Whenever she sings in the early part of the play, she's very near the sea. In our production it's almost Freudian, because the sea is where she can imagine things. You know, there's this thing about the sea and subconsciousness. This first song in the play, and indeed the last song in the play, she sings on the sea-shore. The sea laps up, and she's able able to express herself. Here you can hear the falling base-line, and these little twiddles like a harpsichord, but it's actually an electronic harpsichord. 'Encompassing the sea, …' and my drummer comes in. Then once he comes in, you realise that you've been through Bach; you've hit some harmony that's beginning to sound like Kurt Weil, and then, yes, you are in a sort of *Threepenny Opera* world. Remember that Kurt Weil's always been a great influence on me. What I hope I've achieved just in

that intro is to suck the audience into another context. They can listen to the song as a modern pop song, but they're still in the period. That was the trick of all the songs, to try and get those two balanced.

NB: You're obviously not frightened of drawing on references that an audience will understand and recognise.

DM: No, eclecticism, the sort of magpie mentality, has always been part of me. It's come from working in the theatre, where one was asked in the old days, one day, 'Would you write a fanfare?' and then the next day they want a sort of Noel Coward song – and you had to do it that day; there was no mucking about. So I did develop a technique where I could embrace any style. And I think what *my* style is, is not being frightened of all that knowledge and technique and just using it when it's required. I hope my music doesn't lead people suddenly to say, 'Oh, that's the Kurt Weil bit,' or 'That's the Poulenc bit.' I hope it just comes out of a necessary theatrical moment – when you do need to be sweet, or you do need to be acerbic or ironic or whatever. Actually I often think it's only other composers who are reminded of other composers! I think the general public are just getting the dramatic moment, either clearly or not so clearly, and that's all they need to be worried about.

NB: When you're drawing on this kind of well of experience that people appear to have in terms of musical reference – when you're asking people to respond on a purely instinctive level to something they're hearing which they will recognise, is that part of your work in film and TV as well, or is that something more to do with the theatre?

DM: I think in TV and film it is a little bit more callous than it is in the theatre, in the sense that you have so little time on film to make your point. Something I can't actually do is things called stings, which are moments where you have to sum up the moment in maybe two or three seconds. That's a real technique that even I don't have, with what I think is quite a good

technique. It might not even be about technique; it might just be allowing yourself to do what the director wants and not being fussed by your own feelings about the matter. I find that I can't quite be as anonymous as not allowing something of me through. So this *Hamlet* was perfect, because I was working in an environment that needs an accessibility, but I felt very free in that environment. I think I ended up with something more Dominic Muldowney than in many projects actually.

NB: That's one point I was going to ask about in relation to theatre. Do you have to stop being Dominic Muldowney?

DM: No, not really. I do think though, as I say, in film it can make everybody's life a lot simpler and happier, and you get away earlier, if you just decide to do something that might be a bit of a cliché to you but might be perfect for the moment.

TV and Sharpe

NB: I'm fascinated also by your work for the series *Sharpe*, which is a terrifically popular series, and where both in terms of the way it's shot and, I think, with the music, you found a perfect balance between the requirements of the era and the requirements of Sean Bean's standing as a star. How did you go about scoring *Sharpe*?

DM: Well, I have to tell you, it was very lucky. Sharpe's got a kind of right-hand man. There's hardly a shot in any of the series where you don't see this Irishman on his shoulder saying, 'Yes, you do that Richard Sharpe; that would be a good idea.' And it's this Irishman on his shoulder. It's his music I've been writing, because I'm half Irish, and I love Irish folk music. You get a lot of pseudo Irish – I mean, its Oirish!

NB: But it also, interestingly, lends so much depth to an action movie.

DM: Well, I think yes. I've been listening a lot to Morricone lately, and when you watch *Once Upon a Time in the West* you suddenly realise that all the references, even with an Italian writing an American movie, are folk

music, and to my ears it's often Irish folk music. The wonderful thing about *Sharpe* is that it's set in a period where I can use folk tunes. You know we used this theme which is called 'Over the Hills and Far Away' from *The Beggars' Opera*. I muck about with the tune in every series – it's in the minor, it's in the major, it's in half-tempo, whatever. I've even done a triple canon, which is a technical thing where the tune follows itself one after the other, like cars following each other along, and it gets very complicated, but it always sounds like the period. It's something that I've used a lot in the theatre. I've done it in a version of *The Beggars' Opera*, and it was so strange to realise that it was perfect for *Sharpe*. It's the right period, it has military connotations and everything. Again though, that's been a project where I've been using a lot of modern instruments. There's a lot of electronic stuff in there with the folk music, and I think this is what people like. They like to feel that an electric guitar can sit next to a Russian orchestra – because that's what happens in the opening titles. We've got the Leningrad Symphony Orchestra playing an 18th century tune along with an electric guitar.

NB: The electric guitar does seem to be Sean Bean.

DM: Yes, of course. I mean while you're hearing all this orchestration, you hear this thing on the guitar, and it just jells. There's a man who just looks so 1990s, in the sense that he's very strong, and he's sexy and everything, but we're in the early 19th century, and nobody bats an eyelid.

Ireland and Spain

NB: I know you're heading off to California to work on a new piece by Edward Bond. Can you tell us a little bit about the background to that?

DM: Well, your readers will have heard of or even seen (I hope) the Ken Loach film *Land and Freedom*, which is set in the Spanish Civil War. This is an exact equivalent in the theatre of that moment, about a woman who is politicised by

events. It's a sort of tragedy. It's interesting to me to be in Spain again, because the *Sharpe* series I wrote is about the Napoleonic wars in the peninsula in Spain. It's interesting, because all those clichés of Spanish guitar music that I was using in that, I'm re-using in this, in a much starker, bleaker way, because here we're in a war that's 150 years later – much closer to our own times. I think what is wonderful about that Ken Loach film want the music to be pretty serious stuff. The things I've already come up with are just sketches really. We don't actually get into rehearsals for three or four months yet, but I've already begun just mucking about with a guitar and with, again, a folk music that's more Spanish than Irish, although I still think even my Spanish sounds a bit Irish. That's OK; that doesn't matter.

NB: When you say you want to go for something much bleaker, which is obviously derived from the subject, does that mean that instead of starting at the square one you may have started at with Sharpe, you actually have to start two squares back from there – that you've actually got to go to something that is probably more within you.

DM: Yes, that's right. In fact that's why I would say that I'm not discarding the Irish, because I think if I did discard it I wouldn't know where I was. It's only recently that I've begun to realise that the Irish in me is very strong. As you can hear, I've got a very South London voice; I don't have an Irish accent. But as time goes by – I think it probably happens to many of us – you do start re-looking at what your father did and where he came from. I'm messing about with a cliché that you probably know, which is a particular chord progression. I've got a wonderful instrument here that will play that. One of the wonderful things about technology now is that we've got these instruments that can imitate the instruments of the orchestra. This is what they call a sample of a Spanish guitar, and jolly good it is too. One of the things about playing music to a director whom you're collaborating with nowadays is that you can give him much more detailed sound – a sound world that's much more pertinent for

him. If you play this chord on the piano, it sounds like a harpsichord playing something baroque, but if you play it on this instrument, suddenly you're in Spain 1936. It's a wonderful thing. Anyway, I'm using this cliché, but then, if you like, attenuating it, stretching it out to such an extent that it loses its 'clichéness' and becomes something that's very much what I want it to do, and which is very personal to me. So I really started with the most simple colour – just a red or just a yellow – but because the whole canvas, let's say, is yellow, and because there's only a little bit of red, say, in it, that's not just yellow any more; it's become a statement about yellow. And with music it's exactly the same thing. If you keep on a chord, if you keep tugging away at it, it's about the tugging and not the chord any more, and it's about your personal involvement in that cliché. That's very much how I work. I start with something that everybody knows and don't even know that they know, it's such a cliché. You say, 'Oh, yes, I think that must be Spain we're in.' And then say, 'Yes, you're in Spain, and my God am I going to take you somewhere out of that!'

NB: Are you working right from the start with contexts in mind, or are you assuming just that you're starting from a general overview of the whole work in your very very early sketches?

DM: Well, that's an interesting question, because this little introduction I could play you is actually the last moment of the play. Going back to the *Hamlet*, the first song I wrote was the one he sings – *she* sings, I mean – at the very end of the play. That's very typical of me – to find out where I'm going and then try and work out how to get there. The process is to go to B. A to B. Get to starting B, then the rest of the time's lovely, because you just say, 'Well, I'm in B; now I have to find how I got there.' And that's fun, because it's still a mystery to you. It's not a fait accompli at all. It looks like one, doesn't it? But it's quite the opposite.

NB: So are you then in effect de-constructing in your head where you are at B in order to get there?

DM: Yes. This word 'de-construction' is of course very common now. Composers have always used that word, without any of its philosophical meanings. It was always about de-construction. I mean you have a thing like this, which is a baroque cliché, and that's really being at B. Now how do you make that live? You have to find the journey towards it. So you start, and already you can hear you're having fun with it. That's what I think I do when I compose. I get to where I know I've got to get to and then find out how to get there!

NB: And is it a sort of musical architecture that is just true to the music within itself, or is it a musical architecture which you feel is then acted upon very much by the contexts you're working in? I'm thinking particularly of the Bond.

DM: Well, in the theatre yes. This particular last thing that I began with is a wonderful line. I can't recall it word for word from memory, but it's basically like that biblical expression, 'We who have sown in sorrow shall reap in joy'. It's about a woman who's been so politicised by what she's now seen that she says, 'We won't survive this, but our children will'. I think that's why that Loach film's so strong. It's because we *are* the children of that moment. 'We who are born later,' as Brecht used to say, 'will understand.' I read this line of Bond's, which roughly says that, and I realised that that's where I had to start. I had to start at the moment where everything was clear and then work from there back to the darkness of not knowing.

NB: It's interesting too that when you're dealing with anything even resembling Flamenco, you've got to fight through all our original ideas about Flamenco in order to make a separate statement; your music for the Bond play then does become rather Irish, Celtic.

DM: Yes, absolutely. It reminds me of when I heard 'Danny Boy' played on a kind of high, piercing whistle with a sort of vibrato in it. That's in there. Also, there are instruments in there that are nothing to do with Ireland or Spain: a big, almost African, xylophone and marimbas. I think

that's the great freedom that you get if you look at the music of that period and say, 'Right, I'll just have a bit of that, but I'm going to take it somewhere else.' And wherever you take it is real then, because it's your feelings about the music; you're not just writing a parody; you're not just writing a bit of Spanish for this moment. It's much more than that. That's why, when we were in California, I said to the director, 'Are they going to speak American in all this?' And the wonderful solution we're thinking of coming up with is that, because they're so close to Mexico there, they're going to speak Mexican-Californian, if you like. That might have the same tone and complexity to it that the music's going to have, because it's not just straightforward España.

Actors and Singers

NB: Once you go into rehearsal will you still be adapting, working within rehearsal?

DM: Oh, absolutely, yes. I've *no* idea yet whether we've even got a singer within our troupe who'll do the kind of voice that I think this requires, which is a very hard thing to find, because you want somebody who can be piercing and not Sondheimish. I'm not getting at Sondheim, but I don't want a Broadway voice, and I just know in America I'm going to have a lot of girls come up to me and audition, and I'll say, 'Hang on, could you just sing an unaccompanied folk song that doesn't sound like Joan Baez or Elaine Page. Could you do that?' And I can tell you, I've been there so many times before, they can't do it. They can often only imitate. Then sometimes you get somebody walk in who says, 'I'm not a singer. I mean, I can sing loud, but I'm not a singer.' And you've got your voice, because it's a completely unpretentious natural voice. In fact it's a voice that they use in their acting, and when they sing, they still use the same voice. Have you ever heard that voice where they're talking like me now, and then they suddenly go operatic? And you think, 'Hang on, who's that person just come in the room? He's dressed the same; he looks the same; he's got a completely

new voice.' I hate that in the theatre. It's very hard to encourage actors to carry on just acting when they're singing and not to pretend they're Pavarotti or whoever is their favourite.

NB: The problem there being, I suppose, that you're actually trying to turn on its head a three hundred or four hundred year old tradition of actors sounding different when they sing.

DM: Also I think it's to do with the fact that they think that I want that. They think that we want them to suddenly appear *professional*. At the National Theatre we once did something I loved – a *Beggars' Opera* in which very few of the company were 'singers'. You couldn't put your finger on where the song began, where the orchestra finished, and where the scene carried on. It was seamless. And you realised that they sang in that opera because they had to sing. They had to sing then. That was their way of expressing the next piece of the play. That's a very Brechtian thing as well, that you have singer-actors, and you don't just wheel in the big tenor.

NB: What do you think is the cut-off point at which you say, 'There's no way that this will work as dialogue; it has got to be musically supported'?

DM: Well, that's not just a musical decision. Richard Eyre directed *The Beggars' Opera*, and we analysed very carefully how the accompaniment began, and whether it was a noticeable accompaniment to the audience. It was interesting, we often had accompaniments only the actors could hear anyway. They started singing, and suddenly you heard the orchestra playing. It was all done very carefully. It's that cliché, isn't it, that a magic trick is a highly rehearsed object? It's the same in music. You have to cheat a bit. It is sleight of hand sometimes. But for the audience – if they're getting the thing that we want – the music isn't stopping the action so that you have to wait for the introduction to finish before you express yourself. We threw all that away. It's one of the reasons I haven't written a straight musical yet. Not that I

don't want to, but I just feel that my tastes in the singing theatre are a bit austere. I'm so keen that the drama doesn't keep stopping for the composer, and you know maybe that's a certain type of musical that's to be written yet.

NB: Would you be able to solve that by actually having a through-written musical?

DM: Well, that's called opera, isn't it, you see? Which is the other thing I have a problem with, because I find those great big fat voices not always truthful. I'm a composer that's so determined that when people sing they're believable that I have a problem in both the musical theatre and the opera house. It's why I've always loved the work that Weil did with Brecht, because it began to say, 'Well, actually there's another way of doing this'. And it's that tradition that I'm influenced by. But it's very hard for that to be a commercial buzz for a producer – a big producer I mean. You could do it in a warehouse somewhere, but on the London stage it's difficult. But our time will come! Or *my* time will anyway!

NB: All the work that you've done at the South Bank, particularly having to turn your hand to so many different styles, and also knowing that the musicians would be found for whichever style you decided to write in, means the world absolutely was and is your oyster. I would have thought that might create problems of its own in that you then have to subject yourself to a fairly rigorous selection process in the way you actually work the music.

DM: I don't know if you are aware of this, but the National Theatre where I worked always had a different policy from the RSC, which had a band that they had to use. Because we were open much later than the RSC in London, we had a situation where we could book players on a one-off for each production, so we were never tied to the same orchestra. We didn't have the inevitable drums and trumpets, etc. It was always very healthy, very much more fun for the composer anyway, to have a completely open palate. One of the things about music at the National is its variety, that we do do Sondheim musicals, but we

also do very weird Greek plays with four drummers in them, and that kind of thing.

NB: And you respond to that totally.

DM: Each play gets what's required of it, and you don't say, 'You can have two trumpets and three drummers.' You say, 'I want five drummers.' Do you see? And with five drummers you can start doing something interesting, because it's a very unusual choice.

Barrington Pheloung

Renowned for his work on TV, particularly the Inspector Morse *series, Barrington Pheloung's career began in the theatre and encompasses ballet, film (including* Truly, Madly, Deeply *and* Nostradamus*) and radio, as well as works for the concert hall. He is a prolific composer and has developed a further career educating music students on writing for the media. Our talk ranged over his working methods, particularly the importance of cue sheets, the use of computers and samples in the development but not the recording of scores, and his hopes for the future of music into the next century.*

Inside the Character

BP: When I talk to a a a choreographer or a film or theatre director about the music they're commissioning, it's a question of pinning them down. First of all there's always a conversation over any one part of the film and the plot. My shorthand is first of all to pin-point, to say, 'Yeah, but is it bright and happy music, or are we trying to bring out the pathos of what's being said?' Once we latch on to that, then I write it in my shorthand, and once it's down I remember. If I write down, 'The Keystone Cops; very funny, crashing sounds', it brings back the complete conversation to me. If the music's dark with a big crescendo on the knife, for instance, then I can say in musical terms, 'Right, well, that's dark, isn't it? And there's the big sting on the knife.' And when they listen to it, it will relate directly to this cue sheet. Of course, if they say, 'Actually I was wrong; we should have played the comedy on it rather than drama,' well, that's fine. It doesn't matter who was wrong; we'll change it. But I'm very lucky really. Probably 99 per cent of the time I never have to change a note. If I do, it's usually tweaking things around, maybe extending a cue a little bit, or emphasising a hit point or a sudden change of mood.

I think the most important part of the craft, especially of scoring for drama, whether it's film, television or even the theatre, is knowing how to under-score. It's not just a question of writing quiet music. Sometimes music can be mixed at quite a high level – a loud level – but you still don't notice it. It's the trick of being able to be sparse enough to allow room for the dialogue, the word, but still convey the emotional content. You see, sometimes in a conversation one character's telling a joke and the other one's actually mortified because someone's just died, and you can pick up either side of the conversation. It's amazing how strongly you can do that. If, for instance, the famous old Morse is having a conversation in a car with one of the characters in a film, the information that character's giving us may be totally irrelevant to the plot or to anything else. What the music is very often trying to do is actually not listen to that conversation at all, but pin-point what our main character, Morse, is thinking about. 'Is she lying, or is? …'

It's very important to get that sparseness and to create the mood. In other words, not too many notes. But most important – and a very technical part of the craft – is knowing exactly which orchestral instruments have the frequencies that will clash most violently with the tessitura of a particular spoken voice. For instance, I've never under-scored John Thaw's dialogue using a bassoon in any part of the texture, because it just happens to match the *tessitura* of his normal speaking voice. It's little things like that that you have to be minutely aware of. The crunch comes in the final dub, where a very important piece of music can be lost altogether because one frequency was clashing with a bit of dialogue, and it's then turned down so much that it does become only nuisance value. It can't insinuate itself enough; it can't make it's point enough. There's no point in having it.

Radio

NB: One of the cues you showed me earlier was for radio. That must have it's own particular problems, doesn't it?

BP: No, actually radio drama's a gas to under-score. I love the art form. I think radio drama's beautiful, because the music is actually painting the picture. The music and the sound-track are telling us where we are, whether it's a sunny day, a bright morning, a dark gloomy night or whatever.

It's not only setting the scene, it's telling a story – telling us that we're moving on in time and place, and it's a wonderful opportunity. In this country, of course, we have the highest possible standard of radio drama and the greatest actors and actresses (that work happily for peanuts, frankly) to do these great programmes – classic plays. Some of the best recorded drama has been for the radio. I still do them and will always to continue to. It's actually greater freedom. But I approach it exactly as if it were a film. As you do when you read a book or listen to a read drama, I imagine the picture and then write to picture, but the picture's in my mind. It's as simple as that. It does allow wonderful scope, because they're depending on me far more than you would think.

Morse

NB: How far do you editorialise when you're actually writing? Take Morse in his car. At what stage do you think, 'I'm more interested in Morse here'? Is there freedom for you to work a cue your way?

BP: I think that's the craft, isn't it? Find out what the director, the writer and the producer want, and give them what they want. Yes, it's dark here, but musically you can put any subtext into that that you want. There's a famous scene where Morse simply walks into the police station one morning, and the cue is, 'Bright and uppish, chirpy.' In fact the agreed subtext of the music is confirming the fact that it may well be that the night before he got his leg over – for the first time in ten years! That was a great little joke for me. As you know, I used to put bits of morse code in, and have little in-jokes. That was purely off my own bat.

NB: The mythology is that you gave away who the villain was by drawing on inferences from the opera that Morse was listening to. Is that true?

BP: Yes, basically I let the audience know in some sort of musical code who the killer is – usually within the first couple of minutes of the film – but I won't say how. It does

involve some morse code. That was an integral part of that series, because I used morse code to spell out Morse's name – which was obvious, but that's how the theme got developed. Throughout the 27–29 films, direct references to the generic *Morse* music always involve some sort of code tapping away. So you feel a sense of well-being. You see the Jag going round the corner, and you feel good because you know he's on the case. He's sorting it. I used directly the harmonies and melodic structure of the main theme, which there have been hundreds of hours of variation on over the years, and within that I used morse code – within the texture of the orchestra. You have to have bloody good ears to decipher it, and, of course, be an expert in the code – and also, usually, be very good at cryptic crosswords. It's not always given away in direct language, but there's usually a clue or two.

NB: In terms of scoring for TV – take a film that you're scoring now – can you take us through the process. You have spotted the film. You've been through and found the cues that you'll be working to. What's the next step?

BP: The spotting, first of all is the most important thing. With most films you're opted onto the creative team after the film's been made. There are exceptions. I got *Truly, Madly, Deeply*, for instance, at the script stage. There was so much music involved in the film that, as musical director as well, I had to be on location for every day of the shoot to be Alan Rickman's left hand. My involvement in that was intensely direct. That's the exception rather than the rule. Normally the film's done, and I get a video of it, or see a special screening of it if it's a feature. At this stage, after having written hundreds of hours of music, believe it or not I can usually hear what I'm going to write while I'm watching the film. Then I go against that. I think, well, if I thought music should be there, why did I think it? But I've got a pretty good idea of what I'm going to do before I even talk to the director.

NB: When you say you go against it, do you go with your second idea as opposed to the first idea?

BP: No, I usually go with the first idea, but I argue to myself, why did I think that would work? Am I just sticking with my own conventions? Maybe having nothing there would be more successful. In well-made films, whole sections are shot purely to give the musical narrative its voice, and of course the film without the music then doesn't work. There are also huge time jumps and editorial cuts in a film, where music's the only way to make that jump – and it can make them seamless. You don't even notice it's another time and place. The music can get you there in seconds.

Cloning

NB: Which is why it seems always odd that the composer tends to be brought in towards the end of the process – because of the number of times it would be great to have the music there in advance. Some directors like to cut to music, but you simply can't do that unless. …

BP: Well, you can, but it's a question of trust. It's actually far more to do with the political structure of a film production team and production schedule. They very often just don't think about the music until after they've got the film, and the music's very often a problem-solver rather than seen as an integral part of the overall effect. Of course that's heart-breaking to us composers. It's actually very annoying, because it wouldn't cost them any more to make a commitment to a composer in the pre-production stage, in which case, as in *Truly, Madly, Deeply*, for no extra charge they've got me as a consultant right the way through the filming. If Maggie's playing the guitar in the background as a busker, then on the spot I can solve the problem of having to synch up to sound after the film. That would be the ideal world. A rather ugly and sad trend is unfortunately starting to creep over here from Hollywood. Because of a lack of confidence by producers, studios and editors – and the crisis for the director

who's doing his first film – they're scared to show the film in its incomplete state to anybody without having cut it to some existing music. You have this awful syndrome in America where every film score is starting to sound like every other film score, because they use music from someone else's film score to cut this film to, and then ask the composer to do a clone of that, because they get so used to it with that music. It's actually destroying an art form in my opinion, and I feel very strongly about it.

NB: It's certainly destroying originality, isn't it?

BP: Well, I won't work that way. If people have to cut to other people's music, I'll say, 'Yes, I'd love to do the film, but I don't want to hear what you cut it to. I don't want to know.' But sometimes when you watch a sequence you can guess exactly what they've cut it to. And I don't mind. I love sharing the score/sound-track with existing classical music. The beauty of *Morse* for instance was that I got to choose most of it and just chose all my favourite bits. I had a field day.

NB: So you're now in front of the picture. You're hearing what you're going to do. At what stage then does that hit the paper, as it were?

BP: I come home with my very badly hand-written cue sheet, with the time code written out down the left column, exactly where the music's going to be. That part's important. It's discussing with the director and saying, 'I think we need something from here to here.' And very often I'll think, well, no, actually you don't. You see, some people really don't have aural imagination, and that doesn't just mean musical. You see sequences which could be far more successful if they were left to just the obvious sound effects – that should be there, but aren't yet. It's a question of where not to put music as much as where to use it.

Taste

NB: I suppose there's no hard and fast rule?

BP: No, but it's an instinct, isn't it? And again, to quote Haydn, the greatest or most important aspect – the craft – of composition is really taste. If someone employs me to write, whether I'm writing a piece of music for their wedding or funeral, they're really employing my taste in choosing and selecting those notes – or in a film score choosing when and when not to do it. Very often I'll say, 'At this point go "Bang! xsh, xsh, xsh,"' and the director will say, 'Well, I think that'll be really corny. That might be the convention, but I think it's better to save the bang till much later and not give it away yet.' What I try to impress on students is to learn that part of the collaborative process and be able to talk. It's not a question of being pushy about it. The first thing you learn in this profession is the fact that it's a self-deprecating one. It's being able to say, 'Well, actually I'm really sorry to differ with you here, but I think I've got better musical taste than you've got, and I think using the Pachelbel Canon in that sequence is really, really fucking corny, and do you realise it's been done 5,000 times before?' 'Oh, really?' It's thrashing that out. It's not always a pleasure to do. Usually, though, it's very straightforward, and, with the hundreds of things I've done, nowadays it's getting easier. It's just a question of getting that adjective, getting the structure. So I bring home my cue sheet, and I give it to my poor assistant, who has to try and decipher my hand-writing and print it up. It's arranged in cue numbers – time code – because we all work to code on videos these days. In the old days they had to work in the studio with a projectionist, the footage, the stripes and all the rest of it, taking timings with stop-watches. There's no question, technological advances have made a big, big difference to that.

NB: One assumes that the budget for music has suffered because it has become cheaper to develop music just from that point of view – the practicalities of time code and computer and so forth – whereas before one would actually have had to work to a moviola.

BP: Again, I perceive it as a tragedy half the time. The music, which in the end I believe makes up at least a third of the final artistic impression and impact of the film – it really can do, a good score – is actually allocated usually less than 1% of the entire budget of the film, and that's usually because it's the last taxi off the rank. In the course of production and early post-production, they've pinched money from their original music budget of course. When they suddenly wonder, 'Where are we going to get that extra 20 ft of track?' – well, you know which budget it comes out of. It's a sad trend. It's something that's so important, because I really do believe that at its very best music in cinema, in good filmed drama, is a genuine 20th century art form. It's an ultimate one in many ways – cinema and music. It's really very, very special to me. I'm a real cinema buff. I love all Tarkovsky's films, and I've seen all the Kurosawa films. It really would be a shame to see that art form lost to cloning. The other worrying trend is this hideous preoccupation with making a sound-track entirely out of old pop records which publishers are keen to give a second life to. And the choice of which tracks are used when, where and why is invariably made by people with no musical taste or care or sense at all. That's a pretty sweeping statement, but, Jesus, it happens a lot.

NB: Is there an element there of producers being scared of original sound-track music?

BP: Yes, because they don't understand it, and because it means that they have to deal with another artist. They've had a bad enough time with the writer already; the last thing they need is what they think is putting up with someone else's artistic ego. Especially in Hollywood, a lot of producers *and* directors are first-time producers and directors. They've got a lot of bucks riding on their big baby. They know that the last such and such movie had Abba in it or whatever, and that was successful, so they might be able to get a bit of money back on the sound-track album.

NB: Also, in directing terms, a lot of people now seem to be keen to put their CD collection onto their sound-track.

BP: That's where the problem is. The director can be some young whizz kid with a very limited knowledge of rock music that might span only the last five or six years, and his CD collection could be really poor to average to piss-poor taste. 'Oh, I love that track man! It's so good, it's gotta go there. It's gonna go so well!' And the fact is, it's crude. You get that interminable thing where there's a young couple driving in a car and they're happy, and they're in love, and there's a bloody song in the background going, 'We're young and happy in our car, boom tshh!' You know, rather sad really.

NB: The cue sheet you have here is very descriptive on each cue. There's a lot of detail.

BP: Yes, because there are very few cues, except a few very little ones, where you're just establishing one mood. You're usually going from one mood to another, or there's one emotion underlying a different emotion. There are two or sometimes twelve different strands. Here's one from a thing I did for *Naked Sport*, which is a wonderful documentary series about sport in America – the corruption. The prologue in one of these films starts, 'sparse, sad and edgy (a comment on the crisis in baseball), combined with a sense of lost innocence – should set the tone for the whole episode.' Now that says it all. This, incidentally, comes from a very, very musically sensitive and aware director, who's actually one of my best friends. He's very seriously aware of the impact of music on his photography and direction. That's why they're really usually quite complex. You very rarely get a single word description. But I think part of the art form is getting these cue lists right. … Here's one, 'Twinkle, the solution.' That's fair enough!

NB: 'Twinkle' is a purely descriptive word, but you can hear it; you can hear it musically, and you know exactly what it's going to say musically.

BP: Usually it's a bright twinkle too. It's like the cartoon convention of the light bulb suddenly appearing over the head – 'Oh, I've got it!' Very often you time those twinkles to go with the wink of an eye, 'Bing!' It makes you much more aware that suddenly this person's bristling. It's amazing how powerful these things can be. You can pick on a completely innocent person walking by in the street and, by putting these little notes of low cellos and bass underneath, make everybody think, 'I bet he's the suspect; I bet he did it.' You can sit with your mates and watch something that you've scored, and you'll see them all bristle. And they're not even really aware that they're hearing the music. It's virtually a subliminal impact in most cases.

NB: When you're hearing the music in your head as you're watching a piece, or starting to work out in your head what you're going to do, do you hear a rhythmic form as well as a tonal form? Because a rhythm will make a massive difference. It can almost upset a scene if it's used in the wrong way.

BP: Yes, that's the very first thing I do. If you're talking about a very short sequence, say a big title sequence that's got big graphics, you're trying to wow the audience into sitting down and watching this doc or film – or indeed, television commercial. That's the same sort of thing; it's grabbing someone in thirty seconds and shaking them by the neck. The rhythm and timing of that are almost more important than the tune in some respects. That's usually the first element I look for. I find myself imagining a pulse and imagining that sub-divided and sub-divided again. That's the first parameter when I sit down, nowadays at the computer – which is the equivalent of a word processor for a playwright. It really does save a lot of dog-work when you can simply cut and paste a whole paragraph and superimpose it onto another one. That's exactly how we compose, isn't it? Then you copy that block, but change it, and then copy that one but develop it further. The first thing I do when I'm setting up for that piece of music is decide on the tempo, and then that rhythmic impetus brings the tune. The classic case in point is the *Inspector Morse* theme, which started its life with Mark Phillips, the studio engineer who I was working with at the time, phoning his mum and asking her to look in his scout book and give us the

morse code for M-O-R-S-E. That code implied a duple time or a triple time – 6/8 or 3/4, depending on how you looked at it. That was the first thing. So I thought, right, 6/8 (or 3/4, I can't remember which, and in fact it's existed in both), and then I just tapped that out on a little E, put that in a cycle and just kept it going. I then imagined the melody against that.

NB: The extraordinary thing is that that little lilting feel actually for me then became Morse. It was sad, but it was almost as if it was his mind that was dancing. I'm probably reading too much into it.

BP: No, and as a matter of fact I can tell you where that came from. The man who wrote the screenplay for the very first *Morse* film was the wonderful playwright, Anthony Minghella, who is now a very well-respected film director as well as writer. He, Ken McBain (who was the first series producer) and myself sat down together and discussed what we thought the content of the main theme should be, because in fact the main theme existed long before I ever saw the films. The brief was very straightforward: it should reflect Morse's absolutely chronic melancholy – so it's got to be sad – and then it had to reflect the fact that he loved classical music, so therefore it should be an orchestral rather than a synthesizer score. It also somehow had to reflect the ticking of his cryptic mind, his lateral thinking. Of course the little in-joke of using morse code for Morse just set the whole ball rolling. But that was the brief, and that set up my bed of nails, from which I wrote a melancholy orchestral score with a little bit of intellectual skulduggery as well.

NB: With the later *Morses* I can't remember you using the lilting rhythm until it came as that final cue, and it always had a feel of, 'That is absolutely it folks,' as he drives away.

BP: That was intentional, and it was also because it's conceived as a main theme, a title sequence, which is traditionally the only time us guys get to have our full say – flat-out, full throttle. Unfortunately and tragically, on television now that's

happening less and less, because they've cut the title sequences allowable down and down. Nowadays they stand at about 35 seconds, whereas the very first title length of *Inspector Morse*'s credits was three minutes, just like a feature film – because they are feature films. They've got a huge crew, a cast, and a creative input that should be credited. Then there's another skill too. The plan in all of those films is never to unleash the theme until the end but always allude to it, always predicate it, always have that sense of pregnancy that eventually is going to be pouring its heart out. In the cinema, I always sit and watch the credits until the curtains close, because it's almost a postscript or the dénouement of the play. It's a time for reflection, and in the case of television, for contemplation of what you've just gone through emotionally – before the Kiticat ads come on and destroy the whole atmosphere. Nowadays they've not only cut the length down, but as soon as the credits roll, the music gets turned down, and some announcer says, 'You may be interested to know that over on BBC 2. ... 'Or they'll plug the book, or the sound-track album.
It's really *tragic*.

Cliff-hangers

NB: Because it's so obviously now part of the business, you must also have had to write hundreds of cliff-hanger pieces to go into the adverts with.

BP: Oh, thousands I would imagine by now. Especially on commercial television, you've got to leave a cliff-hanger ending or the viewers aren't going to come back – or certainly that's the concept in American drama where you've got hundreds of channels to flick across and see if there's something fast and moving on. I try always to relate that cliff-hanger to the main theme or the structure of the piece. The olden-day television convention was what was called a sting: the sting out and the sting in, which would normally be lifted from the title music – just a little 'da da da da, boom-bah!' And then a very loud one in to remind the punters that the adverts were over. There's still an element of that

required, although less and less so as your really sophisticated television dramas are aspiring to be cinema. What happens then is the under-score music will surge, and some sort of melodic fragment relating to the generic music will bring you back in. They're decisions that you make with the director and producer. You always try to get them all together – and the editor – so that you can say, 'Don't do it at the end of this part. We did it at the end of the first part; leave this one just effects, or the water dripping, and then the 'end of part' card is enough. Then maybe next time don't come in with a sting; come hard in with traffic noise.' It's very important not to overkill your own craft – not to let them overdo it. A lot of that stems from insecurity about the next scene – is it strong enough to hold the viewers' attention before we get to the huge climax which is going to really keep them rivetted? Very often a producer's insecurity about an early sequence in a film will lead to an enormous over-commissioning of music, which they think will make the viewer want to stay with the drama more. A lot of the time it's because they don't like the way a director's shot it. The director on the other hand feels mortified, and I have to go in as the *mediator* and say, 'Well, actually I love this scene, but underscore *could* go all through the scene, and I'll try one for you.'

The Technology

NB: With the technology you've got, can you demo what you're saying to them in purely musical terms?

BP: Yes. I'll show you an example – the before and after – where I've written a whole cue, a substantial one, and played it on my samples in the studio to the director and producer long before we recorded it with the musicians, so that if there was any element that they didn't like, I could change it without having to write on the spot in a recording studio in front of the orchestra. That's not only time-consuming and costly but also very embarrassing. It's a question of hammering out of them *what they really want the music to do*. It's hard if there's a creative clash between producer

and director. I sometimes end up being the whipping boy. If the editor's not happy with a scene – he doesn't feel the director gave him enough shots to cover it properly – I have to get in there and be the mediator and say, 'It doesn't matter, I can make it work. You won't notice that the picture's upside down, because you'll be looking at the twinkle in his eyes.' And you can do that. You can be as specific as that. The editor's had to use a reverse shot, and the same picture on the wall's actually back to front. They haven't got any time or money left to do anything about it, but it's a crucial scene. You can draw the eyes away from one part of the screen to another with incredible accuracy. The strength of that subliminal advertising, if you like, means that it's such an important tool that it's not to be taken lightly. It's with a sense of great responsibility that you have to attack these things. Not a lot of people are aware of it at all, but I can make you look at any specific split second in any sequence of film by slightly preceding it with a sudden change in the orchestral texture. It's amazing. Your eyes will go straight to that part of the scene. It really can be that specific. That's why it breaks my heart when I see a really beautifully edited and beautifully made film plastered with wall-to-wall, out of date, naff pop music just to sell a compilation album. I'm not saying it doesn't work; you can do wonderful films that way if they're *conceived* that way, if they're based around a song, with a genuine connection between the script and that song and the rest of the film. But that trend is basically saying the composer is now surplus to requirements, and it gets the young producer off the hook of having to collaborate with somebody. There's an enormous amount of insecurity about that. Very often the opening gambit when you're talking to a new director or producer is, 'Look, I don't know anything about music, but I know what I like.' You'd be amazed! I try to reassure them by saying you don't need 'A' level music to understand and love a Mozart symphony or to appreciate what we can do in the context of film. It's very important to let them know 'Relax, I don't want you to know anything. In fact it's best if you know nothing about music. Just tell me what you want me to do, and I'll try and do it, and

then I'll show you how it can work.' That's my working process. First of all get the cue list out of them – and you need a torture rack to do it sometimes. Then I adhere to that cue list, unless I have an instinctive feeling that that one cue could merge into the next. It's too silly to have a little short one in between, and I will often merge cues as an alternative to what's been asked for. Then, ideally, they come to my studio. Now we have the technology to play the whole film in sequence with all the cues already on and mixed. I usually ask them for no reaction at all until the end of the film, because a lot of directors and producers have a real propensity to over-intellectualise their own work – looking for that hidden agenda, and why I'm saying this and why I'm doing that. It's a strange part of the operation, but when you're playing them a film score, what you're really playing them is a symphony, or a set of symphonic ideas that are joined up, but will only make their final sense at the end of the work. Taken out of context and then analysed and re-analysed and discussed and over-discussed, that first piece of music can be pulled to pieces and the rest of the film destroyed. You can destroy the architecture, the morphology of the music, because it's telling its own story, if you like, as a second narrative.

NB: So this is an architecture derived from a traditional form. It's theme and variations at its most simple.

BP: Very much so, and sometimes it can be directly symphonic. Sometimes you can join up all the cues, edit out the gaps, play the whole 45 or 50 minute piece, and it works as a symphony. In fact at its best it should do. Even the biggest and best John Williams scores (I love the *Jurassic Park* one; it's big and bold and corny, but I think it's beautiful) are really just two opposing ideas, which is what all symphonies are based on. It's two themes: one mixed against another one, and they eventually go together. That's how all those strands should be worked.

Structure

NB: In fact you're saying it's not necessarily driven purely by the narrative requirements of the film. It's actually driven by an internal structure of its own as well.

BP: I've always had the belief with ballet (I've done 52 ballets now) that however closely you work with the visual structures, the stage patterns and the intellectual structure that you've discussed with the choreographer, at the end of the day, mate, if you can't play the score to the ballet and it stands up on its own, either to listen to on a CD or in performance, then it's not doing its job. However incidental or coincidental it is to the action, it should stand on its own as a piece of music. Similarly, with the best ballet scores I've done, the dance itself has stood on its own if you watched it in silence. That's when it's a great challenge. You can see the form, the thinking, the clarity, the drama and the narrative (if it's that sort of work) without any music. Then you put the two things together that are meant to mesh exactly (or at some times work against each other, but at any rate they're conceived together). If both elements stand on their own, you gotta winner, because they make a third product, a third thing, which is for me the seduction, and the reason that I am obsessed with working so much across other media.

NB: What you've just described there is a structure that doesn't need a context.

BP: That's right. Well, I really do believe it. If you can't join all the bits together and play it as a continuous piece of music (within reason) then it hasn't got a voice of its own – it's not really saying anything.

Collaboration

NB: Can we talk a bit more about the collaborative process?

BP: Well, you've gotten through the quagmire of what the director, producer or editor wants. You've solved the problems hopefully and – this is the true art of creative collaboration – are still writing

what you want, writing a piece of music that doesn't compromise your own musical tastes and standards. You write what you want, but make it solve their problem. Then you've got it all with its symphonic unity and its morphological importance. I then play the entire score to, again ideally, the full production team. The director's number one boss as far as I'm concerned, although of course politically that changes very much from film to film, programme to programme. Now you have this hideous thing where the accountants want to get in on it as well, and that can be really bad news. I don't mean that against accountants in general, but I mean in television companies, where somebody's suddenly made king-pin, and they want to have their two bob's worth about the score as well, because they feel they're spending the money.

NB: It does seem also that nobody would tell a camera man exactly what distance he ought to be aiming at, but everybody seems to know something about music.

BP: Everybody knows what they like. Funnily enough, the most common difference of opinion that I've had with producers, directors, accountants and sometimes editors is when there's a beautiful, happy little piece that I've orchestrated in a certain way, which, completely incomprehensibly to me, that person will perceive as too melancholy or sad, purely because of an unconscious connotation that their ear has with, say, a cor anglais or an oboe. That's perceived to them then to be sad music. Sometimes you just have to eat humble pie and say, 'OK, look,' and you play the same line on a flute, and suddenly they think, 'Oh, now that's much more open and happy.'

NB: That's old style film scoring, golden age Hollywood, isn't it? Quite often the sad thing would be given to the oboe, and that now has become part of the national consciousness.

BP: Probably so, but the oboe happens also to be my favourite wind instrument. I've got a passion for it. And this brings us on to the next most important part of the working

process. The oboist that I work with most frequently is Melinda Maxwell, who I think makes the most beautiful sound on that instrument. You see beauty in itself can be sad, but it can also express joy, warmth and happiness. I usually argue the toss, but in extreme cases I'm quite happy to make a change – a little bit of an orchestrational shift doesn't hurt anybody. At that very crucial stage, I've played the whole film to the team on my samplers, which sound exactly as the real orchestra's going to sound (except not as beautiful), so there can be no surprises in the final music recording except happy ones. Then someone will have a question about one cue, but no problems with all the rest, or really love that one, and it's a question of genuine concession, of saying, 'Ok, well, I disagree with you, but I'll make it longer,' or, 'I'll make it more rhythmical,' or, 'I'll make it happier sounding for you' – in other words change the oboe to the flute! It happens so often you wouldn't believe it.

There's one director, Peter Hammond, who's a great mate of mine – he did a couple of the *Morse* films. He's a very established film director, and has done some wonderful films. He just had this thing about the cor anglais. It made him cry. It could be playing the happiest little tune in the world, but it made him cry. He kept saying, 'I can't stand it. Please ...' So it had to go. It got the chop. That's the compromise stage, and it's a question of doing it without agreeing to destroy your own architecture. If the pivotal arch goes, on which the whole music is pinned, it'll all fall down. But sometimes you just have to bite your tongue, and change it in front of their eyes. I normally do it on the spot. I won't let them go out of the room unless they're totally happy with the score – I mean smiling, beamingly happy – because that's so crucial to the next step. If I have to take away my pivotal bridge, I make sure that I build it back in such a way that's it's still carrying out its formal function.

A lot of people use synthesizers exclusively to write music, which I think is a cop out, and I hate it. Ultimately the only reason I write music is for musicians to play it. I'm not really interested in computers playing

it. I only use them as a tool, as a means to an end. I don't get a buzz out of sitting and listening to my own music played on synths, albeit the most sophisticated orchestral sample collection in the world. It's that moment – and that moment to me is sacred – when I pick up the baton and go into the studio. That's the point at which I have to say to the producer or whoever else (and they're all welcome to come) that that's my baby now. You've had your chance; you've had your say. I will re-write the entire score for you at any point, but once those parts are printed out and edited, and its all exactly in place (and of course the advantage of using the computer is that all the parts are correct, because they come off the master score, and you make sure they're in the right transposition – if there's ever any doubt you do an A version and a B flat version, or whatever), then they're welcome to watch and participate right through the recording session, but they're not allowed to say a bloody word! That's the point where it's too late.

Of course, if someone says, 'That was great, but can you put another "boom" in?' Ok, so I'll go 'boom'. 'You play another B flat there please, double basses,' or whatever. Sure, within reason. But from that point it's my score. It's finished. And then I have the most fun. I get together my most revered and respected colleagues from the London classical musical world – or indeed jazz players (I've worked with some of the finest jazz players in the world), or blues, or country players, or ethnic musicians – but generally speaking they tend to be the finest chamber music and orchestral players. That's the buzz. That's the reason I do it. Them getting up and rewarding me and my hard work by playing like angels, that's when the magic happens for me. That process is the joyous one. It's also the fastest part of it. With some of these players I can record a whole film score in two sessions or less.

NB: Which is six hours.

BP: Yes, and I've been known to do one in less than four. That's not because we're trying to scrimp and save on budget, because they still get paid for the right amount of music,

but they play so bloody well. If it's perfect in the first take, why make them do it again? And only my ears can be the final arbiter on that. No producer, no one sitting up there in the box can say, 'I don't think that was well played enough.' I know when it was well played enough, because I'm there. It's great. We have a wonderful mutual respect that I've built up over years, since being a music student at the Royal College of Music in the early 1970s. I met a lot of these people, and we all went to college, at roughly the same time. Now they're all at the very top of their profession and constitute some of the leading soloists, let alone string quartet members or leaders of world-famous orchestras. So with these session musicians, it is a super session. It is an orchestra that's made up from the very *crème de la crème* – quite often players who are too good to want to be rank and file players in a conventional orchestra, but supplement their solo careers by doing sessions.

Then a very critical part of the process comes: mixing to picture. It's recreating the rough mix that I got on my demo, being fully aware of vocal and sound effect frequencies. That's the tricky bit, because you very rarely get the full sound effects track. That's usually being made concurrently, so it doesn't all appear together until the final dub. It's a question of building up a good relationship with your sound editor or film editor, and saying, 'What are you going to lay there? Well, if all you're going to hear is gravel, then I won't bother writing music for that bit.' That's virtually like white noise – pink noise rather. It's going to get in the way of everything, so I won't bother. I don't mean that like a spoilt child; I mean there's really no point, because you know it will get lost. If it's for film, I mix to picture, with all the existing sound effects and picture up, after we've got the music working with its own integrity. We mix it at a very, very low level. If it's for television or cinema, I mix with very small speakers, because usually television speakers aren't very sophisticated – they're far more so nowadays than they were ten years ago, but they're not great. You don't pick up the bass frequencies so well. I bear that in mind.

NB: Do you have to have a middle range mix?

BP: No, you tend to exaggerate things. You turn the double bass up, for instance, louder than you would for a CD recording, because if in that cue the double bass is implying a sense of portent or doom, and is therefore at a low level, you won't hear it, because the very low frequencies are the first to go. Next are the very, very high ones. That's probably, technically, where my skill as a trained musician (in other words my ears) is almost the most important part of getting it right. I've got to make sure that all the music that I mix is still going to be there when it's heard against dialogue or sound effects, because the dreaded *sound editor* and the dreaded *dubbing mixer* then come into play. These days of course it's a far more sophisticated procedure than it was even ten years ago – when you mixed a feature film, and the sound-track, however beautifully recorded in living digital stereo, would then be transferred to magnetic film stock. Before the days of Dolby NR that would be the equivalent of a very poor audio cassette recording with all its compression and hiss – which breaks your heart when you've delivered a beautiful stereo or surround sound-track. Then, because of an ancient, and once upon a time unbreakable, chain of contact between the dubbing mixer and the sound editor (who has worked so hard on his footsteps, effects and the dialogue), the music would very often be seen as the weakest partner. If anything had to go, *it* would. And I don't mean just go down. Some of the old fellas really had cloth ears, because they used *huge* listening levels to impress the clients – to show them how good their sound effects track was. At such a loud level of course they couldn't really hear all the frequencies, and in the process of working like that every day, they would invariably lose the top 30 per cent of their hearing. I'm fully aware of that, which is why I work to quite low levels all the time. That part used to be devastating. 'Well, you see, it's conflicting with the dialogue. It's going to have to go. We didn't have this trouble when we did *Lawrence of Arabia*.' And then it gets the chop. A beautiful piece of crafted music that everybody loved when we were recording it, suddenly gets

the chop at this last, very crucial stage. It's important then for either me or a representative to be there in person. But then again, that depends on who's dubbing the picture, Nowadays you get to know all the top ones, and they dub from hard disk mainly. Techniques are much more sophisticated, so there's no generation loss in your sound. In the first feature film I did, I think the generation loss was multiplied by five by the time you got to the cinema, and you thought, well, why bother? It's such dreadful reproduction.

NB: With digital sound now as well, I know the balance is much much better.

BP: Technically speaking, if I've mixed my music track properly to picture, there's no reason why a sound engineer needs to touch the faders at all. It should just come in and go out and be at the right level. They maybe need to shift the overall level here and there, or maybe even boost it if they think it will help some dramatic effect. But all of that has been taken into account at the orchestration stage, when I was thinking, yeah, I'll double the cor anglais with the violas, and when the guy starts talking I'll take the band down until the music's meant to surge. So theoretically they shouldn't have to touch the fader at all. In the old days that was one of the bits where presumably they'd be showing off their craft – 'Ooh, yeah, that's very difficult. Could we have some quiet there please.' Most of it was complete pose. You shouldn't have to touch it. That is something that I try to bring home to young colleagues who ask me for practical advice. It's the ability to pick those frequencies that won't (a) get in the way of the dialogue and (b) the effects, because at the end of the day if they have to turn the music down to a very low level, it can't be heard. There's a level at which music becomes only a nuisance factor. The listener or the viewer gets pissed off, because they can't really hear what it's doing. That final stage is so important to fight for. You have to be vociferous enough to say, 'No, you're wrong'. I can't always do it, and I can't always be there. It's a very time-consuming process, but, as I say, these days if the engineer's a good one and the

equipment's the top stuff, it's not necessary. Usually I'm very pleased with the results.

To context or not to context

NB: The restrictions placed on you when you're working to picture, or working to any context, seem so multi-layered that I can only assume that when you are out of a context it must be the most freeing process imaginable. Is it, or is it in fact just a different process?

BP: It is freeing, but if I'm commissioned to write a concert piece, and I can do whatever I want, the first thing I do, ironically, is set myself restrictions. I say, well, I'll aim to write a piece that's x minutes long, but I won't use this instrument, and I'll. … What I'm doing in my concert music is exploring and continuing to get into my own language, which is essentially tonal – what we're supposed to call 'new tonality'. It's getting back not just to diatonic music but modality as well, with a new music language, with harmonies that are very much of today, and trying to write music that people can understand. When you're writing for film or TV, that's almost a pre-requisite, though it doesn't mean you can't use squeaky gate12-tone techniques to underpin a dead body. It doesn't mean it's not part of the palette any more. What's happened in the last few years would be unthinkable when I was at college – that ordinary people, are buying contemporary composers' serious art music, and it's hitting the top of the charts. That was a pipe dream when I was at college. There's no reason to assume that my cello concerto, when it's released, may not do the same thing. It could happen!

NB: Accessibility is a vexed question. In terms of when you're writing – and I'm thinking now not of writing to context so much. but when you're writing for yourself, for your own work – how far is there a mythical listener in your head at the other end of that process?

BP: That is a very good question. I think the honest answer is that the mythical listener is me. I have a responsibility only to write music that I want to listen to. Now that goes against Boulez's thesis in *Pensées sur la Musique d'aujourd'hui,* which is, how can the ear be the final arbiter unless you have an extraordinary ear? Of course he had the most extraordinary ear. It's a shame he wrote so much music that is so bloody awful to listen to. I don't mean that as a dig; I really mean it passionately. Yes, I'm going to write music that I would like to hear. If I don't want to hear it, then why should anyone else want to hear it? I can write slide-rule music as well as anyone. I've had to do it, and I've studied integral serialism very seriously and had my matrices and all the rest of it, but at the end of the day it didn't sound good. It sounded awful. No one wanted to play it. I have a genuine hope for the new millennium that new serious art music will be something that people will be able to love again, which is something that hasn't really happened since the First World War – in general. Inaccessible music has been the nemesis of the 20th century. That's really what all our art has been about, and I think there's a growing trend now to rebel against all that. So rather than being seen as reactionary, I believe that's the new avant garde. I'm not harking forward to some sort of new English pastoral school, nor am I saying that all new music has to be tonal – a lot of my new music, my concert music, has systemic elements – but I don't think you have to justify modality or tonality by using minimalist techniques any more. You don't have to. If the music sounds how you want it to sound, then ultimately that's what you've got to say. We've got a responsibility towards our own ears and our own emotions, and most importantly all creative art, to me, has a responsibility to beauty. There you are. Sounds like a bloody soap box!

Stephen Warbeck

Stephen Warbeck began composing for theatre and has since received enormous acclaim for his work with Stephen Daldrey's An Inspector Calls (which has won international awards), and plays at the Royal Court and Royal National Theatre. He is also the composer of the Prime Suspect series on TV, and his work embraces feature films (including recent hit Mrs Brown) and radio as well as cabaret music. Our talk concentrated on his working methods, his interest in the live quality of music in the theatre and his desire for experiment and innovation within the more commercial media.

The Timetable

NB: Can we start off by talking about the way that you work with a director in the theatre. Can you go through the time-table once you know that you're doing the music for a particular show?

SW: It varies a lot. The few recent things I've done have been a bit exceptional in that it seems as though there's getting less and less music in them. This week *Rat in the Skull* opens at the Duke of York's. I've only been to the rehearsal room three times, and there's very little music in it. There's just a bit at the end which is used as the beautiful landscape that's described in the stage directions. They're not having a beautiful landscape, so the music has to be the beautiful landscape. So the pattern at the moment isn't one that I'd think of as typical. Normally speaking, you get a phone call, and you get a script. If it's a new play or something you don't know, you read the script. Then you agree in principle that you are interested in being involved. You then usually discover there isn't a bunch of friendly musicians, and you end up thinking, here we go again – we're going to have to put it on tape. I don't want to be negative about it, but I am getting less interested in music on tape. *Inspector Calls*, as you probably know, has had a very long life. At the Olivier, at the National Theatre, it had four musicians playing live, and they were wonderful. Obviously, they bend to the action, and what they do is affected by and affects the other performers – the actors. When it went into the West End, through some dealings with the

Musicians' Union and the producers, they managed to say, 'We're going to do this all taped.' I find it hard to summon up the same enthusiasm for that piece of work now. Because it's fixed, the only thing that can happen is an actor can speak before he was supposed to, and the cue gets faded out early, or the fade is in a different position, so it's a bit louder. But the whole organic relationship between the music and the action seems greatly diminished. The producer who took it to New York, Noel Pearson, had seen it at the National and, very unusually for commercial theatre, said, 'We have to have live music – I've seen it with the live music; live music is an integral part of this play.' So we took it to New York and we had four New York musicians. Once again I was working on a play with live music, and I just woke up again. I think the theatre does. And I sense that the other people involved in the production – director, designer, lighting and the people on stage – respond in a totally different way. They're not arguing about levels, which is the main conversation when something's recorded; they're actually arguing about the emotion, or counterpoint, or the function of the music and what it's doing in relation to what they're doing. You feel as if you're a valuable, adaptable part of the whole process, the whole theatre piece – that you can change it. And after a preview somebody says, 'What about if we put some music here?' Or, 'Don't do that; that music's irritating, isn't it?' 'Yes,' I say, 'Let's get rid of that. But what about if we did this?' You can do another thing the next night. You can say to the trumpet player, 'Take your mute out.' And as we said to both live trumpet players in *An Inspector Calls*, 'Stand up at this point; take your mute out, point your bell out towards the audience *and play out*'. It's fantastic. Somebody's actually playing for you in the same room. My work seems to be more often requiring recorded music, but with live music, as in *Inspector Calls* or *Machinale*, I would be in rehearsal as much as I possibly could. That would typically be a full day and about three mornings a week – so quite a lot of the time. Often I'll just be sitting there, and then talking to the director at lunch time or having bits of

conversation here and there, rather than any major, long formal chat – putting it together bit by bit. In *Machinale*, for example, which had a lot of semi-industrial percussion, we got together a lot of oil-drums and bits and pieces in the rehearsal room, and in a fairly inexpert way I would accompany the action on oil-drums or piano, so that the thing was built up in the room. With *An Inspector Calls*, which is a more conventional score in that it's four musicians playing their instruments, it wasn't possible for me to watch, see the moments of music, imagine what I was going to do, and write the score literally in the rehearsal room. I've never written a score for theatre before the rehearsals have started. Maybe there are conditions where one would have to do that – a very short rehearsal period. The only exception is if I've written something with songs. If it's been a piece of musical theatre with some of it sung, yes, I have prepared stuff in advance, inevitably. But if it's incidental underscoring and not vocal, I find it much better to put that in as you go, because you find what you need to serve the particular project as it's going along.

NB: I assume even when you've written something in advance, that will probably change in some way.

SW: Oh yes, I think so. Maybe, again, songs would alter less than most things, although, obviously, depending on the interpretation, they may alter a bit. It's a long time since I've written any for theatre. There are scraps of songs quite often that people sing as the character, but a piece of song sung for the audience in the Brechtian sense or in the sense of a musical – I think it's a few years since I've done that.

Collaboration

NB: You've worked a lot with Stephen Daldry. Do you find that that relationship, the composer-director relationship, has become easier as you've gone on? Do you have a kind of shorthand now that you use to talk to each other, or does it still require the same input from you both that it did when you first worked together?

SW: Both things, I think. When we first worked together on a version of *The Canterbury Tales* at the Crucible Theatre in Sheffield, we hardly talked about the music. We were just together in rehearsals, and I tried bits out and put bits in, and we either agreed that they worked, or agreed they didn't, or disagreed. That process carries on. When we were talking about *Rat in the Skull* the other day, he said, 'Do what you like; put in as much as you like.' Now I actually know, or I think I know, that it shouldn't have very much music, and I think he probably knows that, but at this stage he's prepared to say, 'Let's try all that,' knowing that we could very likely drop a good bit of it later on. I'm not sure if our relationship's changed, except because of the last three things I've done with him – *The Kitchen*, *The Editing Process* and *Rat in the Skull* – all having been recorded music. It has changed in that sense. It's not not-as-close because we don't want to collaborate on things any more; it's just not as close because those projects have less use for music, and it's been recorded. I always say to him when we work together, 'Don't forget about live music.' And he always says, 'Don't be stupid, how could I ever forget live music?' I say, 'You know that theatre's only really exciting when it's got live music.' And he says, 'Of course. You're talking to the wrong person. I know that; you don't have to convince me of it.' I'm quite desperate to do some more theatre involving live music, because it's a good balance to the other work I do (which is all recorded), and because, as I said earlier, it remains alive during the production. It doesn't shrivel up and become a dried-up thing which remains the same for every performance. Working with a sound designer like Paul Arditti, who's the sound person at the Royal Court, is fantastic. You suddenly have a huge scope opened up to you with recorded music, because he's such an ingenious designer. So I don't want to be entirely negative about recorded sound. You can make a wonderful impression, a wonderful effect on the piece.

NB: His job then is to put together music and sound effects, and then to organise how these are reproduced in the theatre.

SW: Yes, that's it. I think one of the best things that's come out of recent collaborations with Stephen Daldry, is how enjoyable and satisfying my collaboration with Paul Arditti's been. We definitely both interfere in each other's domains. I'm not very technically literate, but I have a reasonable grasp of what he's doing, how he's routing sounds to different places, how the sequence works on the computer, and that it's good that we now have complete digital recording and reproduction so it's never going to tape any more. I can hear the difference, but obviously that's his area of expertise. He'll have quite a lot to say about what the music's doing. It may be that I gather together some concrete sounds, we sample them, and together we put them into a sequence. So it's working in a way which is newish for me, and quite interesting. There is definitely an exciting side to it. With *Rat in the Skull* there is a kind of cinematic score at the end. Now to me that doesn't mean volume; it means a kind of breadth of sound, which Paul Arditti will enable us to achieve. If I'd struggled and said to Stephen Daldry, 'Let's have two musicians live', I don't think we could have achieved what we can achieve with this recorded sound-track, because two musicians aren't big enough for this particular job.

Film and TV

NB: In theatre, then, there is this wonderful potential for the music to be part of an organic process. When we come to scoring film or TV, obviously it's one hit and it's the end. What's the process involved in scoring under those circumstances?

SW: Scoring for film or television, as you say, is a very final thing. Sometimes there's some music pre-recorded for actors to do things to – to move to, to sing to, or whatever. But generally speaking the music's recorded in post-production. Cynically, that means often the film will be over budget and the music budget will be a bit squeezed. So your bit of the budget's quite small. You also have to work fairly fast. You can't really write any music until the picture's locked –

when they've actually cut the film and decided this is the way it's going to be now.

NB: The final cut?

SW: It's got to be the final cut. You can watch rough cuts, and you can start developing your themes and thinking about how you're going to approach the whole thing. You're often approached coming up to post-production. Your really intensive work period is between the final cut and the music recording, with then the possibility of involvement again at the dub, although that's more often arguments about the level of the music – which I suppose is creative. You get the final cut, and then the director and you (with possibly the editor, and hopefully not the producer, but sometimes the producer as well) get together and discuss what they call 'spotting' the film – discussing where the music's going and what it's doing. You also start your discussions about how you're going to do it and what instrumentation you're going to use. That's almost the most exciting thing for me.

NB: Do you have a say in the spotting process?

SW: Yes, you do, and that will vary from director to director. Increasingly (and I don't know if it's because I'm getting more aware of where I think music's a good idea as opposed to not) I'm finding that I would like cues where somebody else hasn't seen them. I sometimes suggest not having a cue where they think there might be one. Having said that, it's usually the case that the director and editor in the cutting room have gone through it and thought, 'We'll have music here', usually for the right reasons, and usually once or twice in the film because there's a sequence which doesn't work very well. You're being asked to help out with that sequence – which is fine, why not? You can help with moving things along or explaining something.

Finding the right palette of musicians is the most exciting bit, because you know that if you don't choose the right instruments, you won't get inspired when you're looking at the pictures. For example, the last thing I recorded yesterday, was a film called

Nervous Energy, directed by Jean Stewart. I listened to a Lou Reed album about the death of two close friends – which is actually a very beautiful and very optimistic thing. What I suddenly realised was how simple it was, how simple the instrumentation was, and I thought, this film wants something very simple. It's a film about two lovers, two men. One of them is ill with AIDS. It is bleak in one way, but it's quite optimistic, because it's sometimes lighthearted about their relationship. So it does have the gamut of emotions. It isn't gloomy all the way, by any means. Looking at it, what I felt I'd naturally jump into would be solo cello or strings, and some quite beautiful 20th century, slightly dissonant string thing. The characters like opera, so also maybe you think about that. Then I thought, no, let's start with an electric guitar. So we got an electric guitar, a wonderful saxophone, fretless bass and double bass, and a wonderful percussionist. All really good musicians whom I admire, and who bring a huge amount to work when they record it.

NB: Why did you use the two bass players?

SW: Because I used the fretless as a solo instrument in the alto or tenor range. So pizzicato bass. I suppose it's a rock/jazz feel vaguely, but long slow tempo, slow pulse, and a very, very warm sustained fretless thing. The melody is shared between the electric guitar, and sometimes the fretless, sometimes the saxophone. I've got very fond of the idea of several bass instruments. The thing I did before had fretless bass, double bass and bass clarinet. You get a great richness in that area. Also, in terms of under-scoring, you are working in an area which doesn't interfere with the frequencies of the voice, so you can put those things under dialogue perhaps more easily than a piano, an acoustic guitar or fiddles.

NB: Dialogue points are something that comes up in the spotting process. Are they something you have to think of that early on in the process?

SW: Yes, when you're looking through. This thing we did yesterday, *Nervous Energy*, was very good, because the characters had flash-backs to a point where the one who's ill wasn't ill, so there were memories of a good time in the past. They didn't talk in their flash-backs, except one, and that's bliss, because the music has a very specific function. You're saying, let's help make this a wonderful moment. You can connect to that; you can connect to the pain of the characters, and you've got an emotional link – your way in is very clear. I then find it very easy to start having ideas. Occasionally you are asked to work round dialogue. I used to think, oh how annoying! But what I've now realised is that, if you do work around dialogue but without seeming to, it means the music will be dubbed a little higher. You have a little musical phrase, and then a character says, 'I never thought you'd deal with that,' and then another musical phrase. That doesn't mean that the under-belly of the music's still running all the way through, but that you phrase it. So it shouldn't feel self-conscious. It should feel as if it's happened musically, and it just happens that the line's between. Another way of thinking of it is like a song. In some under-scoring you'd say, right, the character is singing. Obviously s/he's not; s/he's talking, but you'd say, how will I accompany that character? Then at the end of a verse you can have a little bit of instrumental. You can work round the dialogue in that way.

Music versus Effects

NB: And the times when you have a dialogue-less section, are the the points at which you throw the music into its full potential – all out.

SW: Yes. What was lovely about yesterday when we were recording the music, was that the editor and director were absolutely determined to keep the sound effects (which are dubbed on at the same time as the music, or put together at the final mix of the film) down to a minimum. They wanted to have very specific occasional effects, rather than these wall-to-wall effects that we have on British television – where they're frightened to have just voices or silence or just music. So I'm hoping this

will work well. Those dialogue-less bits are when you can really fly. I don't want to be negative about it, because I don't feel negative generally, but it is true that often you arrive at the dub with the score. You've been thrilled by the score and so has the director and, you've had a wonderful time. You've loved the film. But somebody else has also loved the film and provided an alternative sound-track – which is, wind in tree, man slipping on gravel, motor-bike approach, car pass, ambulance siren. It's all fantastic, but it's all operating on the same frequencies as your music, and you end up having a battle. To be honest it's very often worth dropping the cue. I'd rather not have the music cue than have it just poking it's head out just above the surface. Either you have it or you don't have it.

NB: Who will make the final decision on how all that's balanced?

SW: The director. Most directors will fight very hard to get the balance right. After a struggle, if the music cue is justified, which it isn't always – sometimes you've spotted, written and recorded unnecessary cues – but if the cue is justified, there's an emotional or narrative need for it, then you'll usually sort something out. Having said that, if it's a film that's going to end up on television, when you then come to see it on a domestic television set, and you've been dubbing in something the size of this room (which is the National Film Theatre small cinema), it bears no relation. Which brings me to another point. I do love doing television, but really I prefer something on a bigger scale. Not because I think film's more important than television. I think television's hugely important and does things that film can't do, but I think in terms of music, having a big canvas and being able to make a big broad picture and work alongside the dialogue and the images, film is a better medium for a composer. It certainly feels like that to me.

NB: Do directors differentiate between the fantasy element of adding music to a scene and the naturalism of sound effects? Is it down to a director whether or not he sees something in its most lyrical terms (in other words as a musical piece), or

naturalistically – as if it's a slice of life in a film?

SW: There isn't a theoretical position taken on it. The sound people come, they're given the film, and they're doing the track laying while the director's doing something else, so if they see a helicopter they lay the sound of a helicopter, and if they see a car they lay the sound of a car. Because of the time scale, the budgets and the way post-production's set up, I often think there isn't an overall view which says, 'When there's music, let it be just the music', or, 'When there are effects, let's just have the one motor-cycle and not the rain, even though we can see it's raining.' The one bird and not the whole sky-line, as it were. I think in British television dubbing and post-production, we don't make those broad brush-stroke decisions. Everything's there ready for you, and what we tend to have is a bit of everything. So if you watch *Morse* or *Prime Suspect*, you've got everything generally. You've got the real stuff and you've got the music. I've watched films where very bold decisions are taken, and all you see are the characters, the music and the image. Suddenly you're taken into an emotional or inner world which is not to do with the real world, but is to do with a character's experience, or memory of another character. It intensifies things. Obviously, from a very biased position as a composer, I think that we can explore that more and be bolder. I'd like to be bolder with music. I think a lot of us play safe and hire a lot of very wonderful string players. I love writing for strings, and if you have slow moving strings, you almost can't go wrong. You have a texture which, immediately people see it, they think, 'Good quality music, well played, well recorded, nice amount of reverb; there's a budget here; this is good; this is lovely television film; it's moving, it's English; there are some leaves blowing on the trees.' And actually what are the scores that stand out in people's memory? *Paris Texas*, to give a very clichéd example. There are hardly any instruments in that.
Or Morricone: slowed-down mouth organ or vibra-slap. I saw a wonderful Dutch film called *The Northerners*. There's a whole sequence where you've just got single tenor

banjo playing, 'Dang … dang … dang. …' That's wonderful. I just want to be bolder and say, right, I'm just going to have a mouth-organ on this film. And maybe you sink. Maybe suddenly they say, 'Oh, you've got to do this bit which is a panic, because the dam's breaking and the river's flowing down,' and you realise you've only booked a harmonica player. You think, 'Aahsh! I wish I'd booked strings and orchestral percussion, but never mind!' And you say, 'Well, perhaps you should do it with the effects!' Maybe if we as composers were even bolder, if we used more vivid things. … Our strings maybe fit in too well with the effects, that's the trouble. You've got lovely rain on English window and strings, and everyone thinks that's great. A couple of linen suits and you're laughing.

NB: It is very much to do with what people assume film music is, isn't it? In commercial, mainstream, Hollywood films these days, it seems that in order to maintain the fantasy element in the film, the music is wall-to-wall, full orchestra, and it seems to be going at an incredible rate almost all the time. Is there a move towards this in television as well?

SW: Not in my experience, but I don't know about television the other side of the Atlantic. I certainly know that even people who say, 'Let's make this film a big success and maybe it'll be another *Four Weddings and a Funeral*, this side of the Atlantic still shy away from using a great deal of music. There's a kind of innate restraint in what we do with music, and I certainly have that myself. Whether to say I 'suffer from' that I don't know. I find it difficult to write things in major keys with no dissonance that resolve at the end, because I like to leave questions unanswered. I don't know why that is, but it seems to me that that is a bit true of stuff that we make over here. I don't know if it's too precious to say that we can't say the world is that all right, that we know it isn't all right. It's almost like, 'Sorry, I can't make it that. No, I can't do that. I can't end on that chord. I can't say it's all fine.' I think that, maybe because the North Americans live so far away from other people, they sometimes can believe it's fine, at least for the duration of the film.

I'm not suggesting they're so stupid as not to know that it isn't really, that the world's really in a downward spiral and things are going from bad to worse. I'm sure they realise that too, but their music doesn't seem to reflect that.

NB: No, I don't think their TV or film does either. I think it creates a fantasy world in which things do work out all right and there is a natural system of justice. I'm pleased you say that that isn't the case to the same extent here, because I'd have thought one of the reasons why British TV is still very popular around the world is that it doesn't automatically fall into a kind of immature view of how things are. It seems to have much more of a subtlety about it.

SW: Yes, yes, I think it probably does.

Ilona Seckacz

Ilona Sekacz

Ilona Sekacz is renowned for her work with the RSC, and in theatre, TV and radio. She has a distinctive, risk-taking style which embraces exciting instrumental colouring, particularly in her work with percussion.

NB: Can you tell me about your working methods within the theatre?

IS: I like to be included at the earliest stages of any meetings about the play, particularly with the designer. Directors rely heavily on designers for the creation of a framework for the production, and I often find that because designers work in a very graphic way, they are more able to communicate what the production should look like than the director. A director can have difficulty sticking his neck out and opting for a specific period for a Shakespeare play, but the designer has to know what the set and costumes will look like early on, because he has a limited time for set construction, etc. If I can be at these early meetings, I can follow (and contribute to) the process of evolving an over-all style. This is preferable to having a concept presented without understanding how it came about.

I like to see the actors at the read-through and hear anyone who has a song so I can write for their voice in particular. I like a one-to-one meeting with the director for marking up the script. This will inevitably change during the rehearsals, but it is good to get an idea of how much music is involved. Pacing the writing during a six-week rehearsal period is important, particularly if you have other jobs in hand. I like to attend some rehearsals where the music will play an important part in creating the mood of the scene, or where music is going to underscore dialogue. The earlier that actors can have their underscores, the more they can find out how to use the music to best advantage. I have to say that actors do not generally like being underscored in the theatre. In television they can't do anything about it once they're on film or tape, but in the theatre there is a lot of resistance to music under text. I have had some wonderful experiences when actors (like Gerard Murphy in *The Thebans*) really used the music and worked with it, but he's the exception not the rule. If I have not been able to attend the early meetings with the designer, or if ideas are coming too slowly from the director, I sit in on rehearsals to hear what he is saying to the actors – just to get a crumb of a clue to what the production is about. This can be tedious and boring in the extreme. I used to like watching rehearsals, but now I think life is too short to watch people struggle to find a performance. Having said that, I probably attend more rehearsals per production than most other composers. I couldn't just turn up in the final week with the score. That would be unfair on everyone.

I tend to write my way straight through the score in one continuous stream from beginning to end. It may take a week to sketch and a week to score. I make any adjustments after I've played the music to the director between the sketch and scoring stage. Then the music goes to the copyist, and in the penultimate week we have 'band calls,' when the musicians play it through. Technicals in the theatre can be exciting or tedious for composers, depending on how much music there is. In productions like *The Thebans* or *Beggars' Opera*, I had a huge contribution to make, and the technical week flew by. But I have done shows with eight minutes of music in a two-hour show, and life seems to stop dead.

NB: What is your ideal working practice?

IS: Of course the 'ideal' working practice varies according to the type of music too. I like to mess about with tape and sound effects quite a bit, and that involves working closely with a sound designer, as I did on *Lord of the Flies*. I enjoy collaborating. In other productions I have worked more closely with the music staff, who have helped to make instruments or provide 'sound making' devices such as the automatic pianola which played at the end of *Troilus and Cressida* at the RSC in 1985. It had to be constructed to play 'invisibly', and it also had to play the main theme from the production, so the piano roll was hand cut. For this one cue, a huge amount

of time and effort was expended, but it was worth it.

Working for film and television is vastly different from working for the theatre. And there is also a vast difference between writing for film and for television. Briefly, music for film and TV is saved until the last thing before the dub. That means everything is complete except the sound-track. Therefore I never meet the designer or the actors. The people I associate with, besides the director, are the picture editor and the sound editor. I am sent a video of the rough cut or the fine cut, and then I meet the director to spot the music cues. I sketch it, score it and go into the studio, where I conduct the music to picture with session musicians whose special skills are their sight reading, accuracy, competency. Once the music is recorded, I will check how it is laid to picture and attend the dub if possible, but the working time scale is much shorter than for theatre. I have just written the music for the BBC's *Henry IV*, and the total job (45 minutes of music composed, orchestrated and recorded) was completed in two and a half weeks. Whether the work is rewarding depends not on the medium but on a) whether the script is good, b) whether the director is good, and c) whether I feel I have something original to contribute.

NB: How far are you drawing on previous musical traditions?

IS: All music written to theatre, TV and film briefs draws on previous musical traditions. Composers in this area get one shot only at being effective, and so we look for the most precise way of 'saying' musically what is needed. Therefore a media composer has to be familiar with a huge range of musical styles. S/he has to be able to conjure up a flavour of an era or a location or a sense of the weather in five seconds, and by reference to those sounds with which an audience is already familiar you can short-cut your line of communication. I personally am very aware of the audience. They trust you enough to pay to see your work, so you owe it to them. To be quite honest, I hardly ever go to the theatre these days, so I don't have an opinion about music being written for the theatre. I do, however, love the cinema, and I believe that some of the best music this century has been written for films. It is music that really communicates. It evokes all sorts of feelings, and I think good film composition is one of the great arts. Music for television is a very poor relation. There is so much material being produced on small budgets that music in this area has suffered recently. It is sad to see the small orchestra being replaced by the solo synth – often badly written for and badly recorded. Music is not seen as an integral part of a TV production as it is in a film. It is often an after-thought, added on if there is anything left in the kitty to pay for it. And it is true that music can be very costly. Having said this, I think there are some very good composers working in television, but there are more bad ones.

Martin Duncan

Martin Duncan is a distinguished theatre director who in the last five years has moved into the international opera field, directing for major opera companies in Europe and further abroad. He is one of a new generation of theatre directors who have been responsible for revitalising the theatrical nature of grand opera, bringing to it a uniquely dramatic vision. He is himself a composer and is currently Artistic Director of the Nottingham Playhouse. I spoke to him whilst he was in preparation for a new devised show based on The Cabinet of Doctor Caligari.

Directing Opera

NB: When you are directing opera from the repertoire, is it a process that you think of in terms of how do I present this to a modern audience, or how do I present this to myself?

MD: I think, what would I like to see? What would be diverting to watch and, for me, still true to the story and the essence of the piece. That's what I've always done. Of course, certain music suggests certain things to you. You come to a very well-known opera with a fresh eye. Some of them I do know, some of them I don't. It's a matter of treating it like any text – but with music you listen and see what it suggests to you. I remember when I first listened to *The Thieving Magpie*, when I was asked to do that. I only ever knew the overture. It's difficult, because Rossini (and this is not a criticism) is pretty samey. He writes the same sort of dynamic music whether people are happy, sad, distraught, having a nervous breakdown or joyous. Sometimes it's a bit more dramatic, but often it's in a major key. That's pretty hard. You think, 'Umh, how do we do this?' Dramatically he hasn't really helped it. I do find that with a lot of composers. They weren't really dramatists. They haven't really helped you put this on stage. They've done a fabulous soundscape, it's gorgeous to listen to, but how do you make it work on stage? There are technical bits of action which they obviously haven't thought about. How does someone say this and do that and then appear here, or get up to that level? Silly technical things. But some composers are fantastically well organised.

The first opera I ever did was a double bill. On it was Ravel's *L'Heure Espagnole*, which has a man in it who gets into a clock, and half a bar later the clock is carried off on someone's shoulder. You thought, well, in the original production he cannot have been in the clock. He must have escaped out of the clock through a false panel. How was there time to do this? The composer left no time. The other part of the double bill was Puccini's *Gianni Schicchi*, and it was fantastically accurate. There was exactly enough time to look for the will, to do all the searching around and put the body in the cupboard. It was all there, mapped out. You could tell that Puccini knew what he was doing, whereas Ravel could have worked with a director on the score, and the director might have said, 'I think you may need a few more bars here.' It's really bloody difficult, because in opera everything's sacrosanct. You cannot change it. In a play you could say, 'Well, let's just cut this,' or put something else in maybe – with an author's permission, or if it's a dead author no one cares much. But in opera it's sacrosanct. Yes, you do cut things, but, my God, the discussions that go on about cuts and re-instating cuts. You're treading on hot coals all the time. So sometimes you have the problem of how you physically make it work on stage. How do you get a chorus on in that amount of music? – often not enough to get a chorus of 50 on – or off indeed. So you find yourself in the rehearsal room doing it again and again, saying, 'Go quicker, go quicker!' because we've run out of music, and you can't do anything about it. It's stupid problems like that.

Opera and Theatre

NB: Opera's gained a lot from having theatre directors come into it in the last ten, fifteen, twenty years. There's been a lot more work done on the way an opera is lifted off the score and onto the stage. Do you begin with an overview? Do you hear the piece or read it, and see in your mind, oh yes, this is the way to go?

MD: I think so. When I'm asked if I want to do an opera, as I say, I crack open

the CD, and I usually get an instinct then that, oh, I see, it could be like this – or just some little seed. With *The Thieving Magpie* for instance, I listened to it and read the story, and I thought, how weird! It starts off like *Oklahoma* – jolly country folk celebrating a wine harvest, and suddenly, a maid is accused of stealing a spoon. Then by the second act it's like *Bonfire of the Vanities*. There she is in front of a firing squad, condemned to death for stealing this spoon! It's like two completely different operas. And I thought, well, that could be really exciting to do – absolutely lead the audience off into one direction and then, after the interval, completely change it. I did even have the thought of having two designers design it, so you get a different designer in each act. I thought that was a bit perverse, but in the end we did go into a completely different style for act two. That was an instinct, and it stayed. Sometimes you listen to the opera and you think, I know a designer who'd respond to this music, because I think it should be quite colourful and bold. So you approach a designer. Then you're off on a journey together. That's an important decision in opera of course, who your creative team are. Sometimes you think, this opera feels like a 1940s film story, so obviously that imposes a bit of a concept on things. But I don't wilfully think, now how could we do this one differently this time, because I'm not really into that sort of thing just for the sake of it.

NB: Do you have any thoughts about modern opera?

MD: I think the problem with a lot of modern opera is that the libretti aren't very good – not interesting enough, too obscure, not enough good stories. The modern operas I've seen have just left me confused. Then a lot of modern music's very, very difficult as well. I'm not being old-fashioned. I don't mean a good tune, but there's a very complex obscure sound structure going on, and then with some sort of obscure, Greek mythology-based story, I often find it impenetrable.

NB: It's interesting that in music theatre what you might call opera up until the 20th century, and then what you could call the musical, don't ever seem to have been considered as a through-line.

MD: No, it's funny isn't it? The third opera I was asked to do was a Benjamin Britten, *Albert Herring*. Funnily enough, even though I was a complete Benjamin Britten fan at school and knew a lot of his work, I'd never seen or heard *Albert Herring*. I listened to that completely afresh, and thought, this is just delightful. It's like a really good musical, a little musical. That was *just* fantastic to work on – a very, very good libretto, very funny, very well-crafted words, good characters, good situation comedy, and it worked brilliantly. Somewhere after Benjamin Britten things started to go off the rails. I was sitting at Glyndebourne two weeks ago, at *The Makropulos Case*. Again, I'd never heard that – what fantastic music! Really brilliant! It was like film music. The beginning of it was like a film starting. That really perks you up. But all the people behind me were talking about was *Phantom of the Opera*. They were a bit bemused, I think, by Janacek and *The Makropulos Case*. I think they seriously would have been happier with an evening at *Phantom of the Opera*. I guess the popularity of Lloyd-Webber is that most people think they've seen an opera, and have enjoyed it, because it's through-sung. Of course, it is an opera in some ways, but I think the quality of music is the difference between opera and good musical theatre. It is a thin line. I did a modern opera, a piece by Julian Grant based on an Ostrovsky play, *A Family Affair*. He'd been let down by a librettist, and in the end he took the Nick Dear version of the play and set it to music without the help of anyone, because Nick Dear was busy. It was great, fantastic, because it's such a good play anyway. He set it to music, and I thought the music was great. For modern music, it was very accessible, quite quirky, quite complex, and really grew on you. It was hard on first hearing, as a lot of these things are, but it really grew on me. The audiences absolutely loved it, and the music critics absolutely *hated* it. They completely layed into it, and thought it wasn't valid at all. I don't know why. I think they thought it

was music theatre and silly. They did say they couldn't see why it had been set to music. Now that's an interesting one. It's true, but then they didn't complain about *The Makropulos Case*, which is exactly the play set to music. So you think, what's been added? Some fabulous music, that's what – which helps the big grand moments. Some things you just cannot do with words. I think opera, when acting, visuals, movement and music come together, is absolutely the best. Nothing can beat it.

NB: Under those circumstances how far do you draw a line between your work as a theatre director and an opera director? With the music that you use for a play, do you say, I'm only going to use music here when it's absolutely necessary, or is there an operatic feel to your directing of drama?

MD: I'm only just experiencing this now, because I've just done five years in opera, absolutely solidly, with no theatre at all in that time. I have now come back to the theatre, and I'm onto my third production here at Nottingham Playhouse. All of them have had music in them, and, yes, perhaps I am directing more operatically now. What opera taught me was how large you can go. The music takes you absolutely onto another level, and often things are bolder just because you are in a heightened sense of realism. You start dealing with forty, fifty people, and so the day of my first chorus rehearsal I was practically physically sick in the morning. I'm used to it now. That's taught me a confidence in staging, dealing with large stages and large ideas, which I'd never had before. And that's good. I'm taking large ideas back into theatre again, I think, too. It's interesting, because both my productions here, *The Nose* first of all and *The Cabinet of Doctor Caligari*, have music and big sets. Not that I wouldn't want to do small, detailed dramatic work. That's good too, and you can do that in opera as well – really work on characters and small detail, as in the *Albert Herring* work or the *Family Affair* type of stuff. I think one form feeds off the other all the time, which is fantastic. I've still got one more opera lined up from before I got the job here. I'm just about to do *Xerxes* in Munich with the Bavarian State Opera, on a *huge* stage – but

I hope to get some detailed work in as well. That's Handel, and actually I think it's kind of crazy doing it on that big stage. I think it should be in a much smaller house.

NB: It's a small chamber piece.

MD: There's a small chorus and six singers. That's it. But on this vast stage! I don't know how that's going to work out.

NB: Are you going to feel the need to fill it?

MD: There's a personal little love triangle at the centre of it, so I hope we can focus down on small details as well, but there will be some bigger things filling in the stage. Certainly I have brought my theatre experience to opera. It's a complete myth that opera singers can't act. A lot of them are fabulous actors. They just have a different thought process, because basically all their thought is about producing this amazing noise that comes out, so often their thoughts about acting are secondary. You just have to draw attention to certain things that they don't know they're doing or not doing, and how to think about them. A lot of them are really very good actors indeed. That was interesting, taking my theatre experience into opera, and now coming back to working with actors again is a whole different shift of mind. I think opera's taught me quite a lot about staging.

Live Composers

NB: Is it refreshing now to be able to work with a real live composer to whom you can say, 'I need eighteen bars'?

MD: Yes. The two composers I've got on *Caligari* are arriving next week, so it's going to be fantastic and interesting working with them actually in the room and seeing what they're providing. But the stuff I've had sent up already has really sparked off our imaginations. I'm using music a lot in *Caligari* – not just because it's based on a film. I'm using it pretty well constantly all the way through as sort of background feeling and atmosphere.

NB: And you've got the composers in rehearsal?

MD: Yes, and they're going to be playing for the show. We've got this extraordinary chap, Walter Fabeck, who's invented an instrument called the 'chromosone', which is a strange keyboard. I'm looking forward to seeing it next week to see what it does. I think it's going to look visually extraordinary down the front of the stage too.

NB: When you're working in rehearsal under those circumstances, do you normally want some improvisation from the composer at this stage?

MD: Not quite yet, because he's been working back at his studio on ideas for material and sending them up. Ideally you'd have people there all the time on tap, but it can't be quite like that. Next week is the first time we're mixing it all together. Composers will take a lot of inspiration from the way you talk about a production. They start to look at pictures of the set and costumes, and then come up with a stop-watch and watch bits of scenes, and go away and start creating stuff. They then, *very* tentatively put the music forward with a lot of apologies – 'Well, this is probably rubbish; it's probably not right at all, but. ...' Then you listen and go, 'That sounds great, fabulous.' I used to write music myself for twenty years in theatre, so I've often myself provided music for theatre I'm directing.

NB: How do you go about actually explaining what is in your head musically to somebody?

MD: Once you develop a rapport, you don't have to talk about it. You know that whatever world they give you, is going to be right, because you agree with their taste. Initially it's difficult. I think that's the same with any branch of theatre. You have to talk a lot in the beginning, and the initial time you hear something, it's difficult. It's like working with the lighting designer too. You can't talk about light. It's only when you first see the light put up on the stage that your heart either sinks – you think, 'Oh, no, no, it's completely the wrong style,' – or you know, 'Yep, that's the world we're in, and s/he knows, what we're doing.' It's the same with music. That's why

I've worked with Peter Salem three times. It's harder when you have to pick someone from scratch. I'm finding in this new job that people send me tapes all the time, and (a) it's very, very difficult to find time to listen to them, because it's so busy, and (b) you listen and think, well, I don't know; it doesn't feel right to me, this sort of stuff. Suddenly you might find something that's in that world, and you don't know whether that's what a person writes all the time, or whether this is just a one-off thing. It's so difficult. So when you do find somebody who's absolutely on your wave-length and provides material you really like, you try and stick with them and develop together.

Using Music Well

NB: In general, with your experience of seeing theatre rather than working yourself in it, do you feel that music is used well these days? It's drama I'm thinking of rather than opera.

MD: I've always thought audiences like hearing music in theatre. I think it gives them a lift. Live music, I think, just adds, really adds. The tragedy about places like the National and the RSC is they have fantastic resources for live music, and it always sounds as if it's recorded, because the musicians are shoved in a little room somewhere down a corridor, and to all intents and purposes you're listening to a tape being switched on. It would be really lovely to see the twelve musicians they have, because people like seeing music played. It adds a whole other element. I've always used music in my shows, and of course it was a logical progression that I go to opera. People have said for years, 'Oh, you should be doing opera, because you're so interested in music and in theatre.' I just think it's an element that you have, that you can use in theatre. I know some people are very pure and won't use music at all. Well, that's fine. That's their prerogative, but I really like the possibility of it. People are being more and more adventurous about music now. I think because they're realising the potency of it. Film's always done that of course. A film with no music at all is fairly rare.

NB: Is the potency of film music a bit of a problem when it comes to entertaining an audience in the theatre? Nowadays film scores seem to be wall-to-wall.

MD: Yes, I think that may be true. I think music has to be used very carefully and discreetly. It can do all the work for the audience. That's the danger, that there's no work for an audience to do in all this, because it's all been done for them. I think that's a terribly dead idea.

NB: That must be a problem with an opera as well, in that the score is obviously the driving force. How far does the score swamp your production?

MD: The other problem in opera is that not only is the score the driving force; the conductor also is. The problem is that you have two people in a room vying for leadership in a way. It's very important that you get on well with your conductor and are of a like mind, because at the end of the day you go home, and the conductor and musicians are still there in the pit, driving that performance home. Perhaps I should also be there, standing on the side shouting instructions! But I think it's very important that what you do doesn't swamp what's written. At the end of the day you've got to serve that.

Popularising Opera

NB: How do you feel about the popularisation of opera?

MD: About five years ago opera was suddenly riding high and became really accessible. The ENO was at its height, and there was the big screen in Covent Garden Piazza. It was fantastic. 'Nessun Dorma' was being sung all round the world. If you sit in the audience now for *The Pearl Fishers*, a the ripple goes round the audience when the British Airways ad comes on! You can hear people say, 'Oh, we know this one,' because they've seen it on telly. But then they had to hack the music to fit into the thirty seconds. Bars got lifted out randomly, and it made nonsense of the music. I'm in two minds about whether that sort of use of

opera is good. Is that cheapening opera, or is it making it more accessible? I don't know quite.

NB: It's interesting that a specific musical motif, whether a style or a specific tune, now presses certain buttons in everybody throughout the country.

MD: It's happened to me – I've just remembered, I'm guilty of this! The Kirov were at Edinburgh recently with *Sadko* by Rimsky-Korsakov. Some theme tune came up, and I went, 'I didn't know it came from this!' It's terrible, but television went through your mind while you were watching the opera. Operas are stashed with great tunes, so there's a whole fund of them to be plundered.

Caligari

NB: What do you think is the point in drama with music at which somebody sings something rather than says it?

MD: We've had a big discussion about songs in the *Caligari* script. I said to Barry Simner, the writer, 'We may be able to use songs in this somewhere. I want to use song, dance, painting, words and movement, and mix it all in together, so it's not a play, it's not a dance, it's not a musical; it's some hybrid mixture.' Now that may be disastrous. It may mean it's not one thing or the other, or it may be something a bit intangible. That's what I would like to think, rather than that it's just a boring old play, then it has an interval, then it's another bit of a boring old play, and then you finish. I like mixing things up a bit and pulling the rug out from under people's feet. So he did write in some moments of song. Peter, the composer, has really questioned these. 'I don't know what this means. Why? …' We've had a big discussion about why people sing and why they don't, and does it therefore mean it's a musical. I said, 'No, no, it's not a musical. It's just that they suddenly sing this one.' I don't know whether the songs are in or out. One of them wasn't right, and I accept that. I told the writer, 'No, this is like a musical, and that's not what I mean quite.' There's

another strange moment with Dr Caligari sort of perving over Cesare's cabinet, after Cesare's gone out on a night kill – just shutting the doors on it one by one, and there's this strange little repetitive thing. I don't know yet whether we're singing it or just chanting it to music. I've got to see what Peter thinks about it.

NB: Is there a point beyond which language isn't enough?

MD: Yes, I think so. Music can be used for a heightened moment of some sort, just to tip it into something else. You do burst into song sometimes during the day, if you're happy. Or you whistle. That's the same sort of thing. With *Caligari*, I don't quite know yet what world we're dealing with. I'm hoping things will start to come together next week, as we'll start to see all the elements put together.

NB: Are you consciously working towards or away from the silent movie aspect of *Caligari*?

MD: Sort of away from, though it's hard with this, because the silent movie is such an extremely potent piece of work. But we're not doing silent movie acting, nor is it just a stage version of the film. We've taken the film as an inspiration, and each of the artists involved in it – we've got two choreographers, two composers, a painter and a script-writer – have all watched the film, and they're all interpreting it in their own ways, separately and then together. We're not trying to emulate it. We've taken the story, the themes and the atmosphere of when it was written and why as a basis for this piece of – I don't know what it is. It's a music theatre piece almost, although it's mostly spoken, but dance and painting play a strong part in it. Because of the painted nature of the film, I asked a designer I know, who's also a painter, to participate. He's not emulating it. He's doing his own response to it, which is very different. Obviously it touched chords in him – why they did this in the film in the first place, and what the whole German Expressionist movement meant to him. As

he's an art teacher as well, he knows about the background of it. So it's not just a copy-cat thing by any manner of means.

Carl Davis

Carl Davis is a distinguished composer of music for film (including a British Academy of Film and Television Arts-winning score for the French Lieutenant's Woman*), television, radio and ballet. His specialisation in recent years has been the composition of new scores to silent films as part of the team set up by Kevin Brownlow and David Gill. Their first ground-breaking presentation was Abel Gance's five-hour epic,* Napoleon*, premiered to enormous acclaim in 1981. Our discussion dealt specifically with this area of Carl's career, illuminating the work of music with existing images shaped and controlled by a modern composer for a modern audience.*

Napoleon

NB: How did you begin to score *Napoleon*?

CD: Originally, in 1980, the restoration lasted a minute or two under five hours, though it's grown since. If we do the full version with the triptychs and additional material, the current running time is five hours and 17 minutes. But these things got added later. The original idea was that it was going to be five hours of music, and I had three and a half months to do it from go. There was a little bit of preparation, in that I had done a long television series called *Hollywood*, which was the history of silent film. I had done quite a a bit of research into what the practices were of the time, the sources they went to for the music, how they built up a score, and what the performance practices were. We knew that while in small cinemas you would have somebody improvising on a piano or an organ, if you went to a cinema in the centre of town – your West End, your Stadtmitte, your centre de ville, or your Times Square – you would actually see the film accompanied by an orchestra. There's a huge body of material that exists from that time which musical directors could draw on. Occasionally there were original scores. This was a practice more common in central Europe – in France and in Germany – where people did write, annotate, and publish silent film scores. In the States they tended to use compilations that were drawn from bleeding chunks of the classics and huge collections of mood music that were written at the time. These were very primitively used according to

what sort of mood would support the film. We knew that not only would you get your orchestral accompanied film, but in the middle you would get a show as well. We have all the records and programmes of these preambles of half an hour or 40 minutes of overture, operatic selection, ballet, trained seals, God knows what! – dependent artistically or commercially on the ambition of the cinema. All this is set up to be a nice preamble and give the audience a very complete picture. This idea of show and film continued through my childhood and adolescence. Although it was really drawing to a close in New York in the 1950s, there were still one or two cinemas putting these performances on – the Roxy, the Paramount, and in particular Radio City Music Hall, which carried this show and musical to the most extravagant lengths by having 32 rockettes, a 40-strong ballet company, a choir and an orchestra. This, of course, was built in the 1930s, just after our period, but nonetheless all this came out of what was there before. Of course, once sound came in, and the public were convinced it was far more exciting to hear the actors speak, to hear sound effects, and then to hear music recorded, and the cinemas did not have to carry the expense of live orchestra and so on, this whole practice simply went out the window. It was a huge crisis, because in their hey-day the cinemas were huge employers of musicians – obviously for not much money, but still there was employment to be found: every cinema had to have some musicians. Between 1927 when sound came in, and 1929–1930 when the conversion was more or less complete, was a tremendously critical period for musicians. The whole silent film area and the whole old way of doing things vanished. Studios were unloading and destroying their catalogues simply for space. Nothing was going to be of any interest or any importance, and the whole silent film area became the realm of the film club, the film society, the beginnings of archive interest. It became very special and very much for the chosen few. Until that great day, 30 November 1980, when we unveiled *Napoleon* – a full orchestral score combined with film!

In doing this project I felt a fear of the unknown. I simply didn't know what it would be like. I had already worked for fifteen years in a studio, and I knew what it was like to control a studio situation. Of course, you can do things again. The difference with live performance is that you have to keep moving forward, and there's no way back, no matter what happens. So there really was the whole question of how to create a score which could be played and conducted and remain in synch. It had to be not only a complete musical organism that was satisfactory in itself. In a contemporary score where you're sharing a sound track with dialogue and sound effects, you're a third of the elements, but as soon as you are on your own, as soon as the only sound is the sound that you're going to produce, you then have to think of writing, or creating or choosing things that are far more coherent in their own right. It has to be complete pieces; it can't be simply a long chord in a mood – which would be brilliant and all that is required in a contemporary sound film. The music itself has got to support the action completely. So when I looked back, 27 silent feature films later, I wondered how I did it. And all I can say is, I started at the beginning and kept going until I got to the end.

But there was another factor in *Napoleon* which was interesting. To the first integral performance, I had, having no experience whatever, three and a half months from go – the money was there, the date was set, the cinema was there. It was quite clear that it was going to be impossible to actually compose five hours of music in three and a half months. Perhaps one could, but even with an enormous amount of assistance it didn't seem conceivable at the time. So I did what the silent composers, the silent musical directors of the time did, which is to start drawing on world musical literature. But I thought, well, rather than all this awful mood music which is really quite anonymous, why not apply some of the thinking I would do in a contemporary film? Why not create the sound world of Napoleon himself, Napoleon's time? Instead of drawing on terrible mood pieces, which simply sound

like silent film cliché, why not look at the theatrical work of Beethoven, Haydn, and Mozart, and all the composers that are less well known, who lived at the time of Napoleon's regime? I set a date-line of borrowed music of 1815, which I thought was legitimate. Even though the action of the film ends in 1797, it is forward-looking, and was meant to be part of a six-part biography of Napoleon. I thought this would tie-in and also provide a particular dynamic which exists in that kind of music. At the same time there were other requirements in the film that would not be served by that – a 40-minute sequence in Corsica, and the whole area of the French Revolution, where you actually see the Marseillaise being taught for the first time. There were also portions of a score that was written in 1927 by Honegger, and the question was, do we use the Honegger that exists? And where could we find it anyway? (I found out subsequently that the complete score that was used for the premiere in 1927 has vanished.) One knew that the film was being re-cut on the afternoon of the performance, that there were also some spoken sections, and that several of Napoleon's speeches were actually being spoken at the time they appear on screen. My immediate aim was provide a score that was seamless, that never felt as if you were going to be let down at any point. It was going to flow through the entire picture. That seemed clear. I simply did it according to: well, I can conduct this, and this event should happen there, and so on. And one began to work with measurements, at least with a time code.

What happened subsequently to the performance, which changed history, I suppose, in terms of this whole area, is that Jeremy Isaacs was present at the performance. He was just putting together Channel 4; it was still about 18 months or two years away from its opening. But at the first interval, he said that he would commission a series of silent film classics from Thames Television, which is where myself, David Gill and Kevin Brownlow came in. We had all collaborated on the *Hollywood* series. For his station there would be silent film classics with scores by

Carl Davis, so that gave us the impetus to keep going. As I always tried to create these scores in such a way that they could be performed live as well as being recorded (with some adaptation obviously), that gave us the superb opportunity to have a go many many times. That's the difference between myself and all the others. When I look back on *Napoleon* and I see these empty pages, in which yards and yards of music go by without any indication of what's happening – what it's supposed to belong to – I'm just appalled and terrified. So every time I do *Napoleon*, which is quite rare these days (though in the first years I did it a lot), I keep adding information. Now when I put together a score, I actually write every single shot at the top of the page, so I know exactly where I should be at every point. I know if I'm behind or ahead or too slow or too fast, and I can absolutely gauge my synchronisation.

NB: Have you gone back and re-annotated *Napoleon* since?

CD: Every time I go back to an earlier score, I fill out more and more. The danger, of course, is that now we're in a situation where other people want to conduct these scores and use them, and do. I'm paranoid about, am I giving them enough information, so I try to make sure this is done. But as part and parcel of handing a score over, we also try and give the video that's been made of it. Virtually every score I've done has also been recorded for video for Channel 4.

The Modern Audience

NB: How much are you aware of a modern audience's requirements?

CD: I am very conscious that the audience of the 1990s is not the audience of the 1920s. The audience of the 1990s has had far more music made available to it – the rise of the gramophone, of radio, of television, and decades of listening to film music. The things that might have been extremely effective in the 'teens and 1920s of the century, would seem extremely naïve and obvious today. The point of this whole

exercise is to try to get away from the cliché of silent film music, and to try and look at these films, which are carefully chosen for having particular qualities that make them timeless, relevant to today. We're not choosing any old silent film. We're choosing a film to deal with in this way, to take this extra care with, because of particular qualities they have that make them valid works of art. If we believe that a film can be a work of art, or have elements that are artistic, effective, dramatic, moving or funny – if we're choosing a film for that reason, we must have a score which for our ears today makes that film effective. Don't send it up, don't topple it, don't attempt to dominate it. Respect the period in which it was made. Respect sometimes the fact that its thinking was far ahead of its period. Some things are set squarely in their period, and should be respected for that. There's a lot of thinking as to the over-all artistic philosophy of the people who made it – the director who made it, the stars who were in it – what their intention was, and what is interesting about it today. Those elements play a great part before I would even begin to write.

NB: I know you are steeped in the history as well as the music of silent film. Have you ever been in a situation where you have agreed to do a film, and you've sat down for the first time to look at and think about it, and have actually found that you don't have a great deal of sympathy with the film?

CD: There have been a number of films which have had to be sold to me. But then, in the end, I do trust David and Kevin 300 per cent because I know they would not actually take on a bummer. On *one or two* I've had to say, 'Come on, why are you doing this? Why are you choosing this one?' And then in the event sometimes I've swung around and been really quite passionate about it. But on the whole I'm in it because I am an enthusiast for it. I always did think it was fascinating, without ever thinking I would do it excluding everything else – any other kind of film or any other kind of music. It has proved extraordinarily important for me. It's something that I've slipped into almost

accidentally, but it has proved quite central. Moving out of what one would call the National Film Theatre syndrome of playing to at the most a couple of hundred (more likely under a hundred) or the club and university thing, we have now moved to a situation where we are playing for thousands as opposed to hundreds. Even something like the Chaplin films, which are regarded as immortal, have scores. *City Lights* does, and his earlier films he went back to and scored. We are now offering the Chaplin family, the Chaplin estate, a chance to show Chaplin films for a much broader audience. There would never otherwise be a situation where *City Lights* and *The Gold Rush*, which was my second reconstruction, would be screened publicly for such large audiences, and they recognise this as reviving an interest. So do the Harold Lloyd estate, as far as Lloyd goes. All these other collections we've actually revived a public interest in, and so there are more screenings of these films. Then people have the opportunity of actually seeing the film with a live orchestra and with a score which is actually created to fit it.

NB: Your work with Kevin Brownlow and David Gill has undoubtedly been responsible for the resurgence of interest in silent film in this country.

CD: More than this country. You have to think broader than England, because we had this extraordinary experience after we had been going seven years or so and had done possibly ten or twelve of the films. We were involved in a competition of silent films for television, which was staged in Frankfurt of all places. You suddenly thought, we're hearing in this competition thirty-five to forty different scores being played live to the pictures. Some of them were the original scores; some of them were brand new scores. We did feel that without us it simply would not have broadened so. Of course what's exciting now is that the scores and these reconstructed prints are also travelling around the world. They have been to the Adelaide Festival – it's gone that far. I've been to Hong Kong with it. I've done *Napoleon* in Tel Aviv. It's extraordinary things like that. Lots of

activity in Spain, lots of activity in France. A rather unexpected centre has arisen in Luxembourg, where they have a very, very lively cinemateque with a visionary man running it, Fred Junck. There's lots of activity in the Low Countries – Belgium and Holland are very interested and doing a lot. Germany, of course, has this tremendous tradition of silent film, and they tended to publish and save their scores, in particular Fritz Lang, who had a composer he always worked with, and so there is this repertoire of the scores of Hupertz. The Meisl score for *Potemkin* is controlled, but it can be done, and so on. There is also a French repertoire from that time, but that's less explored, though I did exhume one, which was for a film called *The Chess Player* by a very good French composer, Rabaud, who was a student of Fauré, and a post-impressionist French composer, but symphonic. He did a lovely score for this film. I'm very, very proud that that is heard and has been played in France and Poland. So has my work – though that didn't have any *original* music from me. It was a kind of backwards view – taking the music which had been written for the film and trying to make it fit. That was an extraordinary logistic exercise.

NB: Do you find that there are national characteristics in the way certain films are accepted in certain countries? Recently you seem to have toured the world almost entirely with *Ben Hur*.

CD: *Ben Hur* is a magic title, and the re-make also helped – the one in the 1950s, which we regard as the re-make! People are loving the idea of seeing the original, and I can tell them that it's infinitely more exciting than the re-make. Chaplin, of course, is very major in my life at the moment, and will keep going, as yet a third project has been mooted. Griffith less so. I've not been able to exploit my *Intolerance* as much as I'd like. It was unveiled in Leeds, as part of the Leeds Film Festival, which was celebrating the first film ever shot – which was supposed to have been off a bridge outside Leeds. That has been to London, Luxembourg and Munich. But I feel that it is a film that I should actually do more. I like doing it very much, and though it's

very long (two hours and 40 minutes) it's still a baby; you're only half-way through *Napoleon* at that point!

NB: With *Intolerance* you have a particular technical problem as well in that there are four stories in it, and the cutting from one story to another gets faster and faster and faster as the film gets towards its end.

CD: Yes, but *only* as it gets towards its end. The transitions from the four stories – the biblical story, the Babylon story, the renaissance story, the contemporary (by contemporary we mean 1915) story only start rapid cutting – and not that rapid when one studies it – just before the end. Then each incident has its own character, each story has its sound world, and that is really quite important as a way to differentiate. As soon as you start moving swiftly from story to story – from the fall of Babylon to the Crucifixion, to St Bartholomew's massacre, to the man about to be hung – it becomes less urgent to differentiate, because Griffith is saying these are now parallel, so that a general mood of urgency and crisis and tension is more to the point. As the rapid cutting starts, I start being more generalised, saying this idea of impending disaster is universal, so it becomes less difficult. In the earlier parts of the film – I would say for three-quarters of it – there are quite defined transitions, usually with quite an elaborate card and a lot to read, because he was a real tub-thumper, Griffith. He really wanted to tell the audience what to think. He put over his message. He was like a Victorian preacher. So that gives you time. Those transition cards are my escape-hatch. If I'm a little too fast or a little too slow, I know that that's where I draw breath. There's a hold and you wait, or you can move swiftly through, depending on your metabolism that day!

The Process

NB: How do you actually work against the images – where do you project them?

CD: Video is the answer. But, especially if we're going to do a live performance, I try to see

it large once, because (although I have a very large video in my working situation) if you view everything on a video screen you tend to misjudge moods, to lose what's on the outline. For instance, the end of *Napoleon* has this extraordinary triptych where the screen grows and becomes three times its normal size. It's a sort of precursor of cinerama, and when we're able to do it with three connecting interlocked projectors it really is three times the size. It is absolutely amazing. But when I composed this, I had only the middle screen on my video, and I really didn't have very much idea, because it was impossible to show it to me without setting up the three projectors. I think the first time I saw *Napoleon* was on a Steenbeck, so it was even smaller. I had no idea really what was going on around the sides. And then when we did it for the first time in 1980, I suddenly thought, my God! this isn't big enough for the scale of what is happening on these outer screens. Either Gance has composed a single shot which goes across the three – *Napoleon* starts lining up an army and riding across the three scenes and back again, or there is triple screen montage, which is incredibly exciting, then joining up into a single sentence which will go across the three screens. I had no idea of the scale of this, so that when it was revived (which was almost instantly, the premiere being 30 November 1980, with four sold-out performances on successive weekends in March 1981), I immediately amplified the whole ending. I added an organ to it, which was saved just until that moment of the screen going into three and then used from there to the end, so that the whole thing acquired an epic quality. It's very dangerous to judge the thing entirely on video, because one can go wrong, and you can miss details. For instance, if you have a scene full of uniforms – an army scene, such as in *Napoleon* or some of the subsequent films – you wonder, identifying, are they British, are they French, are they German, what are they? And scale is very important. But basically my working process is to analyse the film from the video and create the score from that.

NB: As you're analysing, even before you get to the piano to begin working on the composition, are you hearing the score in your head first?

CD: I'm beginning to conceive it, but the important thing is to see it larger than video. We used to have a funny ceremony for years. (We haven't recently; we're all too busy.) We used to have a ceremonial screening at Kevin Brownlow's flat, on the wall of his sitting-room. That was fun! Kevin was the soul of this enterprise, because it was his initial enthusiasm, way back in the 1950s that propelled the whole thing forward. So I build it up from information, notating shots and things like that.

NB: Do you see any reason why the interest in silent film should just be a passing phase? Do you think it is something that will continue to grow until eventually silent film is recognised as an absolutely valid art form?

CD: What is happening is, of course, that there is now a movement to preserve these films, and as long as the films themselves are preserved – moved from nitrate onto acetate, videoed, and more prints made because of the demand for them – as long as they exist, perhaps it will die away, but it will come back again. It is being protected. Or the master works are – except for the master works that are lost, of course, which we don't know about. But the films that are regarded as major, as also the films the thirty odd features Photoplay have made, those are saved; they are on acetate, and so on. There is a movement now towards preservation, and, of course, that will keep the basic repertoire alive. As long as they are there, they can be revived. Perhaps there'll be a phase when I stop doing them, or I'm not around any more, when the interest will go, if all the people who created the interest aren't doing it any more. But then it will come back again, because it's possible to, whereas the fact is that if they were all lost – which they all were in danger of being – then it would be impossible to keep it going. But the scores are written. The scores are recorded. Videos are made of all these. We are far more advanced in the whole area than we were when we started in 1980.

John Altman

John Altman began his music career as an arranger but has since gone on to be a highly respected composer-arranger for film (including Goldeneye, Hear My Song *and* Funny Bones), *television and commercials, as well as working in the rock music business. Our discussion covered his eclectic approach to each new project, the problems of working in the field of advertising, and the specific nature of recording, arranging and editing music for sound-tracks.*

Monty Python

NB: Let's kick off by talking about *Python.* You started working on the Monty Python series, before the film *Life of Brian* was made.

JA: Yes. How it happened was quite interesting. I was very friendly with a guitarist called Ollie Hanson, who is unfortunately no longer with us. He used to phone me to invite me along to sessions that he was on, and I used to go. He called me up one day and said, 'I'm doing a session for *Monty Python.*' It was while they were preparing *Holy Grail,* so it would be just after the TV series had finished, when they were already icon figures. I thought I could come along and watch *Monty Python,* and that would be great. So I went along to the studio for what proved to be a rather dull day of Gary Glitter impersonations, but I started chatting to various guys in the studio. Ollie was also talking me up saying, 'He does some great arrangements,' and, 'He's a sax player'. I then got called on to work on a single that Neil Innes was doing, whom I'd met through Ollie, and we enjoyed ourselves on that. Neil was starting to prepare a thing called *The Ruttles,* which was a satire on the Beatles with Eric Idle. Simultaneously he was preparing to do his own TV series, *The Innes Book of Records.* Also the Pythons were about to do *Life of Brian,* so it was a very fertile time for them, moving into larger scale works. I got caught up in all this. I got asked to do *The Ruttles'* arrangements, to do 'Always Look on the Bright Side of Life' with Eric Idle and to do Neil's TV series – three series as it turned out – *The Innes Book of Records.* That was all specifically as an arranger.

NB: Were you learning on the job, or did you already have that kind of knowledge to bring to it?

JA: It was a mixture of both really. My family were all in music. My uncle, Wilf Phillips, led the Sky Rockets at the London Palladium and conducted for Danny Kaye and Sinatra and Judy Garland. From the age of three or four I was interested in who these people were. I would listen to Judy Garland – and in fact I got up on stage with her at the Palladium one day, much to my horror in later life! My mother took me to a matinée, and apparently I spotted my uncle on stage, shouted out, 'Don't worry Uncle, I'll conduct the orchestra, you have a rest,' and charged up onto the stage. Either I knew where I was going or I was a complete idiot – I'm not quite sure which! So I had very much the feeling of the family in show business. I knew that people like Danny Kaye were family friends, and I became aware that this was out of the ordinary. Also, through the record collection we had at home, I acquired a great love of things like Dixieland jazz, Count Basie, Duke Ellington, Sinatra and Crosby, at a time when all of my contemporaries were starting to listen to Elvis and things like that. I always remember in school being horrified when the teacher said, 'Tomorrow we're going to bring in our old 78s and make lampshades out of them, or ashtrays.' I thought, 'You can't do that!' We had a music appreciation class where everyone brought in Tommy Steele singing the blues and Elvis, and there I was with Count Basie's 'Mama Don't Want No Peas and Rice and Coconut Oil', saying, 'Oh, this is a great record, I really like this one,' and everyone looked at me as if I was crazy. I'd always been very interested in how different types of music worked. Being in a position, to say 'Let's pastiche the Beatles,' or whoever else was very educational, because you'd sit there and listen to Beatles records, and suddenly you'd hear things. We did this send up of 'Penny Lane'. There's a flute that suddenly appears in the middle of 'Penny Lane' for about three bars, and then it's gone. I'd never ever heard it before, so I shoved it into my version, thinking, well, obviously it's there for a reason. I remember

playing it to a guy who became very important in the business but had been a tape op on Beatles sessions, and he shook his head in amazement and said, 'That's exactly what they would do.' They would get a flute player in and have him play all the way through, and one phrase might take their fancy. Because I had that sort of grounding in pastiche, later when I was doing commercials or any type of writing which you were asked to do in the style of such and such, I could hone in on it straight away and know exactly what was meant. Unbeknownst to me, it was a great training ground to get further into other people's styles, hopefully forging one of your own as you went along, but certainly being conversant with all the different aspects of writing.

Songs and *Hear My Song*

NB: Particularly in the big films, you seem to use songs or pieces which have meant something to you, and then you develop a further strand out of them of your own.

JA: Very much so. Peter Chelsom is probably the leading example – though there are others I've worked with – of a film-maker who really is so music driven that he sees the whole fabric as being guided by musical style and musical content. He's very much an evolutionary director in the sense that a certain piece of music will inspire him to write a certain scene in his film, rather than him writing a film and editing it and then saying, 'What on earth are we going to do for music?' – which, of course, a lot of the time is the norm. So the opportunity really is there to throw all the boundaries down. Certainly *Hear My Song,* could have gone two ways. One way would have been to say, well, there's going to be Irish music; there's going to be operetta; there's going to be something else. Right, we'll get somebody who specialises in each of those, and one person can do this bit, and somebody else can do that bit. This is of course what happens on a lot of movies. You see a composer listed, you hear some great big band music and you think, 'Well, this guy's really talented.' The credits go up at the end, and it says, 'Big band by Billy

May.' So you've been cheated in a way, because you know what's happened: the guy who's writing the score really has no affinity at all with that particular style of music, and therefore the score itself is a real hotchpotch. There might be six records strewn across the picture, a couple of old Sinatra tracks and Billy May stuff, and you think, what's the other guy done? Where's the evidence? Oh yeah, there was that synth pad in the middle of when the aeroplane took off. Oh right, well, that's his score! That happens a lot. *Hear My Song* and *Funny Bones* gave me the chance to say, these are all types of music that interest me and have influenced me. What happens if we put them all together? My main theme goes from being synthetic to orchestral, to swing, to operetta, and is treated in those ways, but all by me, rather than me ringing someone and saying, 'Come on, help me out; I don't really understand operetta; I don't know how you write for Joseph Locke. What do you do?' So that was the key. That for me has always been the key, because I've always orchestrated my own music. I always know exactly how I want the stuff to sound.

NB: So what then binds the film is the melody – how you've treated it.

JA: Yes, in a lot of ways. It's being slightly clever about it as well, in as much as *Hear My Song* is driven by violins. There are violins playing on the Irish music; there's Stephane Grapelli style violin played by the late Johnny Van Derek; there are the violins that accompany Joseph Locke, and there are violins in my big band treatment. There's also the percussion in *Funny Bones,* where I was driven by the sound that Alex Acunia made on some of the classic Weather Report albums. We got Alex Acunia to play on the *Funny Bones* sound-track, and that became the motivation that I used on the big band stuff – to use tom-toms as well, so there was always that sort of feral beat going on somewhere in the film, which again drove the film along. It was a conscious move.

NB: It seemed to me that an element of *Funny Bones* was the thriller, and that it was therefore bound to have that kind of

driving beat to it, but then you have also used variations on the sea. At what stage did 'the sea' (la mer) become a major thought in the score?

JA: The sea was interesting because Peter had seen a set that looked like a ship. He decided that the link at the opening of the film would be the Lee Evans character in 'the sea', followed by Las Vegas being done up like a ship. In the final cut there are sub-titles that say 'Blackpool' and 'Las Vegas', but in the original cut there were no guide-lines; it just went into Harold Nicholas's song. So it really was very surreal. You thought, 'What is going on? He's in the sea, and now there's a sailor singing and dancing on a ship.' For me it was wonderful, but obviously for general consumption, the idea was that people would be sitting there saying, 'I really don't understand what's going on in this film at all' – which possibly is what happened anyway, even with titles. But Peter then said to me, 'Is there a song that connects with the sea that we can use on the scene?' We were thinking about 'Anchors Away'. But then, before shooting had started at all, I came back and said, 'How about 'La Mer'?' – which in English was 'Beyond the Sea'. He rubbed his hands in glee and said, 'That's it; that's what we'll have; that's what we'll do,' and he then wrote all the stuff in the film that has 'La Mer' involved with the French actors. I knew that there was a French strain to the film as well, so 'La Mer' became obvious to me, and as soon as I said it to him, it became obvious to him. But then he re-wrote a lot of the scene so it became a unifying part of the film and actually recurs as a motif throughout. That's how that element originated.

NB: It does work beautifully, because anybody who knows 'La Mer' probably knows it both as the original rather light French piece and this big band standard. You hear it again and again.

JA: That was why, of course, it became glaringly obvious, because when you go to Las Vegas it is a big band, all systems go. Peter, of course, wanted a big show business name to perform it. He was thinking of Mel

Tormé, Tony Bennett and all these people. I had worked with Harold Nicholas and the Nicholas Brothers and thought he would be perfect, because he was a dancer, which the others weren't. He also had that legendary standing in show business, having been in it for such a long time. His first film was around 1930, and he was a star in those days, which I thought fitted in with the whole concept of the film as well. Again, people wouldn't necessarily pick that up, but it's that sort of subtext thing that appeals to me when I write scores. I think if you can get resonances or make it deeper, you'll have a deeper film, and whatever else *Funny Bones* is, it's certainly a deep film.

NB: You must have been in on discussions right at the very beginning of the film. Does that often happen?

JA: No, it doesn't. With two or three directors I work with regularly it does happen, but it always seems to be against the flow of what normally happens. That's not to say, of course, that you can't do something spectacular on a film you've just come across two days before and have got a week to get on with and then it's out. In fact that happened on a film I'm very fond of that I worked on, *Bhaji on the Beach,* which to all intents and purposes was ready to be released when it was shown to David Aukin at Channel 4. He said to the director, 'Look, this film really needs a score, and I suggest you ring John Altman straightaway.' Which is very nice of him. But that's a great one, because you're suddenly confronted with a film which is sort of Anglo-Indian, and you think, 'Well, what's it going to be? How do you score it?' Because it's not an Indian film, and it's not an English film, you have to have elements of both. That was a case where I roped in Craig Pruess, with whom I work a lot. He is a wonderful keyboard player, but also an expert in Indian music and plays sitar. I left him to get on with the purely Indian material in the film, and I sat at the piano and thought, well, if I were writing something that had Anglo-Indian feeling to it, what would it be? And I just started playing what turned into the main theme of the film – after about two days of turning

it around in my head. That was a perfect example of coming right at the end of a project and not living with it for years. But when you do get in at the start you really have got the chance to have an input that's very sizeable, and it always seems to show.

Technique

NB: So it is actually then two very different techniques. When you're part of the original discussions on the movie, you're definitely using the music to drive the film. When you're watching a film which is almost complete, where everybody else has had their say, and the director's vision theoretically is up there on the screen, you're drawing on something else in your head rather than necessarily just the musical background you have. That's when it must become a sort of instinctive approach.

JA: It is. Although, of course, the same criteria do come into play. One would hope at the end of the day that you could never look at a film and say, well, the music in that was written at the end or the beginning or whatever particular time. One would hope that you'd get to a technique that applies to both. Certainly when I see *Bhaji on the Beach* now, my feeling is that you can't imagine it without having the music that it has. Mark Isham's score for *A River Runs Through* was very much a rush job – took two days to write and three days to score, and yet it just sits on the film perfectly. You can't imagine that the film was ever conceived without having that score on it, whereas, if the truth were known, it's a bit like the stories about who was originally cast in *Casablanca* or when George Segal walked out of *Ten* half way through shooting. These stories don't actually become general knowledge, but if you sit there with the knowledge that that's what's happened it's one more dent in the myth of movie-making.

NB: Does it get any easier as an approach, as a job?

JA: It gets easier and harder. I think technically it gets easier, because you do come up with

a bag of tricks that you can delve into, not necessarily to help you coast along, but to cut down the aggravation time of how do you go about writing a score. You get your conceptions of what you should be doing and what you should be looking for into order, which makes it easier. The best example I can give is from my own experience of working a lot on a television series, *Peak Practice*. I've now done 36 programmes, in virtually every one of which I'm writing music for somebody to be ill by. If you write for a horror film, you can write something that you think is absolutely great and made everyone scared, or made everyone cry. You've done your job. Of course, in the next situation you'll probably be confronted with the same emotional upheaval again, so all right, last time you thought you'd done the most wonderful thing; now you've got to top it. You really then have to make a fresh approach to a scene that you may have scored 20, 30, 40 times, and say, right, here's somebody else who's feeling ill, so now I'm going to have to write music that will make everyone feel unsettled or uneasy or unhappy or whatever it might be. Then your pure music-making instinct, where you'll write just to satisfy yourself, really does become subordinated to finding another approach to this. Is it going to be: ok, it's a tense moment; right, high strings, tremolo G? Is that what you do? Because that is how you make people feel that something's about to happen. It's cliché number one in the book. Do you short-cut? Do you say, let's find another way to do it, or do you say, to hell with it; I know that will work, let's give them that? It's a very tricky area, and it's very interesting to see composers, particularly on Hollywood movies, who seem a lot of the time just to run through the same variations on an idea. You think, oh yeah, here they go again, but then the films themselves run through the same variations on an idea, so does it matter?

NB: With the mainstream Hollywood movie these days, you're always talking about a certain style, big hero, violence, etc. They are covering the same thing again and again.

JA: In a way it's a bit like the 1970s concept of the library – where *Starsky and Hutch* and every other cop on television would just have a library, created by Randy Newman and people like that. It would be one minute 42 seconds of chase. It didn't matter what show it was and what went on, that bit of music was just dumped onto that particular sequence. You feel a lot of the time that that's what's happening, that you are just getting the same music churned out on every film. But then, as I say, the corollary of that is, do you go against type? What's been interesting for me as well, because I work as an arranger and conductor for other composers, is seeing how they solve problems – quite often not by the route that I would take myself. I'm not saying that's a bad thing or a good thing. I've just had an example of that working on *Goldeneye,* the new Bond Film, with Eric Serra, the French composer whom I've worked with now three times. He came up with some very interesting solutions to how you write music for the Bond films. Some of them hit and some of them didn't. The ones that worked particularly well were completely out of left field to what you would expect.

NB: I suppose they'd have to be though, because the Bond film is rather like how many different ways can you do the 'To be or not to be' speech in *Hamlet.* The Bond film has certain built-in requirements.

JA: Yes, and it's interesting that Eric Serra wrote a score that went away from most of those requirements virtually throughout. What then happened was that the producers did want the more traditional Bond feeling in one particular sequence, so I then came in and wrote that sequence, but on the whole the approach of the film has been very different from the normal Bond film. I tried to keep the sequence I did in sympathy with the rest of the score, but there are places where you just say, oh, it's obvious what you're going to write there, isn't it? What Eric did was to say, no, I'm not going to do that; I'm going to go completely in the opposite direction.

NB: So did you use his themes or his orchestration or anything like that when you say that you tried to fit it in with the score?

JA: Yes. There are certain techniques of his that I've obviously become familiar with through having done *Leon* and *Atlantis.* It was really the fact that I was going to use the Bond theme itself virtually throughout this sequence, which he hadn't done in his score. His music is very percussion driven, and I had specific percussion, like a triangle and orchestral bass drum, doing things that he likes to do with those instruments, so the base of the whole sequence is actually in sympathy with what he's done in other parts of the score.

Contemporary Music

NB: In relation to what you said about, do you go with the obvious, or do you go with something different? – it seems that everybody has a well of experience which composers can go straight to, and through which they can find their way right to the heart of how people respond. Are we now getting to the stage where our well of experience is being devalued by the amount of music that everybody hears?

JA: I think things have been going the other way in the last few years if anything – particularly the explosion of so-called world music. People are now hearing African, Asia and Indian music, and relating to it much more than anybody ever did. It *was* inconceivable that you would have an African singer in the top 20 or anything like that. Because there's this sort of cross pollenation now, you can draw on aspects of international music, whereas years ago, if you were doing a film score, you would have a symphony orchestra, and that was it. Certainly you might have a synthesizer or two – and you might have only synthesizers when it became financially practical only to use synthesizers. Now I think people will start employing African drums or calimbas or instruments like that – odd percussion, odd effects. Not necessarily because the film is set in Africa. It's a lot more open in that way.

Something else that I feel has always been open but has also always been misunderstood a lot is the whole concept of contemporary. People have always said, 'Oh, well we want something contemporary.' To me what's contemporary is what's happening now, and that's the only definition you can have. If what's happening now happens to be a dance tune from the 1920s, then that is contemporary, because it's happening now. I always have this problem, because certainly in the record business I've done tracks that have gone to the top of the charts, like 'That Old Devil Called Love' with Alison Moyet, or at the moment 'It's Oh So Quiet' with Björk. They're retrospective musically, they're using big band language or clarinets or brushes or that sort of feeling, but there's no way you can listen to any of these records and say they're old records. They've got state of the art production. People go out and buy them, and they go to the top of the chart. So full stop: that is a contemporary record. If you do a score for film like *Funny Bones* or *Hear My Song*, I think you really are at liberty to make any choice you want to make and have it under the banner of contemporary. If I wanted to write in a 1920s or a 1930s style, because of the way instruments sound today and the recording techniques, those will become modern recordings. There's much more of an audience acceptance, I think, than the record companies would have us believe. They always see these things as one-offs and flukes and freaks, but of course they aren't. If more people buy, say, that particular record of Alison Moyet's than buy any other record of hers, then it says something about what people want to hear.

NB: Your own musical enjoyment is obviously very wide-ranging, but you must also have to attempt to listen to every possible kind of music in order to be able to draw on it.

JA: Absolutely, but I don't divide music, because I'm one of these people who has somehow lucked out and found that his life's work is actually his life's passion. I still get excited by hearing new things that I've never heard before, or a composer that I've not been familiar with, or a style of music that I've never really listened to that

suddenly becomes relevant. Somebody might give me a record of Indian music or an African artist, and I will be excited by that. I will be excited by it as a punter as well as as a creative person. It just so happens that I'm in that field anyway, but if I weren't, I would enjoy listening. And my in-car listening or in-house listening is terrifyingly eclectic. I can go from 1920s Dixieland jazz or traditional jazz through to Steely Dan via Count Basie Band via Ravel or Delius or Walton, and listen to one after the other without really making too much of a scramble in my head. The biggest scramble that I ever had was on *The Innes Book of Records*, where we did a day and a half with a string quartet, and then the afternoon of the second day we had a bluegrass band in. That really was a culture shock – to go, 'One, two, three, four,' and have this foray of banjos suddenly going when we'd been used to the docility of a very delicate string quartet! If I go out and hear music, I will go and hear virtually any style of music. If I go and play music, I'm just as happy playing rock and roll or blues as playing Dixieland or jazz, and that's how I've always been. I just love music-making, and I'll make any sort of music that anybody wants me to make – and feel comfortable in it. I learnt a very interesting lesson very early, because somehow or other at my 21st birthday party I managed to get Muddy Waters and his band, who played for the whole night. I'd grown up loving Muddy Waters, and my first band had been a blues band. I was really the only one who was still full-time involved in music. One other guy was a scientist, one was a photographer, one is now a judge, and they got up as well. So there's Muddy Waters singing with our band, which was an amazing experience. I took a little sax solo, a two-chorus sax break in the blues style, which I really enjoyed, and towards the end of the second chorus I thought, I'll put in a little tricky run now and show them what I can do. As soon as I did it I realised that was a complete and utter mistake – wrong. It immediately taught me a lesson. If you're going to play a Dixieland gig you don't throw in John Coltrane licks, or if you go and play modern jazz you don't lie on your back and start playing harmonic rock and roll licks. You stay perfectly true

to the style that you're using. When I write, that doesn't apply so much, because I feel that you can take liberties, but what happens to your writing over the years, obviously, is that you get rid of the excesses. I've recently been making up a tape of stuff that I did 20 years ago, and I've been cringing a lot of the time, because it's over-written; it's clever stuff for the sake of, well, I can do this. Occasionally it's very cheeky, and you think, I'd never get away with that now; I'd never do anything like that now. But usually it's just cringe-making, and you think, how could I have thought that that was going to achieve anything?

NB: That appears to be the learning process, going towards a simpler and more effective dynamic all the time.

JA: Yes. I was watching a film very recently. It was a score I particularly admired, and I suddenly realised that it was incredibly simple. It was one of those scores where your perception of it is that it was quite complex and involved, and then you actually hear it and think, that's just orchestral sustains with very simple melody, and it did the trick. But when you're writing for the visual, obviously, it does change your perception of how you write.

Drama

NB: Do you mind having that sort of restriction – slavishly having to follow time, having to follow sequences, having to follow drama?

JA: I quite enjoy it. It is obviously a different technique. You can sit down and think, oh, it would have been nice to have been able to write this and not suddenly had to change mood at that point, or not had to suddenly break off for a line of dialogue and then come back again. But generally, I always loved the idea of real under-score, which hopefully adds a new character to the film. I certainly have never been a fan of aural wallpaper, and most of the directors I work with aren't either. It's never been a case of, look, nobody says anything for the next minute and a half so you'd better shove something in. We're not

quite sure what it should be, because it's not actually saying anything, so just stick something in that's going to carry us through to the next bit of the film. But that happens a lot. It's almost asking you to save the sequence, or make this actor look better, or make this scene tense, which also happens quite a lot.

NB: And can music save the sequence?

JA: I don't think it can save a bad film. It can certainly make a film with promise better, and it can certainly make performances a lot deeper. It's very interesting, and it's probably not politic to name names, but there are films that I've worked on where certain players have come out looking much better after the music's gone on than they did before. The obvious example, of course, is the driving through the rain sequence in *Psycho*, in which if you watch it silently nothing's happening – she's driving the car through rain, and the windscreen wipers are going. But you put the music on and immediately it's got so much that you read into her face, and the momentum, and where she's going, where she's been and what she's done. That is a powerful thing. Similarly I've done a sequence in a film where the main character is wandering around an empty house reading a letter. Without music it's very, very uninteresting, because there's no play in the actor's face or anywhere to show what could be going on. But then you write a reflective, wistful piece to go underneath it, and suddenly people will think that they're actually seeing something else go on in his face. That is the true art, I think, of scoring sequences like that, to give a new dimension to players, or to the story-line of the film, or bring out parts of the direction.

Speaking the Language

NB: Again without naming names, have you been in any situations where the director hasn't been able to see that that's what the music's there to do? Have you ever been in a situation where you think (a) I'm not sure if I can actually do the job and (b) I'm not sure that we share the same language?

JA: Well, there's a very interesting TV series that I worked on where the composer, the director and I sat down, and there was a sword fight going on. At one point in this sword fight the character drops his sword, and when he picks it up and starts fighting again, there is an obvious realisation in the character that he's about to die – he's got no hope of winning. He was a very fine actor, and you actually got this. Although he didn't say anything, you suddenly got this look of resignation to his fate. The composer and I were talking with the director, and we said, 'It would be marvellous here to take it out of that excitement music of battle and write something very elegiac, as if to say 'I've given up,' so that it almost becomes a slow motion sequence.' And the director said, 'Oh, well that sounds very interesting; great, let's go ahead; let's do it.' So we're recording; we get to that point; the guy drops his sword; he picks it up, and this very lovely cello piece starts. Everybody is looking looking up at the screen and going, 'That looks really good; that works really well.' We went up to listen to the playback, and the director's sitting there saying, 'Where's my stabbing music? I have to have the stabbing music.' So that really was a complete non-communication. But then you're into that whole thing about communication, and how people can mean something and actually say something else. What I always try and do when I start to talk about film music is pick people at random and say, 'Name me a classical composer,' or, 'Name me a Country and Western artist,' or, 'Name me a jazz musician.' It's interesting, because you correlate the answers. You say 'classical', and you've got Mozart, Britten, Walton, Shostakovich. You might have the most stylistically diverse list of names, but that is everybody's immediate perception of classical music. Similarly with jazz you could have Louis Armstrong or you could have Stan Getz. With Country and Western you could have Jim Reeves or Hank Williams, so you really run the gamut of the style. It's very easy to say, 'Oh, I want something sort of Country and Western here.' If you don't pin down the definition, you can come terribly unstuck. A friend of mine did a commercial for Holland, and the guy wanted a jazz track. He did a Miles Davis, Weather Report type thing, and the client walked in carrying a banjo and said, 'Right, where's the jazz?' It's a perfect example of total lack of communication. And then of course you get the experts in the field. You never know quite whether the best thing is to work with someone who has no knowledge at all or a little or a lot.

NB: Then it comes down to the dreaded guide track, doesn't it?

JA: Well, the guide track is of course the bane of every film composer, as you know. They're an interesting area. They can be very effective of course, in that they can focus a lot of directors. What's assumed, but sometimes quite erroneously, is that directors put together guide tracks and then give them to composers on films. What tends more to happen is that the *editor* will concoct a guide track from various sources, and that will be what is seen by the studio and by the director. Of course that will be what everybody will live with for four, five, six weeks, two months, three months, however long it may be before the composer works. So the composer is always going to work against those constrictions, and it's always been the same. The classic story about David Raksin writing *Laura* was that the film had been temped with *Sophisticated Lady*. It was his first real film assignment. Before that he'd just been arranging for other composers. He saw his chance of having a score go down the drain. So he said, 'I really feel that I could write the theme for this film,' and they said, 'Right, you've got the weekend. Come back on Monday, and it'd better be better than *Sophisticated Lady* or else that's what we're going to use.' So he went away and wrote *Laura*, came back, and the rest is history – luckily for him, because quite often you could play *Laura* to a director and a producer, and they'd go, 'I'm not quite sure about that. I don't think it's as good as. … It's not as catchy as. …' That's the other bane, when they say to you, 'Write something like this song.' And, of course, if you like it, you're thrilled; and if you don't like it, it's not going to sound anything like that song at all.

NB: What they mean is, 'We want this song but we can't get the rights.'

JA: Yes, exactly. I have lots of arguments with people about what's catchy. To me something is catchy because you've heard it before, and if you've heard whatever it is 150 times, it'll be catchy. The most difficult rangy melody, like 'Dancing in the Dark' or 'That Old Black Magic', can be catchy, because people know it, but if you heard it for the first time you'd just get totally lost. It goes on and on and on. 'That Old Black Magic' is not an easy song. If you asked the general public to sing it, they'd sing two lines, and then they'd probably stop, because it goes off on so many tangents. The same with 'Blues in the Night' and songs like that. So there is this misconception of what a catchy piece of music is. To me, the only catchy bits of new music are bits that sound like something else. That's always the danger when you sit down and write something yourself and think, 'Oh, that's very catchy.' It probably means you've heard it by accident played under some programme on TV. It's very worrying.

TV Commercials

NB: With advertising you've got yet another layer of recognition in people's minds. What do you find particularly rewarding about working in commercials?

JA: I was very lucky in that I got into commercials at a very fertile time, when a lot of the people who are now respected film-makers were making great commercials – the Ridley Scots, Adrian Lines, Alan Parkers – people like that. What they were doing was particularly cinematic and not at all the old jingle concept. I have written maybe two or three jingles that have played for years and years – which I'm probably very embarrassed about and have blocked out of my mind quite well! I certainly didn't write any of the major jingles that everybody thinks of as being ads. People still call them jingles, which always grates on me. If you ask a musician, 'What are you doing?' and s/he says, 'I've got a jingle at ten,' it might be a

sort of symphonic piece that they've written, but you hear it called 'a jingle'. Over the last five or six years this new trend has come up for just taking an old record and sticking it on, and then in a lot of cases writing the campaign around the record. It works sometimes but is unfortunate, because advertising music had become – particularly in this country – a very interesting area where people were doing very original things, and the films were original. It is an odd sort of time now. I think it's got to get back to that sort of creativity. I think British advertising has gone into a new blind alley. The worst part of it now, I think, is that the technology, which is fantastic, is being used as an end rather than a means to an end. You see these spectacular effects in commercials that don't actually say anything. There's no story; there's no art. They could be advertising anything in the world, whereas the things we did were obviously much more product-related in certain ways.

NB: In commercials are you still part of the decision making process in the same way or do people come to you and say, 'Look, this is British Airways; we want opera'?

JA: I am, very much so. British Airways is an interesting one. I worked on all their commercials in the '80s. The whole operatic thing in advertising is very interesting. Like the number of people who were there on the day anything exciting happened (which of course escalates to billions), the number of people in advertising who discovered opera for commercials is myriad! What actually happened was that the editor of the Fiat commercial dubbed on *Figaro* just because that's what he had in his cutting room.

NB: This was the famous Fiat commercial where you saw the car being built by robots.

JA: Exactly. And that was the only reason that music was on the film. Nobody made the creative decision, 'We must have opera; we must have that opera; we must do that.' But now everybody takes the credit. In fact it was very prosaic: the guy dubbed it on, and everyone saw it and went, 'Wow, that

really works!' But that was an interesting time with British Airways, when we were doing the Delibes, the Verdi *Nabucco* and all those pieces. I was doing so many operatic tracks by then – for Bailey's Irish Cream, Gillette and Ragu – pastiches of opera, which were great fun. But it was getting to the point where people were going into shoots and saying, 'Have you got that opera from British Airways?' It was bringing a consciousness of opera to people, but that is where I chart the beginning of the era of 'let's find a bit of music and stick it on,' which had never really been a particularly major strain in advertising before. Certainly the campaigns I did that people remember – like the Telecom 'it's for you' campaign, the Mail on Sunday, Pontins, the Buzby Berkley pastiche, and a lot of the films that Paul Weylan made in his early days (Heineken and all those) – were very much music driven, as much music driven as they were driven by the writing or filmic point of view.

NB: It does still seem that music is the main influence in advertising – certainly in TV and film advertising campaigns. It's always seemed to me, again coming back to this well of experience, that there must be some correlation between a certain kind of music or a certain style and the way that product is then going to be accepted by an audience. You make a product fit, even if it's toilet paper. How far are you able to lead under those circumstances? Can you actually go to somebody and say, 'Look, I think you want something a bit more like this'?

JA: Yes, it works like that sometimes. Quite often you'll find that you're presented with a film, and nobody has got the slightest clue as to what the music might be. It really can be a case of, 'We've put every conceivable style of music up against the film and nothing works.' Then sometimes you can have a brain-wave and say, 'This is what it should be.' There's a classic Volkswagen commercial that David Bailey shot in a health farm, where the girl comes out, and she's got chocolate lying on the dashboard. She slips down and eats the chocolate, and the slogan is, 'VW: if only everything in life were so reliable.' It was

very stylishly shot. They tried blues, and then they thought because this is in a sort of a boarding school type atmosphere they should have a St Trinian's type track. So I did a 1950s type thing, and that didn't work either. I sat looking at the film, and I suddenly thought, it should be a '30s dance band. So I wrote something in a '30s dance style, and as soon as we did it the whole film came to life. It was amazing. That was mine; that was my credit, but equally I've done things where I haven't hit the mark for whatever reason, and then they might go back to something else or go for a totally different style or play without music. On the Safeways commercials that are running at the moment – the little boy and the voice-over – we tried so many different types of music, and I actually said in the session, 'Look, maybe this is the wrong way; maybe this doesn't need any music at all.' And that's how it played. None of them had any music.

NB: What was it about that commercial that made you think that it probably didn't need music?

JA: It really was going in and trying it – trying humorous stuff, then little stings, then just having a bit at the end and then playing it all the way through. And it just didn't seem to do anything. It didn't seem to say anything.

NB: It must be the same in films.

JA: Sure, it's the same in films. You can write a tune on paper that you think is going to work, and then you put it in the film, and it just doesn't do anything. Conversely, you can have whole sequences that cry out for music but never get scored. You can only ever really see that when you watch the film completely assembled with all the score. I did a film in Moscow with Malcolm MacDowell. It was in no way a Russian production, but the director was Russian. Somehow the Russian conception of music in film now is very odd. It's very minimal, with virtually no under-scoring – dialogue is never under-scored. Music is always either bridging or at the end of scenes – in the same way that in their films they tend to show two people talking about what

they're going to do, and then they do it. It's a very stylised convention. I was called in basically to make the film European rather than Russian, so I was given carte blanche to score. I scored the sequence after the Tsar is assassinated in the family. There's a long sequence. The bodies are taken out for burial; they try and burn them, and they can't, and then they take them somewhere else. Then Malcolm MacDowell, who's main assassin, is standing there thinking about what he's done. I scored this four and a half, five minutes of film, and the director particularly said, 'This must not have any music. I feel very strongly it shouldn't have any score at all.' The English editor said, 'I think you're very wrong, but you're the boss on this. We'll dump it.' So the whole of reel ten had no music at all. Of course what happened was the scene played as if it was endless – just long turgid, long, long, long, long, long. When they ran the film at Cannes, the director came up to me and said, 'I'm sorry, I was completely wrong. It needed the music. I was totally wrong.' But then it was too late.

NB: Do you think that was because he actually felt that himself or because people had said so?

JA: I think it was the sort of conventions he was used to, plus the fact that he felt that the pictures said everything, because it was all there, but it did need binding together. It was so long, and there was no dialogue. It just needed the help that the music would have given it. Any composer will tell you they've sat through whatever it might be with no music on it, and the film was two hours longer than it ever is when it's seen by the public. It just goes on for ever and ever and ever. It's very much a gut feeling you get when sometimes you can actually say, 'Look, I think that might need scoring,' or, 'Let's leave that bit alone.' And not necessarily the logic of, oh well there's a fight scene here; let's have some music. It's not as simple as that. Each film has a different set of requirements.

David Pownall

David Pownall's plays have been presented by Paines Plough, the National Theatre, the Traverse, the Royal Shakespeare Company and in theatres around the world. He is also a prolific radio dramatist, and his particular interest is in the creative life of famous classical composers. He sees the composition of music as mirroring the work of a writer in its complexity, its need to attain perfection and the way in which it is shaped by the society within which the artist has to work. He describes the power of music as 'freedom without words'.

Composers

NB: What is it about composers that that has fascinated you enough to write several plays based on specific composers' lives?

DP: I think it started by using music in plays and working with composers in the theatre. The first play I ever wrote about composition was about the writing of a song – a group of folk singers who were trying to get a new song right that was written as a deliberately archaic piece of folk. The way the characters interacted in trying to get this song right, the battles that they had, and the issues about music – why they were doing it and why they felt as they did – got through to a very close friend who was an ex-composer, and who had kind of given up on it because it had driven him crazy. He, actually, by putting a story under my nose, got me interested in composers as such. This was the story of Gesualdo, from which I wrote the play *Music to Murder By*. That was more because of his intelligence than mine in some ways. He saw that there was a space there and a natural interest which I could follow up on and do something with. He just gave me a poke, and I responded. That, I suppose, started the whole process and has made me everlastingly interested in that relationship between composers and the theatre, and the use of the two languages, the language of music and the other language.

NB: Did your love of music come from a folk music background to begin with or have you always had a love of classical and folk and so on?

DP: I think that all first started from being a choir boy – though I was a pretty mechanical choir boy with a treble voice. I had a good ear, but I went to the kind of school where singing was good for you, but the last thing anyone wanted was for you to be taught music! Singing was good for the boys. I could sing, and I could pick up any tune, follow it and learn it, but I was never taught to read music, so it's always been a sort of battle to penetrate the mystique. Which is not a mystique really – it's something to do with language and the way the symbols work. By the time I got to university, I'd just started to piece together some kind of penetrating feeling about there being another music beyond popular music. My memory is still full of thousands and thousands of bad songs of the 1950s – occupying valuable space! – which I can't get rid of. I was just beginning to realise that there was this other world, this other sound world when I went to university, and fortunately, I did meet a few people with quite marked taste, one in jazz, another in opera. They realised my ignorance, sat me down and said, 'Well, listen to this!' So that began it, and then I slowly built up my own repertoire of taste and added things to it. It was a slow organic growth without any educational structure underneath it other than practice. I think in some ways that's really a help. I think too much formality in the knowledge of music can shut imagination down. You get too involved in that world, whereas I'm interested in the contact between the two worlds, between language and music, and between the stage and what goes on inside the mind.

NB: The response of an audience to music fascinates me, because it's something that is purely instinctive. They don't have to understand the notes – how the music works – it can be just something that washes over them. You say you've grown up with 1950s and 1960s tunes in your head. Do you think your emotional response to music comes from the dramatic side of those pop tunes, the way that those songs were full of passion?

DP: There were narratives as well. They told stories, and that's, I suppose, why I can remember them – and I can remember the

words. I can sing for hours the songs of Frankie Lane, Doris Day, and people like that. I can still sing all these songs, because they're telling a kind of story. Then, of course, that changed. By the end of the 1960s that had gone, besides which I'd changed by then anyway.

NB: Gesualdo was a madrigalist.

DP: Yes, he was a madrigalist, but what also struck me immediately was that I could tell that the sounds that he was making were very strange for his time, that he was a man who had broken through certain barriers and gone his own way. This coupled with his extraordinary life was enough to draw me as a playwright to him. I read this book in one hit on a train, got off at the other end and knew that I had to write a play about it. The book was written by a musician and composer, Peter Warlock, and the play I wrote was about Peter Warlock and Gesualdo. It was about the author of the book and the man he was writing about, so it became doubly complex – doubly interesting.

NB: If I remember rightly, the play was about the way Warlock was almost taken over by Gesualdo, as in a kind of Faustian relationship.

DP: Deliberately. He went out of his way to be taken over. He wanted that. He conjured it up into his own spirit in order to replace his exhausted persona as Philip Heseltine (who he was before), whom he considered to be knackered as a composer. He had nothing more to give. So, because he was interested in magic, and evidently believed in necromancy, he took the practical step of conjuring Gesualdo one way or another to occupy the vacancy. He became, if you like, a reincarnation of Gesualdo – with a distinctive English cast to him. What he got was his force, his energy, perhaps even his brutality. I don't think he got his inventiveness and true originality, but he got that diabolical thrust that enabled him to commit the great crime, killing his wife and lover, and then to write music which was perhaps essentially about that act.

NB: In a lot of your plays you do equate a sense of magic with the composing process – as if it is like lowering a bucket into a well, and up to a point the composer is at the mercy of what comes up in that bucket. Am I reading it right?

DP: Oh, you're certainly reading it right. I haven't really come across any composer who would disagree with that, even in these occasionally over-rationalised times where there's an organic or psychological reason for everything. I think composition in music is as much a mystery as it ever was, and it'll probably be the last bastion in the creative process to be broken down. That's a long, long time ahead. I think composers are listening to something that is from outside, and most of them seem to recognise that. To them it's a curse as well as a blessing; it's slavery as well as being something glorious, and there are times when they would do anything to get away from it, to escape from it. Then if it leaves them they're completely bereft. It's a very emotional rather than cerebral relationship, even if they write cerebral music.

Music in the Theatre

NB: Many of your plays don't involve composers, but you still use music as part of the drama. Do you think there is a point at which words fall down in trying to put ideas across, and the music then has to be there to support a particular idea or theme, or is it not as black and white as that?

DP: I used music a lot early on in plays. I was aware that I mustn't use it like film music, which I find very, very annoying – the underlining of manipulated emotions by music, as signals to the audience of what you've got to feel and think. I've never had any time for that at all. I don't see that it's a valuable function in the theatre, nor in film frankly. I'd quite cheerfully watch films stripped of music, unless they've tried to do something else with it. My early experiments were crude, and I think they depended on the 'cue for a song' idea – that once you'd decided you were going to use actors who could sing and play instruments,

you would have to work the text and the action to a point whereby it was credible that they would sing or play instruments. So those characters would have to have that ability built into their stage selves. Eventually I was writing plays about musicians, because they were obviously the only people who could do this! Otherwise, some perfectly ordinary character ssuddenly starts singing or playing an instrument. I began to get quite unhappy with that – to say this is absurd. For that reason, if I take a step aside, I find I find musicals and operas essentially absurd – which is perhaps part of their charm. But that wasn't what I was interested in. I didn't really want to be part of that world. So I was getting involved with actors who could do this. They stayed together as a group, and taught each other music as well as how to do a part. Actors who couldn't sing, or thought they couldn't sing, came into the group and they were taught to sing and play. It was just in the air; it was part of what we did. That was in Lancaster, at the Duke's Playhouse, and then in Paines Plough when we started it twenty years ago. Music was always part of what we did, and these were all people who wanted that. They didn't want extra skills they didn't use; they wanted to be able to show their voice and their instrument, and so I wrote in some ways to please them.

NB: I've always found that in theatre shows where songs have been used well, my response is raised to a different plane completely. I'm very interested then in what you say about having to justify dramatically these people bursting into song. On the one hand there are musicals, which you're not interested in; on the other hand there's Brecht, who thought actors should break into song in order to break that very realism that he'd set up. Do you think that what you have eventually come to is a mix of fantasy and reality worlds which can exist side by side?

DP: Well, I have to look at what I've done, I suppose. I think you should always do that – look at what people do rather than what they say. When I look at the plays I've written about music recently, they are about practitioners, and everything is real. So the music is coming from a real

situation on the stage. It doesn't come as a surprise – on the basis of a cue for a song or a cue for some music. I do work quite hard at finding those situations in any given play. In anything that I write, I'm always looking for the music. And it's amazing how it's there, because music is now so much a part of our lives. It wasn't so; it was part of the lives of a very select few, but since the war, it has been perhaps the most powerful cultural force if you take all kinds of music from popular to classical. Music is everywhere.

Needing Music

NB: Why do you think that is?

DP: I think it must be because we needed it. It must be because people wanted it – there was an absence there, a space. It seems to give people an enormous amount of joy; it seems to be terribly, terribly important. If you watch a child growing up you see that their musical allegiances become very important – quickly. Nine, ten, eleven, they're talking about the songs, the singers and the groups that they like. It's an extraordinary development, and I'm sure that just wasn't the case before.

NB: Before the war?

DP: Yes. I'm sure it's to do with technology and availability. The rise of popular music especially is what we're looking at.

NB: And you think there is something progressively emptier about society which music fills?

DP: I'm not sure that's the case now, because I think perhaps we're in a time when we're watching the decline of popular music. It's been replaced by certain systematic forms of popular music amongst the young, which I don't pretend to understand completely as yet. I suppose I'm scratching my head at the moment as to where it can possibly go, but I'm absolutely sure about the strength and the power of music since the end of the war. I was part of it; I saw it happen around me. It swept me along as well.

The 20th Century

NB: Do you feel that composers working now –
I'm not thinking so much of composers
working within the media, but composers
working with music which is personal and
intended for concert halls – do you think
they have a harder job than the composers
of the 19th century and previously, when
there was an automatic acceptance of
music? Now society's very defensive about
composers who are looked on as at the
cutting edge of what they do.

DP: I think there is a gap of comprehension
there. The difference between, for want
of a better word, the work of a *serious*
composer and that of popular music is
enormous. There's a great deal of
impatience amongst the average
listenership with what such composers are
trying to do, why they are wanting to do it
and how they define the sound that they
make as musical. These composers seem to
have no structure that listeners can
understand; they make no appeal to any
part of them that they can respond from.
All the things that people like in music –
strong rhythms, melodies, colouring and
emotion – seem to have been just pushed
aside in a quest for something else which
they don't really understand. What is it
that composers are looking for? Is it really
the world that we live in that this is a
reflection of? So I think composers have a
much harder time, yes. And I suppose they
feel very guilty, because they know that
they're appealing to as small a côterie as
any 18th century court composer scribbling
away for his piece to be performed in front
of a duke. It still applies. There is a kind of
a duke there who goes along and listens to
modern music.

NB: And also, one assumes, a patron. It has to
be commissioned.

DP: It must be very, very hard for composers –
and I know a fair number who struggle with
this, and nevertheless carry on. At times
there seems to be support there from the
older composers – the people who have
struggled and been condemned. There are
composers who are now commanding
respect and attention. Then you think,
well, perhaps it was always so.

NB: Who do you have in mind particularly
when you talk of composers now who are
commanding respect and attention?

DP: Well, think of the attitude to somebody
like Michael Tippett. This is a man held in
enormous affection and respect, and he's
managed to live to enjoy this turn-around.
It's hard to guess the future – whether in
fact everybody's going to catch up. I think
perhaps in this century we've taken an
enormous amount of time to catch up with
everything, including things like physics –
the way the universe works. All this was
sorted out around 1910, but people still
don't know how it works. They're still
struggling with it. It's eighty years ago that
this happened, but most people are still
Copernicans! That's the way they operate.
I think music's a bit like that. People just
take a long, long time to catch up. It may
be because of the power of the
communications media that popular music
is *immensely* popular. It goes out in a kind
of great deluge all the time, and anybody
now who's trying to swim through this, like
a small, young modern composer trying to
be heard, is having a terrible time.

NB: Whereas in fact the theatre is a very
fruitful ground for a modern composer to
work in.

DP: Yes, and some of them realise this, and do
their work there, because they can get a
good job where money is – and they've got
to live. They get attachments and
commissions in the theatre and the BBC.
The theatre and the BBC work quite hard
at giving that sustenance, because there
aren't many other places where you can get
it, I think.

Collaboration

NB: How do you yourself work with a composer
when it comes to finding the music for a
play of your own? Do you actually have in
mind the sort of music you're going to want
as you're writing? Do you hear that in your

head, and then say to somebody, 'This is what I want'?

DP: No, I don't. That for me would just defeat the whole object. That would take a lot of my fun out of the whole process, because my fun is in seeing what the composer will do – on which I'll have opinions, but not because it doesn't accord with what I expect. It will be because I think perhaps it's just taking the play in the wrong direction, or also quite often because it is going to run out of itself. I think music often delivers too quickly; the whole thing just goes down the drain.

NB: So then it becomes a process of trying to drip feed the effect the music's having.

DP: Yes. It's a kind of orchestration, because you're listening to the play as well as the music. I suppose writing a play and writing music aren't all that different, because both depend on movement. The sequences of music aren't all that different from scenes. There are dénouements in music; there are calm patches; there are furious patches; there are times when the action accelerates and when it slows down. So there is a certain parallel between the way that they work. I don't think it's necessary for the music to wait for the motions of the play. I think sometimes you can have almost a head-on collision that will produce something extraordinary. But I really do want something out of the composer. I want to be told something; I want to learn something rather than to have that control. If that was the case then I'd learn how to compose and do it myself.

NB: The discussions that go on between a composer and a writer or director will probably not happen in musical terms. They'll tend to be on an emotive or instinctive level. Does that ability to describe the effect of music come easily to you? Is it part of the writing process for you?

DP: I think it's part of the writing process. All writing is to some extent a guessing game – in terms of the creation of characters, the way stories apply to characters and the way people work. It's never over-defined, because there is an energy inside both the story and the characters that is going to produce surprises for you as the writer. You're not dealing with a science in any way at all. When people talk about formula writing, in a way there isn't any such thing. You are trying to create an organism that will operate in the mind of the reader, and the reader will apply their own judgement and filters to the story and the character. They will see what they're going to see. They will hear what they're going to hear. I think for me it's impossible to talk about the music in musical terms, because they are too technical, and I find it quite difficult to imagine composers doing this between themselves. So in no play have any of my composers spent a lot of time talking in terms that the audience can't understand. That would be defeating, and it would sound a bit like some of the worst aspects of Radio 3. That would be building a wall over which the audience – my audience – couldn't climb. And I don't think any composer would expect that of you, or want it of you. They know that in many ways that kind of discussion comes long after the creation of the feeling and idea that will produce the music, so they would never come to me for technical guidance. What they'll want to know is what I think of it when I hear it, and what it does to me. That's their interest. So they'll ask me questions about the characters – 'Why does he do this?' or, 'What is he feeling at this moment?' 'What does she expect?' or that kind of thing. Or, 'I don't understand this,' sometimes! 'Why does this happen?'

Composing and writing

NB: You have a tremendous facility for seeing inside the mind of a composer. I'm thinking particularly of the wonderful scene in *Elgar's Rondo* where Elgar is sitting there with the aeolian harp. The process of composition came across simultaneously as an absolute joy and, as you were saying, also a curse. It amazes me that you have that facility to to see how that feels without being a composer yourself.

DP: It's to do with the fact that it isn't all that much different from writing plays or books. I think the way it affects you in terms of the blessing and the curse is the same. Writers are not dealing with, if you like, voices that are telling them to write, whereas composers, I think, often are. They are not just mechanically producing a piece of music that works to some kind of geometric pattern. I think all of them are aware of the fact that the music is being composed outside their immediate control. With plays and books you get that once you've battled through opening the thing up, establishing it, creating characters, giving it a push and letting it go. I suspect that with composers it's much more initial. There is a sound that will come to them and will define what they're going to do to a much greater extent than in writing a play or book. I know composition is very hard work, but it does have that kick-start element that writing doesn't.

NB: How do you feel about composers working today who are composing to order, who aren't working for the concert hall but are writing music because it has to fit that advert, that programme or that film? Do you think it's the same process? Are they also lowering a bucket into a well?

DP: I think there has to be an element in all music that is the same, because the composer is making something that wasn't there before. Although it is music to order, it can't be completely imaginable by anyone else, otherwise someone else would do it, and they wouldn't need a composer anyway. I have enormous sympathy with people earning their living. It's possible to write good music for that kind of thing, and I think most composers would go along with that. Writing the music for a commercial isn't all that removed from writing for the theatre or for film. It's very difficult to condemn anybody for writing music!

NB: Is there any composer who still fascinates you about whom you haven't written?

DP: Obsessions never leave you, I suppose. You'd be worried if they did. I've just written a big play about Brahms for radio.

It's called *Brahms on a Slow Train*. We haven't recorded that yet. And I'm writing another radio play, called, *Pound on Mr Greenhill*, which is about Ezra Pound and Monteverdi, and is set in Venice. At the end of his life Pound lived in Venice. In the play he spends all his time going round churches to listen to Monteverdi, because Monteverdi, as far as he's concerned, had the same kind of problems that he has. He was somebody who changed music as Pound changed poetry. Pound thinks Monteverdi thrived, and ended up understanding himself, whereas he has ended up not understanding himself. Those are two quite big plays, and I'm writing another radio play about Louis Armstrong – which is probably about the most difficult play I've ever tried to write. The Brahms play I've done, but the other two I haven't finished writing yet. We'll do the Louis Armstrong play in America. It'll obviously have to be done with American accents. And somebody is going to have to imitate that incredible entertainer – that voice and that presence. So that will be interesting.

NB: Your plays tend to focus on a process of change in a personality, in a life. You can see it in *Elgar*, in which you've picked up this wonderful point at which he wanted to write a piece of music which was hopeful and optimistic, and couldn't – the music simply wouldn't come in that way. I'm interested to know at what stage in Brahms' life you've found the sense of a move.

DP: It's when Clara dies. She was the woman he loved all his life from the age of twenty, but whom he never lived with. He gets the news early on holiday, up in the Alps, and he has this terrible rail journey – with all kinds of problems with slow trains and missing connections – to get there to attend the funeral. It's really about their relationship. It's a very strange train! There are some very odd people on it, as he finds out as he goes along. By the end of the journey, the whole relationship has been uncovered and looked at, both dramatically and in terms of his music. It's about the essential spirit of the romantic – this great bachelor romantic – and the nature of frustration and creation.

George Fenton

George Fenton began his career in the theatre, wrote music for television, and went on to a distinguished career scoring feature films, receiving Oscar nominations for Gandhi, Cry Freedom *and* Dangerous Liaisons. *He works mostly in Hollywood, and our talk concerned not only his working methods but his experiences dealing with the Film Factory itself.*

Spotting

NB: Can we start off by talking about the spotting process. When you come to a film for the first time, and you're sitting in the screening room with the director, what are you looking for in a film, as a composer?

GF: Well, of course I will have seen the film a lot of times myself before I officially spot, but it's a very good question, from my point of view anyway (and I'm sure everybody works differently), because I do very much use the spotting of the film a substitute for structure. What I use it for really is to decide the architecture of the score. I think it's important to do that, because if I try and work from an overall thematic point of view outwards, I find that more often than not I can't necessarily find the outlet in the right places for the theme that I've written. There are films that demand one theme, and they need that theme to be played over and over again. Of course that's a great opportunity for a composer. Either I don't see them like that or I haven't had many of those kinds of films to do. I think when a film is complex that spotting can identify (a) the architecture and (b) the music's changing role throughout the film. I think that music still has an old-fashioned role to play in a film – the traditional role, which is to act as an interpreter of the film in various different ways for the audience.

NB: You mean old-fashioned like a melodrama?

GF: Yes. In a silent film the music was there to illuminate what was being said – or not said – but what had been written and was being acted on the screen. I think music still very much has a role to play in that way, and that that's a complex thing.

When I, for example, work for Stephen Frears, I spot the film on my own, because he's a reactive director, and he likes to know what my whole take on the film is. In other words, he wants me to (this is his phrase not mine) 'read the film,' and he's interested in my reading of the film. I think that a composer has to do that. You have to be able to read the film and identify where you think the emphasis should lie and what its strengths are, so that you capitalise on those minimise its weaknesses. All of those things you can do. You can inject pace; you can inject tension; you can inject a sense of shortening a time span on the screen or lengthening it. You can do all those things, and really what you need is an overview of what this film will be like when it's finished, just in general terms. In Hollywood, the spotting process tends to be much much more formal. Directors normally have a very clear idea of what they want and where they want it. You go to a meeting there, you sit down for probably two days (because you've got to go through every reel), and the director says, 'I think we need something here ' It's like a shopping list. You say, 'Thanks very much,' and off you go. If the film is constructed in a perfectly straightforward way – you know, acts one, two and three; resolve, happy ending; the second biggest moment at the front of the film – the usual shape that everybody learns about on film courses at Harvard or wherever they go – then you can just spot the film like that. You can say, 'Of course, it needs this, and this theme, and de da da da dum,' and go away from that session. I suppose what you can do then is channel all your energies into thinking of a really good piece of music to fill that spot. I think that one of the things about working with certain directors is that, if you're involved in the actual process more – the post-production process of bringing the film out; in other words, if you have your own view about the spotting – you're assuming more responsibility, rather than just being a gun for hire. You're saying, 'Well, shouldn't it be this and shouldn't it be that?' It's a much more conceptual school of film-scoring. So it will take you much longer to write the score, because you're part of the film-

making. NB: I assume you prefer that in films rather than being for hire.

GF: I do, although I don't dislike either – and when I'm in the middle of one, I infinitely prefer the other! It can be very very exhausting, and you get fed up with the film. Obviously, everybody does. But it is good. It's a fascinating side of the job. It teaches you a lot about film-making and about your own feelings about things. There comes a time when it becomes my film, and that's one of the reasons I cannot bear the preview process going on and on and on, which in Hollywood studios it does. It means that your film never settles down. In Hollywood studios, the post-production process of film-making hasn't really changed. Basically, the film comes off the floor; the editor has X weeks; the director has X weeks with the editor to get his cut; it gets shipped off to the sound department; it gets shipped off to the music department; it then comes into the dubbing theatre. The schedules, haven't really been changed either, but into that you have to inject this new factor, the preview. Now, previewing isn't a new thing. They've done it for years. They previewed Sunset Boulevard and re-shot because of what happened in the preview. But although the process isn't new, the way the previews affect post-production to the degree that they do, is a newish thing, and an increasingly important factor. If you have a preview three weeks before the dub, and you want to re-cut the entire picture and re-conform the sound, all you've got to do is throw people at it – you can open ten cutting rooms with thirty people in there, and they can turn the whole film around in a week. But with the music, although it's theoretically possible to do the same thing – throw thirty orchestrators at it – for a composer what situations like that tend to do is deny you time when the film is your own. It happens far more during that time, for me anyway, than it does in any of the early meetings – the official spotting. Also (I don't know if this is the same for every composer, but I'm sure it is in the main), by the time they get to doing music, there's really nothing else much happening, and so you do work with the director. You can see him on a daily basis if you really want to,

and in fact he probably wants to see you on a daily basis, but you try and stop him coming round too often because you need a bit of space!

The solitary composer

NB: If the film's going to be re-cut, the architecture of the music must go out of the window.

GF: It does. Composing is a very solitary business; film-making is a very un-solitary business – very cooperative. Composing is a very precious business; film-making is very un-precious. A film composer has constantly to juggle the sense of preciousness and the lack of preciousness. You have to be incredibly robust about what you do. Somebody's going to come in and say, 'I don't like that cue,' or, 'Can we start that cue later?' and you have to be incredibly robust about how to make that work. It's no use standing there saying, 'But I love that first minute,' because nobody's interested. You just have to say, 'OK, right, and therefore it's going to be this.' You have to be very, very flexible and not take things badly. At the same time, every single moment you get when you can do something, you have to take it back to yourself and give it everything you've got – for yourself. People think you can knock film music off. Well, you can't. Although film is a mixture of all these elements, if the elements themselves sit happily with the others and are part of it, but also have an intrinsic quality of their own, it shines. It makes that part of the picture glitter a bit more. If you have a wonderful performance, the performance lights up the screen. If you have a great set designer, the camera-work looks fantastic. Of course it doesn't actually matter in a larger sense. 'Who's doing the camera work?' 'Oh, so and so.' 'Is he good?' 'Yes, he's great.' 'Fine.' But there's a difference between that and, 'Well, have you seen this film? The *camera* . . . !' You constantly have to rock between being intensely private and concentrated and really trying to do your best for yourself, and at the same time being prepared to wrestle with all the cooperative problems that you get from being in cooperative art.

That's its dynamic. That's what I think is fantastic about it.

NB: That is the plus for you, is it?

GF: Yes, it's the most invigorating thing. To me, the most thrilling music in the repertoire is music that's been written for a reason. It introduces a dynamic, and when that isn't there you're always left with a 'Why?' question mark in your head. When you see something, whether it be Handel or Bach or Haydn or Mozart or Stravinsky, the virility of the music is partly, I think, because it had to be done for this, and it had to be done by then. That gives it an edge, even if it's not great music. It introduces an edge and a discipline that makes you work, and I'm very grateful for it.

NB: In a film, the music has to stablish itself and its intent 100 per cent right from the start of that cue, as opposed to working up to that.

GF: Yes, it does, although I think there are ways in which scores can creep up on you so that they add up to more at the end than you've got from the very beginning. There's always the question of what is right for the picture that's in front of me. A lot of directors will ask, 'Why is it that the composer's always brought in so late? Why can't I work with a composer from day one? I'd like music written to shoot to.' People do have music written to shoot to. I find it quite a hard thing to understand. Not that I haven't written music to shoot to. I have, but it's always been for a specific reason. In *Shadowlands*, I had to do an anthem to shoot to, because it was the opening of the film. But I knew that it had to be an anthem, two minutes long, sung by the choir at Magdalene College Oxford, sounding like a 16th or 17th century English anthem, in Latin text – because we didn't want the words to become part of the script. It had to start like this, it had to end like that, and a boy treble had to sing a solo in it. Indeed, if you sit down and write a piece of music for no reason at all, obviously you have to work that out too, so I'm not saying that no film composer can sit down and write a piece of film music on

his own, because that would be childish, but surely the purpose of film-making is that someone writes a script, and someone interprets the script in terms of setting that up as a film. You set the camera up on the day, and the camera-man lights it, and things change. The actors come onto the set, and things change. They act, and you look at the rushes, or the dailies, and things have changed again. The editor gets it and cuts it, and things change again. Then the composer comes along, and things change again. The composer's job is to take what has come through – the line that's come through this whole changing process – and make what this film now is, accessible. I don't mean in a cheap way, but accessible moment to moment for the people who are going to come into the theatre and watch it. That's the tradition of cinema, that the musician has that interpreting role – when to unlock certain feelings. Writing music before, makes it rather like a music video to me.

The common language

NB: What is the key in to people's reactions that the composer has, and nobody else has?

GF: I suppose the common language really. Of all the art forms available in cinema, music is the most seductive. A cinema audience, because of the traditions of cinema, enter into a conspiracy when they enter a theatre. It's an irony that techniques of film-making have gone further and further in making things more realistic: better special effects, more life-like, more in your face – and yet there's this conspiracy between the audience and the film-maker that no matter how real life on the big screen has become, we will have music! It's very interesting. And because we always have music, we sometimes don't have music, and that's OK too, but that's part of the music – if you see what I mean. When I make all these grand statements like 'architecture of the score,' 'read a film,' you can say, 'What a load of pompous crap!' But I don't necessarily mean that a film has to have music the whole way through, because I think that the sections without

music are just as much a responsibility as the ones with music, in the sense that you have to say, 'Well, there is no music there because…"

NB: When you're writing for a particular scene, are you writing in effect for you? Are you writing for an audience that is a grey mass out there – or is it something even more nebulous than that? You obviously understand what music is necessary to make that emotional or instinctive cut through.

GF: That is a particularly interesting question, because the thing that I'm constantly asking myself is where I myself stand culturally vis à vis film-making. I don't have a problem if I'm doing a film for Richard Attenborough, because his sensibilities are wholly centred in him as a person, in his emotional responses, his Englishness. He has a very strong and, I think, attractive viewpoint. He's also mainly appealing to an audience that isn't a dating 15 year-old – which is why his films don't take $100 million at the box office. It doesn't make them less valuable as films. But if you are doing films where the expectation (or the hope) is that they'll take a hundred million, I think, you have to be prepared to re-invent your own responses to both film and music. Where would I have been, doing a film like *Groundhog Day*, if I'd started off the conversation by saying, 'Well, I don't like pop music"? Or, 'I can't stand country and western"? A really important aspect of film music is that you've got to say in the end, 'I think it should be that, because I think it's good.' In other words, you've got to have some sense of quality control over what you produce. A very dangerous thing, and quite a common thing – it happens all the time – is when people say, 'Oh, so and so's doing so and so.' 'What's it like?' 'Oh, you know, it's a so and so score' – his name. It means, we've heard it before. Somebody's made a new film, but the composer hasn't moved the goal-posts to accommodate it. Then people get tired of that music. They say,"Well, you know, it's always worked; it's nice music, but there's nothing fresh about it.' You have to try, if you possibly can, always to start from the beginning. I don't

think you can change yourself. I can't write music that sounds the same as the music that Thomas Newman or Hans Zimmer writes. I could, as an exercise, sit down and write something that sounds like their music, but I couldn't write it in a film score. I would just do it slightly differently – and they would do it differently from me and each other. But you can take things into you and try and use them, try and do things that perhaps can appeal to people who aren't you, and still see them as being valid. At the same time, I'm totally against gratuitous gestures – 'Let's give 'em a pop song.' People (of any age) can see through that kind of bullshit straight away. People like things that are cool, hip, and that means things that work. It doesn't matter if it's old-fashioned, new-fashioned, ethnic, vocal, orchestral, funk, techno, jungle – it doesn't matter, if it's good. I think it's very dangerous to ignore the expectations for the product, and you should enjoy them really. You should say, 'Isn't it great? I'm doing a Hollywood comedy.' I am doing a Hollywood comedy actually, quite soon, and I'm thinking isn't it great, because it's a whole different set of pressures. I'm making a film for a mainstream audience. I very, very seldom go and see anything that I've done in the theatre, but, because I was working out there, I did go to *Groundhog Day* on the Saturday night of the second weekend that it played in America. It was a big commercial success. I went to Westwood and saw it in a huge theatre at about 10.00 at night. It was packed out. The credits came up. I wrote for the beginning, this daft parody of a Nino Rota march. This thing started up, and the audience started clapping in time with the title music. They were having such a good time in this film. Every musical joke I made, got a laugh. It was just ridiculous! I got such a kick out of thinking, 'How nice that it connects!' There are certain things in your own culture that you know connect. If I write the music for *Dangerous Liaisons*, I know who that music connects with, and that's great. When I did all the Handel for *The Madness of King George*, I knew who that would connect with. But the challenge is to make it connect with people it wouldn't normally connect with, for them to like it, for a kid in the cinema

to sit there and say, '"Zadok the Priest" is a really happening piece of music.' That would be very, very nice. Part of being flexible, and what makes you have to work hard as a film composer, is that you keep saying, 'Oh, I see, I thought it was this doing film music, but now this film's come along, and my job *is this*. And I don't know how to do that, so I've got to try and start again work out how to do that.' Each one that comes along
has a different set of problems.

Variety of work

NB: Has that always been the case, or do you feel it's increasingly the case now that you're going into a completely new field with a specific film?

GF: It's nearly always been the case that I've done different things. I put that down, curiously enough, to the fact that I'm English, and the generation of film-makers that I grew up working for in England are incredibly magpie-like in terms of what they're prepared to borrow culturally in order to tell their story. England isn't somewhere that has traditionally celebrated its own culture in film. I do films for Ken Loach. I did one that was set in England, the last one was set in Spain, and the next one's set in Nicaragua. I've worked a lot for Stephen Frears. The film I've just done for him is set in Scotland.

NB: That's *Mary Reilly*?

GF: Yes. The one before that was about the American media. The one before that was about France in 1780. That's great, isn't it? That's fantastic. I suppose I've gone on like that because I've got known for doing those sorts of things. When I'd done *Cry Freedom*, I was offered quite a lot of things set in Africa, but I wasn't particularly interested in them, because I'd done *Cry Freedom*. I'd rather try something else. There are people, particularly in Hollywood, who happily and successfully go on doing the same kinds of films over and over again. It's their genre; they like it; they do it brilliantly well, but I can't

imagine what they do besides that, other than lead a nice life.

NB: Has there ever been a time when, as you've been working on a film, you've lost sympathy with it – found that you have less in common with the movie, so that the music then becomes like drawing teeth, or have you always found that your facility to bring ability and enthusiasm to the score can always override a situation like that?

GF: There are times. I think there's a time, first of all, in every film when you feel it's too hard to do, but that's a natural thing. That's because you don't want to step into the pit of despair. That's the same for anybody writing anything, I'm sure. But there have been times when I have become frustrated because I can't, in my own terms, crack the film. I begin to hate people in the film, to the point where I almost can't bear to watch them – there have been times. But it's usually a passing phase. They annoy me, and I realise later that actually what it is that annoys me is that somehow something in what they're doing is stopping me getting to the top of the hill. Quite often it's actually because of something structural. In the film there's something that somehow just doesn't jell. Say, someone drives up to a house, gets out of a car and you cut to a close-up of someone looking at them, and you think, 'Well, why are they looking like that?' What's wrong actually is not why they're looking like that, it's the fact that the film shouldn't have cut to them until the person getting out of the car had said, 'Guess what?' There are people that I work for with whom I can, and do, go into those issues. I'm ashamed to say this really, but I do say, 'Look, excuse me, but when I see that shot, it tells me this. Is that right?' And they say, 'No, that's not right.' I say, 'Well' And then they say, 'Oh, well, maybe I should change it.' And they change it.

NB: That's fascinating, because music, somehow or other, is an absolute lie detector.

GF: Absolutely. Now you've said it in one sentence. It is a lie detector. It sounds as if I'm so grand, but I'm only saying it because

people are so incredibly willing to remain open and let things evolve – I have had people move whole scenes when I've said, 'You ought to move this scene.' Music's such a clear way in to the internal rhythm of a film, the pulse of what's going on – on a very basic level, not an intellectual level. I suppose as you work with somebody more, and you get older, you're invited more to comment, because you've done a lot of pictures, whereas when you start out, you don't open your mouth to anybody. You just say, 'That's it, OK, great, goodbye,' and go away and write. Even now there are people I work for to whom I wouldn't consider it my job or my place to say anything at all. But I think the composer has a responsibility to the film-maker. He's the last person onto the film, and therefore he has an important role as commentator and can be very useful to a film-maker.

Collaboration

NB: I wanted to ask you finally at what point you decide to use received music, music that already exists – for instance in *King George*.

GF: It wasn't my decision in King George. But in terms of other received music, like a song, it's this dual role. On the one hand you want to write music yourself; on the other hand you have to be broad-shouldered enough, or big-hearted enough, to stand on the other side and say, 'Well, if it was my film, would I want this song?' If I would, because it's absolutely great, then I've got to somehow embrace it. Obviously, in some ways received music has an effect on your own work within the film, and certainly on other people's perception of your work within a film. But I think it can be very, very important, because there is no new music you can write that will have the same power of association that existing music has. When you use received music, it's very seldom other film music – obviously. It's nearly always other music that exists as music qua music. Often film music is one part of a picture, so it doesn't necessarily have all the strands all the time. It doesn't necessarily have the completeness or formality that music

written for its own sake might have. When you use that music in a film, whether it be a song, a piece of classical music or a jazz track, it brings to the film a much more dominant musical presence, because it's uncompromised. And therefore it can be very, very effective in set pieces, as, for example, in *Dangerous Liaisons*, where the Bach harpsichord concerto is used for the French farce bit with the key in the middle of the film. Although I cut it up a lot, adapted it, its incredible vivacity, and the fact that it is complete in its own terms, mean that it literally drives the film in a way that probably whatever I'd written score-wise wouldn't have done in the same way. That's an example where it was a choice, and I thought it was a good choice because there's a kind of confidence to the music which somehow makes the audience relax into the idea of it. If you score something that's farcical, you're relying on people enjoying it. If you use scored music, you have to have had the opportunities before in the film to build up the perception of the score to the point where you can turn it on its head and make it do something. If you haven't had that lead-up in the right way, then you're in very dangerous territory, because the audience just might not particularly enjoy it. If you use existing music, it's as though it tells the audience that the film-maker's saying, 'Look, we're just having a bit of fun now.' The presence of existing music lowers the anxiety level about the way the sequence delivers, because it's operating on more levels than simply the film's terms.

NB: I think in *The Fisher King*, with the Terry Gilliam vision of epic legend going on in New York, the music was carrying very much that sense of a timeless legendary world, in spite of the fact that they were all walking around in Manhattan. Does that kind of irony come relatively easy?

GF: I think in the case of *The Fisher King* that kind of madcap legend approach is much more because of Terry. That's his vision really, and I just was trying to emulate his vision of the film. It was full of wonderful ironic opportunities. Such mind-blowing experience throws up opportunity after opportunity. Terry Gilliam is a really

phenomenally gifted film-maker. When it's disciplined, he's not distracted, and he just gets it right, it's fantastic – and fantastic to work on because it's really vibrant, and such a happening-looking thing to work on.

NB: Is he reactive to you in the way Stephen Frears is?

GF: He's more demonstrative. He has a lot of input. He's obsessed with the project, and clear about what he wants. That doesn't mean you can't discuss it, but he is very much on top of what it should be and what the possibilities are. He's all over the place with it, and that's his personality. Very, very different to Stephen.
But then they make very, very different pictures.
The films they make reflect their different kinds of approach.

John Schlesinger

Distinguished British director, John Schlesinger, has been working in Hollywood since the early 1960s, making such classics as Midnight Cowboy *(for which he won an Oscar),* Billy Liar, Far From the Madding Crowd, Marathon Man, Yanks *and* Madame Sousatzka. *He is passionate about music and its use in film, and, interestingly, provides a view of the composer-director team which is mirrored in the subsequent interview with Richard Rodney Bennett.*

NB: What is your method of working with the composer on a film?

JS: I like to think of the score for a film as early in production as possible. This has not always been the case, and I sometimes have been obliged to engage a composer when the film has been finished, but this is not the way I prefer to work.

I will not see the first cut of a film without a temporary score added to the picture, because watching a film silently, in places where you know music is going to play some part, is extremely misleading and depressing. For example, while I was shooting *Far From the Madding Crowd*, I would have the radio on in the car, tuned to a classical station, on the way to a location. One day I heard Gustav Holst's *Somerset Rhapsody*, which is a delightful piece of music featuring the oboe, and I felt it was exactly the style we were looking for, for the score. Most composers don't mind if you show them the film with a temporary score with other music on it. At least you can point them in the right direction. In the case of *The Falcon* and *The Snowman*, Pat Metheny was engaged to compose one of his earliest, maybe even his first score, for the picture. He came to Mexico City, where we were shooting, and we showed him a sequence of the film with his commercially recorded music on it. He then went away and sent us back a tape with some ideas which were immensely helpful. In the case of *Midnight Cowboy*, we asked John Barry to write the score for it, but we already had in mind Harry Nillson's 'Everybody's Talkin', which we had on the first cut of the film. The head of music at United Artists, when he heard the LP that we were using, said that anyone could write

such a song. We spoke with many people, all of whom came up with ideas, but none of them fitted the film as well as Harry's voice singing the theme song. Both the lyrics and the rhythm of the piece fitted the film perfectly. Both John Barry and Harry Nillson themselves, collaborated on an original theme song, the rights of which were to belong to UA, and they came up with something which became quite a success – 'I Guess the Lord Must Be in New York City' – but it still wasn't as good as 'Everybody's Talkin''. When United Artists executives finally saw the film for the first time, with the rough music track, they were both impressed by the film, and in particular by the theme, which they had forgotten they had heard. So the synchronization rights were immediately purchased, and Nillson himself re-recorded the whole score and composed another theme for the film, which became very successful.

NB: What in your mind is the composer's job in the finished film?

JS: I've always found in post production that the moment you listen to the fully orchestrated score for the first time, the film starts to come together in a way that you could only imagine. Because I have a fairly extensive musical knowledge, I am either a bane or a help to most of the composers I work with, because I can tell them immediately what I do not like or what I think works, and if a piece of music has to be re-orchestrated, they are given definite reasons why. Many directors are very wishy-washy at this stage of the proceedings, but it is one of the parts of film-making I find the most exciting. To me the score must add another colour to the film. The music should not be adding pink to crimson but rather something that elevates a scene or a sequence to the right dramatic temperature, to help support the scene. I have several times worked in the thriller genre and have learned a certain amount about what to tell an audience in the story-telling, and music can help this enormously.

NB: Do you have any views on the use, over-use or mis-use of music in film?

JS: I sometimes think that music is very over-used. There are moments in some of my films where I did not have the confidence in the scene standing on its own and have used music where I shouldn't have done. Occasionally, I have discovered this before the final mix and have removed the music. But in many films I have noticed over-use of music and at much too loud a level. In the old days of the studio system, when the director probably wasn't even present for the mix, I found the scores almost endlessly wall to wall. They told the audience exactly what to feel at every moment. For example, although for Lean's *Lawrence of Arabia*, Maurice Jarré had written an extremely good theme which was used with a very large orchestra, several times in the movie I felt that the same theme played on a single instrument might have emphasised the loneliness of the desert.

NB: Which of your films are, to you, the most satisfying in terms of how the music worked as part of the whole experience?

JS: It would be invidious of me to select any of the films that I've made for its music, as I have enjoyed working with almost all of the composers who have been commissioned to write the score. I have very fond memories of working with Richard Rodney Bennett on *Far From the Madding Crowd* and *Yanks*. Pat Metheny wrote a wonderful jazz score for *The Falcon and the Snowman*, though we didn't agree on the music for the final sequence. One of the dangers of using the music from a temp dub is that you become wedded to that particular piece, and sometimes it can't be bettered. In the case of *The Falcon and the Snowman*, there was a final piece of commercial music, also by Pat Metheny, which I felt he never improved, and the piece he wrote especially for the film was never used, much I think to his frustration. I also have very good memories of both *Midnight Cowboy* and *Sunday Bloody Sunday*. We used a single synthesizer for *Sunday Bloody Sunday* and repeatedly used a trio from Mozart's *Cosi Fan Tutte*, which added considerably to the success of the

movie. In the case of my films of suspense, I particularly liked Hans Zimmer's score for *Pacific Heights*, which kept surprising me when I first saw it on the film. I can't leave out James Newton Howard, who contributed mightily to the success of *An Eye for An Eye*. I expected thinner orchestrations, but he had scored the film for over 90 musicians, which I thought a little excessive. But when I heard the final mix it was just right.

Richard Rodney Bennett

In a career spanning 40 years of film, television and concert work, Richard Rodney Bennett has produced distinguished work, including Oscar-nominated scores for Nicholas and Alexandra and Murder on the Orient Express, and has composed for directors including John Schlesinger, Ken Russell, Mike Newell and Sidney Lumet. Our talk covered his early years of working in film, during which he learnt the art form, and his views on the scoring of films in the present day. He received a knighthood in the 1998 New Years Honors.

Early days

RRB: I came from a musical family. My mother was a professional writer, had been a professional singer, and so although we lived in the country and it was war time, it was always impressed on me that I should write music from what was around me. That's to say, I didn't make that awful mistake which children make of taking a huge sheet of paper or an exercise book and writing *Symphony No 1*. They have no way of turning that page. So I wrote music for songs that one of my sisters could sing – and she also played the oboe, so I wrote her oboe pieces; piano duets I could play with my mother; pieces for the local choir, and then pieces for the school orchestra and the school choir. It was always writing with a view to having it played. I don't mean for glory or anything, but it was a very practical commitment to composition. People say, 'When did you decide you were a composer?' I never decided I was a composer, any more than I decided I was tall. You know, I was tall. I knew that I couldn't earn my living by writing concert music – art music. Also when I was at a very impressionable age – around 16 (that would have been 1952), that was a time when all kinds of exciting things were happening in film music. When I was a student, I particularly remember seeing *East of Eden*. I remember one or two things with jazz scores. When I was 16, I saw *On the Waterfront*, and I remember sneaking out of school and going to see *A Streetcar Named Desire*. We thought it was a dirty film – you know, it was a teenage thing. Actually it was a wonderful film, and I was knocked out by the music. And the thing about those

scores, *East of Eden*, *A Streetcar Named Desire*, *On the Waterfront*, and also a lot of other things that happened in the 1950s, was that they spoke a language which had something to do with contemporary music. I had no interest in the traditional language of film music – that mish-mash, if you like, of Rachmaninov and so on. I'm not putting those composers down; that was what was being done in those days, but just as, for example, design changed a lot in films in the 1950s, and the style of acting, so too did film music. And to hear the score of *East of Eden* (which apart from having a very good tune also spoke a language not unfamiliar to somebody who knew the music of Schoenberg, Bartok and Rosenmann – who was a pupil of Schoenberg) was electric. I always liked the cinema from when I was a child, and suddenly – well I don't know if it was suddenly – but I realised that this was an area where I could work.

My father wrote various text books on drama, and he did a lot of amateur play production, so I remember, even in Devon during the war, lots of plays that he produced. He wrote a book called *Let's Do a Play*, which is a classic text book for amateur drama. It wasn't a theatrical family by any means, but this combination of music and plays was always familiar to me. When I was a child I was really much more interested in making model theatres, for example, than I was in music. Music was in a sense too close to me, because that was what I did, but there was a glamour about the theatre.

When I was at the Academy one of my teachers was a wonderful man called Harold Ferguson, a composer and pianist. He was the one who was responsible for recommending me to John Hollingsworth, who was the other musical director in those days. Muir Matheson of course held the reins. It wasn't until later that I worked with him, and that wasn't a very happy collaboration. But John gave me my first film. I had actually done a little bit of fake film music, just to amuse myself, to pretend I was really writing a score, when I was about 17. I got hold of a score for a pre-war documentary. I can't remember

what it was about. The score had been composed by Walter Leigh, a very good composer who was killed in the war. I don't remember his original music, but it had the timings in the music sections and the description in the script, and I wrote a little pretend score for that. So when I met John Hollingsworth I was able to show him a bit of film music. That was very important, because if I'd just shown him a string quartet, he'd probably have said, 'Well, this is a very talented boy, but I don't know if he can do. ...' But he could see something approaching film music.

NB: Was it influenced by Rosenmann?

RRB: Oh, no. It was very much the English pastoral school of film music! He gave me my first film, a documentary about the history of insurance, which goes back to the Great Fire of London. I mean it's a giggly idea, the idea of a film about insurance, but actually it was nice, because I was writing disaster music.

Another contributing person in this film writing thing was Elizabeth Lutyens, whom I was heavily influenced by from the age of 14. She was an absolutely electric woman, very difficult but very talented, and a very inspiring person for the young – and she was an inspiring person for the young until she died in the 1980s. I knew her when she was doing quite a lot of documentaries. I used to come up from school at half-term and spend the day with Liz, and it was wonderful. It was like being in the workshop of a really professional composer. She'd be going off to her recording sessions, and it wasn't exactly Warner Brothers – it was Beaconsfield Studios – but it was real. It was real music-making. She never gave me any film work, because she was in desperate need of money herself, but I looked at her scores, and she taught me a lot about things, like notation and how to deal with cue sheets for a film, how to approach it. She had a very healthy attitude to film, which I think that I've always had, which was that it's a high class of journalism. It's an imaginative kind of journalism. I've never thought of my film music as being

important in any way. I don't even really like it being taken out of context – but sometimes, with *Orient Express* or something, it works. Unfortunately, I never do enough music in my films for it to work as a CD. They have to make it up with other bits of film that I've done. Albums are OK, but when you've only done 40 minutes' music for a film, which is enough for most films, and you have to do 70 minutes' music for a CD, you have to think.

I went on doing films, and I gradually graduated from documentaries. I did a couple of B pictures; I did some terrible feature films, but it didn't matter. I knew that it wasn't important music, but for me it was infinitely glamorous, and it was wonderful to have to write music that was going to have to be played next week – and being paid for it! I remember the first cheque I got, which was £100. It was just amazing that I could write something that I enjoyed so much and have it played – and Leon Goosens was the oboe player in the orchestra, and John Hollingsworth was very good to me – and be paid for it! It was marvellous. I'm not an ambitious person as such, but being a professional composer was everything that was glamorous to me. I worked a bit for Muir Matheson, and that wasn't a very happy experience at all, because Muir was absolutely locked into what to me then was the very old-fashioned kind of film music that went back to the 1930s. Remember, I was 19. And it was always the symphony orchestra with the horns and the four strings. Anything that he could vulgarise in those scores he would do – more crashes and more drums. If the strings were playing a sustained chord, instead of a sustained chord he'd have them all tremolo to inject old-fashioned drama into it.

NB: It would be looked on now as clichéd film music.

RRB: It was clichéd film music. And I know that Muir worked with William Alwyn and with William Walton. He worked with very, very good composers, but nevertheless what he was doing was promoting a kind of film music that was

long, long out of date. And he never saw films. I remember once telling him about some score I'd heard – it was something major. (This was around 1960.) I said, 'It was a beautiful film, you must go and see it,' and he said to his secretary, 'You must go and see that.' He would never have crossed the street to listen to anybody else's film music. So our collaboration didn't last very long. Why it fell apart was because Malcolm Arnold gave me a film that he'd been asked to do and couldn't take on, a picture called *Blind Date,* which was directed by Joe Lessing. I was thrilled and honoured, because Malcolm Arnold was really something. And Muir was so offended that I did a picture for Malcolm Arnold that he never spoke to me again.

By the 1960s I was doing a lot of big films. In the 1970s I began to realise that first of all I had never wanted to be a film composer. I was a composer who did films on the side, which a lot of composers in this country did. And it's not a snobbery; it's that my heart was not in the film music world. I have never thought that film music was great music, and give or take the odd Prokofiev or Walton score, I'm not interested in film music as such.

NB: Is it the fact that it has to be tied down to a dramatic context that is the problem?

RRB: Well, yes, that's one way of saying it. It's the fact that it is not generated by the composer from scratch. I mean if I do a film – if anybody does a film – the film is probably made in advance. The parameters of the style are already decided. I learnt very early on when I had a score thrown out – which we've all had – that if you try and take the whole thing to a higher and more experimental intellectual plane, it will be thrown out, and often with good reason. I did that with *The Go-Between,* which was *quite* a good film – Joe Losey. I thought I would do a very dark and mysterious experimental score, and that wasn't what they wanted, so it was thrown out. Joe said he would have loved to let me do it again, but I was teaching in America then, and I couldn't do it. I wasn't interested in doing an experimental job – teaching them what contemporary music was about. The people who influenced me were Bernstein, Leonard Rosenmann, Rosenthal, and of course contemporary music – and Michel Legrand. But it was not the Franz Waxman, Max Steiner, Dmitri Tiomkin generation. I was born at a slightly different time. I respect those men enormously, but I wasn't particularly interested in that kind of music. So I went on doing films, and I still do films occasionally, but I don't have to do them to live. Also, since about the time of *Star Wars,* music has become so commercial. I'm not known for commercial hits, so I don't get asked to work that often, and it's not even a world I really want to work in. But it taught me more than I could have possibly learnt in any other way about orchestration, about the practicalities of being a composer. The fact that I had to write in all kinds of styles was no bad thing, because I was very well aware of what I was doing, and I did have a musical language which was slowly developing of my own, which was nothing to do with film music.

Musical language

NB: In developing that musical language, you said when you started out you didn't particularly feel you had a career writing concert music, and that you went into film. …

RRB: I had a slowly developing career writing concert music, but I knew I could never support myself. I was always a 'classical composer', but I wanted to earn a living as a composer, and I couldn't have done it as a composer of classical music.

NB: Because that is what you have become in effect.

RRB: Yes, film music was always a means to an end. And gradually over the years the work has rather dried up for composers who are not commercial. I'm not remotely bitter about it, because it's been my bread and butter.

NB: One of the points the book is following through, in terms of talking about music as narrative (and it's not just film music but really all music), is the communicability to non-musicians that music has – this ability to somehow touch people. They may not have the technical capacity to understand how it's working, but it is simply working. That language which you have such a facility for, within film music and outside it, was that something you felt growing as your career grew – an ability to speak to people through music – or are you writing first for yourself?

RRB: Inevitably myself. That's a very deep and complicated question. What music does which is so interesting is things which you can't turn into words. If somebody says to me, 'What is that movement about?' I'd have to look at them blankly. It's not about anything that you can put into words, and that's why it's wonderful. If the music sort of flashed a neon sign, saying 'hope' or 'joy' or something, it wouldn't be very interesting, because it does something so much more complex than that. What music does in films, I think – the best film music – is to add something that wasn't there before. If you're just gilding what is on the screen, dressing it up, well you can do it, but whenever I have had to do that, I've felt slightly ashamed that I was just being a sort of window-dresser, just selling the goods. Occasionally the music does something – and I think the train sequence in *Orient Express* is this thing – it turns into something which wasn't there on the screen before. When I did the music for the film of *Equus*, for Sidney Lumet, I knew what Mark Wilkinson had done in the stage production, which was a very frantic, modernistic, impressionistic kind of music, and I said to Sidney Lumet, 'Look, you can't do this on the screen.' And the film didn't look like that. So the music in fact was very withdrawn, and what I was actually doing, although whether I'd have said so at the time I don't know, was compassion – was a very brave, very expressive, rather withdrawn kind of music. It didn't go with the madness you were seeing on the screen, so it added a layer of meaning which wasn't

there on the screen, and that's the best thing that film music can do.

NB: In the case of the most famous one which you've just mentioned, the train sequence, Did you come with that in mind?

RRB: Yes, I did, yes. I know why I was thinking of waltzes. It was because Steve Sondheim had just written *A Little Night Music*, which I loved, and at that time I idolised him. I still idolise his music of that period – that includes *Company* and also his score for *Stavisky* which I think is a marvellous film score. I remember the train sequence without music. Sidney was very good; he didn't tell me too much what he wanted; he trusted me, and that's the best kind of director to work for. I knew that the music could carry that particular sequence, could do something fantastically glamorous to it which wasn't actually there. I mean it was a train for God's sake! Even if it had Lauren Bacall on board, and Ingrid Bergman! … But it was a train just going along. But the music made it dance, and that was very good. You don't always get chances like that. I thought at the time I was taking a terrific risk in doing this rather surrealist juxtaposition of a huge waltz with a train. I saw Sidney Lumet and the producer in a corner of the recording room sort of whispering to each other, and I had a paranoid fit, and thought, oh God, I've blown it! I said, 'You hate it.' And they said, 'No, we were saying it's absolutely marvellous.' It was a great moment of my life which I'll never forget. Sometimes you take a risk like that. I mean doing something in a sense quite foreign to what is going on on screen, really sticking your neck out, and you cannot help but think, they're going to think I'm mad. I did this in fact with *The Go-Between*, for Joe Losey. I don't know if you saw the film, but it was set in a beautiful English pastoral summer landscape, and the music was saying, 'No, no, no, no, no. There's something horrible going on.' I remember this technique from very early on. It was one of the very early times that I noticed film music, in a movie called *The Bad Seed*, which is still a pretty good thriller. It's based on a stage play, and it's about a child murderess. There is this

dear little moppet going off to school at the beginning, and her mother is there, and the nice lady from next door, and it's a lovely sunny morning, and the music is saying, 'There's something terribly wrong.' I remember thinking when I saw that, that's what film music can do. It wasn't going bang and doing terrifying noises. There was a terrible sense of unease in the music which wasn't there actually on the screen, and that's the best thing film music can do. But occasionally, as in *The Go-Between*, you go too far. I've gone too far in the opposite direction, and it wasn't what we needed. But that's the most exciting thing you can do in film music, add a totally new element.

Working with Directors

I would like to say just one thing about working with directors. As I said about Sidney, he trusts you. The worst kind of director to work for is the kind who would do it if only he had the talent and the language, and that is murderous. Ken Russell is *murderous* to work for, because he's so inarticulate. And Ken Russell is an extraordinary man, but there are some incredibly stupid men I have worked for in my time who just can't bear to let you go home and get on with it. They've got to try and tell you. But then there are people like John Schlesinger who *really* know about music. Maybe I shouldn't say 'people like John Schlesinger'; I should say, 'Then there's John Schlesinger who really knows about music.'

NB: In an interview for this book, he has actually mentioned how much he enjoyed working with you. He said that because he feels he knows something about music he is either an enormous help or the bane of a composer's life.

RRB: He's both, because he asks so much of you, and because he really can tell you why something isn't working. There's a sequence in *Far From the Madding Crowd* where there's a sort of visual seduction of Julie Christie by Terry Stamp on a horse out on the downs. It's a *big* music sequence. And we were practically at one

another's throats. Every time I thought we'd got the take, John would say, 'Well, yes, it's beautiful but. ...'

NB: Was the argument about the orchestration?

RRB: Partly about the orchestration, and the infuriating thing was, he was right.

NB: What was it that he had that he brought to it?

RRB: Music is very important to him, and he knows a lot about music. He had some wonderful music laid as a temp track when I first saw the film – Holst and Vaughan-Williams, I think. And then later on I did *Yanks* for him. At the beginning there's a big military march, and it's the American army moving into the north of England – I think it's Yorkshire. We tried all kinds of tunes – American military marches orchestrated as such. Then finally I ended up with a fantasy American march that I orchestrated myself, but it took so long to get it right. As I said, then there's John Schlesinger. He really knows about music.

NB: And under those circumstances you don't mind guide tracks?

RRB: Oh, no, I'm used to guide tracks. The only problem with guide tracks is when they get too attached to the original guide tracks, because then they don't really want to hear what you've written; they want the guide track. On a film I just did called *Swann*, which is coming out this summer – a beautiful film – they laid some of Michael Nyman's music from *The Piano*, which I happen to like. I know a lot of people hated it. It's not the piano music; it's the string music. I found it so atmospheric that I couldn't get away from it when I started to write. That's the first time it's really happened like that. What I did doesn't sound like Michael, but it was a brilliant choice of temp track, and I thought, well, that music is really the best that they could use here.

NB: So where does that leave you under those circumstances?

RRB: Well, I'm finding it very difficult to write now, so it was a very hard score to write. But that was a wonderful film, because music is *crucially* important in it, and very often, as I say, it's just a sort of dressing up – window dressing.

NB: Do you think the days of that kind of film are almost numbered, where the commercial nature doesn't wholly drive the film, but where someone like yourself has a chance to find a director? …

RRB: Oh, this *Swann's* not a 'commercial' film. It has Miranda Richardson and some terrific actors in it, but it's not a commercial film. But then neither is *Sense and Sensibility*. Neither is *Dangerous Liaisons*, which I would have given anything in the world to have done the music for. George Fenton did a great job on *Dangerous Liaisons*, but I wish I'd done it, because I'd have loved to have coloured that, put my own – that terrible American word, 'input', into that film.

NB: There are bound to be certain films with which you know, that's there for me.

RRB: Yes, that's there for me. That has my name on it. We don't generally get them. But *Swann's* brilliant from my point of view, and it was brilliant for me.

Music with no purpose

NB: How far do you think the public sensibility is getting jaded with respect to film music?

RRB: Oh God, I don't know. I think it is. What distresses me, and it's something I've only become aware of in recent years, is this. So often music is being used for no purpose at all, *no* purpose. I'm a member of the Academy of Motion Picture Arts and Sciences, which means every year I get about forty videos of new films – and I can't complain; I love it. I run down to the mail-box every day to see what Santa has brought me today! But with one or two films I've seen this year, I've been absolutely amazed, because the music never stops, but it's so quiet that you can't actually hear it. It's as though the public

has to have music. You can't tell what notes it's playing; you can't tell what the orchestration is; it's just like the traffic noise here – there's something going on out there. And that is disgusting to me, because it's such an insult to the public. It's an insult to the composer as well. If I put music in a film, there's a damn good reason every minute for it to be there. I think this blanket use of music comes from television. About ten-twelve years ago I was doing a television adaptation of a serious play, and the director kept saying, 'Richard, we need music to get us from here to here.' I said, 'What do you mean, 'Get you from here to here'? That's what the camera's doing. It's going out of the living-room into the hall.' 'No, we need music to take us through there.' I said, 'But there's no emotional affect to this scene; there's nothing going on. What shall I do?' He said, 'We just need music.' And I realise what he was saying was, 'We're going into a commercial' – so to speak. It's *that*, that music is somehow. … I can't even think what you call it. It's a sort of revolting glue that holds things together. Or it's a conveyor-belt thing where it drives you around. I can't do that. The hardest thing for me to do in films is to do nothing, because I'm still judging the music as music. And when there's nothing happening, I am just ashamed! I've never written anything so dull. This is a criticism of myself. I should be able to be more cool and more objective about it, but I can't.

NB: You were saying at one point the style is often decided well in advance.

RRB: Yes and no. You know what is acceptable, and sometimes you can stretch it.

NB: The hardest job, I should imagine, is writing not just the style, but the theme of the film, in which you have to have, in a sense, distilled the essence of that film into something from which you start. Is that the case?

RRB: The theme of a film is not necessarily what you start from. That's to say, it's very easy, particularly in a commercial film, to make up a little theme which you know

will work. But to find a language which is really specific to that film, to find a style, to find a colour, can be very hard. The hardest job I ever did in commercial music – well, you could hardly call this commercial – was for the radio, and it was the diaries of Nijinsky, read by Paul Schofield. This was probably in the late 1960s. That's an incredible book, and I thought, I haven't got any language to put to this. The insane Nijinsky was so amazing, and it took me weeks to get anywhere near it. But for the average commercial film, it's not hard to write a score – I mean a tune – which will be acceptable. And also you're not inventing music from scratch. With a lot of commercial films I've done, I've thought about Michel Legrand at his best, I've thought about Johnny Mandel, who is an idol of mine and a friend, and you know how they do it. Also you have to bear in mind that probably they're going to record the music in three weeks, and you can't it around waiting for a cloud of inspiration suddenly to pour all over you. You have to get going as fast as you can. But sometimes finding the right language is very hard.

Good and bad experiences

NB: Out of all the experience you've had in writing music with narrative, whether it be film, whether it be any other form, is there one particular one that you think is most successful, or one thing of which you're proudest, or of which you felt that the actual process of writing it was the most enjoyable?

RRB: Well, the two things don't go together! I love the score I did just now for this movie, *Swann*, but it was *murderously* hard to do. It was terrible. So it wasn't enjoyable at all, but I was thrilled with the results, and I believe they're thrilled with the results.

NB: Is that Swann as in Proust?

RRB: Yes, but it's not. It's based on a novel by a Canadian writer called Carol Shields, who won the Pulitzer prize this year with a novel called *Stone Diaries*. I loved doing

that, and I knew, as I said before, that the music was crucial to the film. I loved doing *Far From the Madding Crowd* because of (and in spite of!) John Schlesinger, because he was so demanding, but he was so inspirational as well. I loved doing *Orient Express*, because we all knew that was going to be a smash hit – and it was such fun to do. But there are little films I've done. I once did a Bette Davis film called *The Nanny*, which was a little low-key Hammer film, but the music had a lot of style, I liked the film, and I was doing something very stylish and important as a film. I enjoyed it a lot. So it needn't be the best film. It would never be the film on which I've had a horrible time. I would never be pleased in any way with a score where I couldn't stand the director. The two things are not compatible. But sometimes it's a very little unimportant job, and somehow you've hit the nail on the head, or you feel you have.

NB: For preference do you like to be involved right from the beginning of the film?

RRB: No, I don't. That's another thing about John which gets on my nerves! He wants you to be part of his team from moment one, which is very flattering, but nothing means anything to me till I see it on the screen. I can talk, but I don't like talking on the basis of the script. In *Far From the Madding Crowd* I was on location with the film, and I remember sitting in those fields in Dorset and just streaming, because in those days I used to have terrible hay-fever! There's a sequence in *Far From the Madding Crowd* where there's a harvest festival supper going on, and I was sitting there, and my eyes were running, and I was sneezing, and I was cursing, and it meant absolutely *nothing* to me at all. I mean it was fun looking at Julie Christie and Alan Bates, because of course it was. But it means nothing to me in musical terms until it's on the screen. I never think of anything on the basis of the script, and I think of even less on the basis of the location or the actors. That doesn't speak to me.

NB: Was John Schlesinger asking you for music to cut to during the course of the filming?

RRB: No, it wasn't that. There was a very great deal of folk music, and a lot of live singing with fiddlers and stuff. We had a wonderful folk song adviser, named Isla Cameron, on that film, but John wanted me there nonetheless. I remember also on *Billy Liar*, which was the first picture I ever did with him, going up to some Mecca dance hall in Macclesfield. I was there for that, and I hated it. But John, bless his heart, wants one to be part of the team, though the composer doesn't do anything until he puts a pencil on the bit of paper, and nothing is real till you see it on the screen. Until it becomes artificial you can't write music for it. You don't write music for Julie Christie sitting in a field; you write music for Julie Christie on the screen. There's another picture I like very much, called *The Return of the Soldier*, with Julie Christie, Alan Bates, Glenda Jackson and Ann Margaret. A very interesting film which for various unattractive reasons never made it.

NB: I can remember it coming out – in British Film Year.

RRB: Yes, but there were awful troubles over the financiers with that film. But, again, I think music was very important in it. I liked it. And they treated me very well. This sounds an idiotic thing to say, but sometimes you really get treated like shit. Or like somebody who's come in to paint the house.

NB: There is that sense that music, particularly film music, is the last thing thought about.

RRB: Oh yes, it is.

NB: And that it is going to save the day if necessary, and if it doesn't. …

RRB: And if it doesn't, you're in trouble. Yes. What is interesting is that very often as a composer one is the first outside person to see the film, and so they're quite interested in your reactions to things. Quite often I've said to the director, 'I didn't understand that. I didn't understand what they were saying. I don't understand the scene.' And they will actually listen to you, because they're so close to it till that stage, that they're very interested in somebody's reaction like that.

NB: And do you think that goes back to your interest in theatre as well? Obviously what you bring to your work is an awareness of drama and the way drama is working as well as the music.

RRB: Yes, that's true. With commercial films they very often have sneak previews, and on *Four Weddings and a Funeral*, I went to an incredible sneak preview in Secaucas, which is like going to, you know, Barnet! This awful cinema. But they were vitally interested in what the audience thought, because this was the first time that anybody had seen it. Actually it was the second time, because there was one in California.

NB: *Four Weddings and a Funeral* has been an extraordinary success story.

RRB: Yes. Unfortunately, that music was decimated, because they realised they had an enormous commercial success, and so they took out a lot of the original music and put in a lot of music which was more commercially appealing.

NB: Which is basically hits and stuff that was out at the time.

RRB: Mmh. Yes. But it was fun to have been involved in it, and I like working for Mike Newall very much.

5 Tales From the Edge

David Raksin, the composer of the theme from *Laura* (1944), one of the most successful pieces of film music ever written, found himself asked again and again to come up with more film music that was, 'as good as *Laura*'. His answer to the film-makers was simple – 'Just make another film as good as *Laura*'. The future for narrative music is the future of the whole process of creating popular art. That collaborative operation is reliant on every creative member sharing the same artistic goal – the pursuit of innovation and excellence.

Compared with preceding generations, today's society is bombarded with more music, better recorded music and more wildly contrasting music than any that has gone before. Any attempt to peer into the future of narrative music must take that into account. Some eight minutes into Haydn's oratorio, *The Creation* (1798), the chorus quietly sings, '… and God said let there be light, and there was light!' Famously, the entire orchestra and choir sing a major chord on 'light' as loudly as the voices and instruments will allow. This was probably the loudest musical sound the Baroque audience ever heard. In the 19th century, the orchestral resources required by Verdi and Wagner, Berlioz and Mahler were not only dazzling in their variety of tonal colour but ear-splitting to order. Audiences of the day would hear nothing louder than the Dies Irae of Verdi's *Requiem* (1874). Audiences today can listen to the loudest moment of a 19th century symphony in the concert hall, then go home and repeat the experience even more loudly on their stereo system.

Today's music lovers are used to the speakers or head-phones, not the actual sounds of instruments. On the stereo, the music can be made even louder. It can be heard from the point of view of the microphone placing in a hall or recording studio. It can be heard within the narrow (in comparison with the human ear) frequency band and ambient awareness available even to the best recording technology. Those are the minor drawbacks. The advantages are that music can become a solitary or communal pleasure, it can reflect the taste of the listener, it can place him or her in the 'best seat in the house' to hear the work to advantage, and the technology can clean up the recording and send it out as near perfect as the musicians can manage.

Pop music is, of course, studio created and controlled from the start. Mile-stone hits like the Beach Boys' 'Good Vibrations' or Queen's 'Bohemian Rhapsody' could only be studio creations. Yet live concerts in the 1960s and 1970s often proved disconcerting reminders of how superior studio technology was to live technology. Some bands could barely reproduce that number one hit when left to do the work without studio help. Early classic concerts must have been all but inaudible. The Beatles played a screaming crowd in Shea Stadium with a couple of hundred watts of amplification and the stadium's own PA system. Since then the science is there to make a band sound as good live as on CD, and the more machines are used to create the music, the more control there is over every aspect of their use. Sampling has allowed musicians to lift sounds of all kinds, from the tone of real instruments to entire lines from previous generations' songs, and replay them, edited, encoded and put to a new use. Instrument samples can allow keyboards to reproduce string sections, guitars to produce brass sounds, and there too, the technology is reaching to new heights of perfection.

Yet that very perfection may be part of the problem. Digital sound is clean, clear and note-perfect. Real instruments are not. Samples of high string sections 'build in' slight discrepancies in the tuning to reproduce the real experience. Part of the reality is in the very imperfection of the instruments themselves, which have not changed in design and manufacture in two hundred years. Samples can reproduce certain frequencies, but the sound waves travelling through the air from a symphony orchestra or a single triangle are too complex for a machine to reproduce fully. A trained ear will be able to tell the difference. Yet what, today and in the future, is a trained ear?

Technology has allowed the composition of music, including scores for drama, to be within the capacity of everybody who is, even in a small way, computer literate. That same technology has opened up music to musicians who would happily admit that they could never play a 'classical' instrument but understand the fundamentals of rhythm, harmony, melody. This is not a devaluation of music. On the contrary, this is the way an art form always evolves – the rules are there to be broken, rewritten and broken again.

Ultimately, the only fair arbiter, the public, will say if a certain kind of music is valid or not. This may not be entirely the case in the pop world, which has shown an amazing ability to create demand for its product – in effect to create the market first, then supply it. Take that proposition to its logical extreme, and you have a society being primed as to what it should listen to. Whatever the ethical concerns of that situation, mass-acceptance of a musical work is significant. Today's computer-generated hit is tomorrow's nostalgia. Yet with the convenience of machine-made music comes the temptingly easy option of cloning previous work. If that becomes the only ambition of scoring to drama, the future looks bleak.

In the light of the steady advance of musical technology, whither music as narrative? What will music, ultimately, *mean*? The application of music to drama depends on the thematic, emotional, imaginary resonances it carries. The deeper and more complex those resonances, the more insight can be drawn from their application. Music that contains something deeper than its context is just such music. Yet the trend in much scoring for film, TV and theatre today is self-referential. What much film scoring makes you think of today is other film scores. That is more and more the case with the films themselves. The slow death of an art form is assured when it begins to feed off itself.

Composers are increasingly being asked to sound like other composers. They are given guide tracks which, ultimately, contain the music the director wants rather than the music he is commissioning. There has always been a broad referential aspect to creating music with drama – necessary and valid if the audience is to respond, yet today's composers are limited not by their own imaginations but the imagination of the commissioner, be it director, producer, editor or financial backer. The un-nourishing prospect of film score clones, continuing increasingly diluted into the next century with no more resonance for an audience than arcade game sound-tracks, is all too probable if Hollywood insists on betting only on certainties. The trail-blazers for the future, in music and media alike, are those with a unique, independent vision which is shaped by the past but not subservient to it.

Generations in the future will shape narrative music according to their own tastes. This does not necessarily reflect contemporary trends in popular music. Music with drama either connects or it does not, irrespective of the style or genre used. The audience's response is a complex recognition of abstract connections, both musical and contextual. I do not believe, as some do, that musical taste is being slowly bred out of the human animal. The cutting edge of popular music reflects the first impressions of a new generation to its surroundings. The quality of responsive 'palate' it develops is partially the responsibility of the media industry, its composers and decision-makers. Beyond that, musical taste is instinctive, impossible to dictate or shape in any way. At least future generations will have recourse to all music from every time and every civilisation, generated within technically perfect reproduction.

The rise of what is known as World Music is one of the great successes of this age. Born from the New Age revolution of the eighties, wherein older societies and civilisations were looked to to cure some of the ills of the present day, the music of many eras and cultures became available as music publishers began to serve a growing market for music that was previously unavailable in this country. Traditional folk music, exotic instruments, different textures and timbres are now available on CD in the high street, incorporated into mainstream popular and classical music and put to the service of film and TV, bringing their sounds to a much wider audience. The music of the far east or South America rubs shoulders with Gregorian chant, Russian orthodox choirs and African drums and suddenly the context of the music matters less than its therapeutic effect on the listener. Within a decade the popular awareness of diverse music grew exponentially, a fitting end to a century that had seen music outgrow the concert hall and become the property of everybody. Now composers are bringing all these new instruments and styles within their palate when composing for drama, not just as geographical or historical references but as universal and emotive elements in themselves

The fundamental growth area for music as drama is the context within which it is used. We expect it with film, TV, theatre, but we are increasingly sharing our work, leisure, shopping and living spaces with it. Muzak is the product of post-war commercial thinking that recognised the super-market as a cold, mechanical, faceless

environment in which to shop. Soothing music could help to warm a chilly experience. The same commercial thinking realised ultimately that shoppers could be influenced by the choice of music. The right music sells products faster, makes people want to stay or marches them through the store as quickly as possible. This is music working as drama – it is as influential as in the theatre.

In hotels, the music is probably with you in the lift, the foyer, the communal rooms. Again, a cold, faceless area is being 'warmed' by a communal and personal experience – music is the link with humanity that would otherwise not be there. Many people hate muzak for precisely that reason. These are usually people for whom music is a very special part of their lives. Music being thrust into their attention is, to them, a devaluation of its purpose. The music chosen is, likewise, usually too bland to appeal. Yet canned music proliferates in public areas, and will continue to do so.

The reason is simple. Take the music away and look at the environment it serves. The chances are that it will be an environment that overwhelms, that makes us feel small, insecure, inhuman. Airports, shopping malls, service areas which we need to pass through but may not enjoy the experience, crowds, confined spaces – all these places use music as a relaxant. Buskers on the London Underground during a rush-hour momentarily draw the attention away from a de-personalising environment and into one where the personality still considers and reflects upon what it hears. The radio/cassette in the car speeds the dull journey and soothes the grid-locked driver. In factories, particularly where the work is repetitive, music takes over the mind and allows the work to go onto auto-pilot.

Music therapy is defined as a behavioural science that is concerned with the use of specific kinds of music and its ability to affect changes in behaviour, emotions and physiology. It tends to be divided into two schools of approach, one whereby the patient, by playing musical instruments has the ability to communicate, grow, express themselves in a different way; the other in which the playing of music to a patient helps to free something within them, break through an emotional or logical blockage. Patients can achieve a state of deep relaxation, learn self-awareness and creativity, improve their

learning skills and quiet ceaseless thinking and restlessness. As already discussed the ability to make music may survive a trauma in which the ability to speak has been lost, but in a wider context the therapy of enjoying music in a group, the shared awareness of its effects, can do untold good for people suffering a bewildering range of physical, mental or behavioural difficulties. By tapping into a well of deep response within people, music becomes a healer, an emotional educator, revealing deeper structures of communication and insight through which the most isolated personality can be reached. At a simpler level we all enjoy a musical massage as a matter of course. Just throwing on the stereo at the end of a long day is music therapy for millions.

Music therapy is a recognised educational and medical aid. New age thinking includes music, both self-created and ambient taped music, to release aggression, assist trance and combat stress. Women in childbirth are played music specially formulated for that very experience; babies are soothed not just by their crooning mothers, but by taped sounds from with in the womb or whale-song, and even the dentist's drill can be soothed and accompanied by a choice from the CD collection.

Representations of the future in popular entertainment tend to suggest that music will be electronically created, but tend not to hazard a guess as to what that music will sound like. In *Star Wars* (1977), Han Solo and Luke Skywalker enter an alien bar where a band of weird life-forms are playing futuristic-looking instruments. The sound those instruments are making is suspiciously close to jazz, a heartening concept and an optimistic indication for future UFO contacts should it prove accurate. The development of music as narrative is one with the future of that narrative. If said narrative reflects the human condition, the future seems dystopian rather than utopian. We cannot avoid the sense of dehumanisation that is inherent in the growth of technology, the increase in world population, the continued destruction of the natural environment. The future of music may be impossible to predict, but its future use to humanise the inhuman, deepen the shallow experience, calm the stressed spirit and represent the eternal in the transitory, is not. Ultimately the world it contains is an alternative reality that, by comparison with the real world, can

only grow more alluring with every passing second.

The way forward for music with drama lies, as it always has done, with the individual creative spirit. The views of the composers interviewed in this book represent the determined, uncompromising approach that assures the future of the art form. Their creativity is enhanced when they are given the latitude to experiment. The music they create binds us to the drama we watch, but it finds new ways to perform that binding function. The history of narrative music is the history of innovation, the stories of creative individuals who have dared to experiment within a commercial medium and with the cooperation of gifted collaborators who have allowed them to do that. As society has changed so those changes have been accepted and considered, without blunting the edge of creativity. Now, with a technology that allows miracles of recording and compositional quality, an audience that has access to world music of every period in history, and dramatists in every medium gearing up for the challenges of a new millenium, the future for dramatic notes should be rosy indeed.

The missing elements in the formula are the commissioners, the directors, the producers, the hirers. These are the collaborators who ultimately give the composer the space needed to produce their best work. They must be musically aware yet not dictatorial, acknowledging the potential of music to influence but not frightened of that potential, demanding yet realistic, aware of current trends yet not satisfied with slavishly cloning them. Their expectations of their audience should be of the highest yet realistic enough to remain accessible. Their relationship with the composer should be uncompromising yet based on the awareness of a mutual need.

This may seem to be asking a lot, yet the responsibility for the future potency of two allied art forms lies jointly with both exponents. It has been proved that the growth of a healthy society is mirrored by a healthy culture. When that culture falls within the category of mass popular entertainment, the responsibility it owes to society is, I believe, all the greater. Film and TV shape our view of the world, and the potent stimulus of music is something we imbibe with our mothers' milk. Yet the responsibility of the artist in any medium is not to give us what we want in the way we expect it. It is to constantly surprise and involve, to fight for innovation and creative latitude. Drama and music are in this together, the composer, director, writer, producer alike, and within that alliance we find every individual who has a creative part to play in realising the end product. With the extraordinary power of music put to work, honed and defined to that ultimate aim, future generations will experience works of popular art the like of which we could not even begin to imagine.

Selected Bibliography

Banfield, Stephen,
Sondheim's Broadway Musicals,
University of Michigan Press, 1992.

Chomsky, Noam,
Aspects of the Theory of Syntax,
MIT Press, 1965.

Cohn, Nick,
Awopbopaloobop Alopbamboom,
Minerva, 1969.

Evans, Mark,
Soundtrack – The Music of the Movies,
Hopkinson & Blake, 1975.

Lisle, Tim de (ed),
Lives of the Great Songs,
Penguin, 1994.

Marshall, Robert I,
Mozart Speaks,
Schirmer Books, 1991.

Potter, Dennis,
The Singing Detective,
Faber, 1986.

Prendergast, Roy M.,
Film Music – A Neglected Art,
Norton, 1992.

Priestley, M,
Music Therapy in Action,
Constable, 1975.

Scholes, Percy,
The Oxford Companion to Music,
Oxford University Press, 1938.

Storr, Anthony,
Music and the Mind,
Harper Collins, 1992.

Thomas, Tony,
Music for the Movies,
Tantivy Press, 1979.

Glossary

Button – a short, completed finish to a piece of music, eg, at the commercial break of a programme or as an applause-getter at the end of a musical number.

Cue sheet – a list of musical requirements, including the time code and description of the piece, used by composers to plan scores for film and TV.

Glissando – on piano and harp, is the drawing of the finger quickly up or down adjacent notes.

Guide track/temp track – a piece of existing music laid onto the rough cut of a film by the editor or director to give the composer an idea of the director's intentions for the final score.

Libretto – the words, lyrics or text of an opera or piece of musical theatre, also known as 'the book'.

Recitative – the element of opera which resembles dialogue rather than aria, in which a thought, emotion or subject is formed into a song.

Sample – a digitally realised reproduction of a piece of music or musical instrument, used with computers as part of composition and recording.

Steenbeck – a table-top method of viewing films on a small screen.

Sting – short, bright musical motif, sometimes a single chord, used predominantly in TV to bring out a particular visual image.

Harmony – the combination of musical lines read vertically to form the chords that accompany a melody.

Counterpoint – the combination of simultaneous musical lines read horizontally, each independent but all forming a uniform texture.

Sonata Form – a form of musical architecture used in large works such as symphonies, wherein a musical idea is worked and evolved through a series of related keys and bridges, changing in shape and intent, but with a traceable journey from its start point.

Hook – a particularly insistent or memorable musical moment that makes the listener aware of and interested in the music and remember it when next heard.

Resolution – the progression of music from a discord or suspended chord to the note or chord that gives a satisfying sense of completion.

Aria – a song, usually a high moment in opera, with ornamentation to display the virtuosity of the singer.

Programme Music – a form of music wherein the listener is given a scheme of literary ideas or mental pictures which the music evokes or recalls by way of its sounds and textures.

Spotting – the process whereby a composer and director will go through the rough cut of a film before the music is written to decide the number and length of music cues, i.e. where the music will go, what it will evoke and where music will not be used.

Serial Music – a method of composition (developed by Schoenberg) using all twelve tones in the scale which does not follow conventional chord relationships, has no home key or related keys and repeats the combination of notes without departing from the order until the series has been exhausted and can begin again.